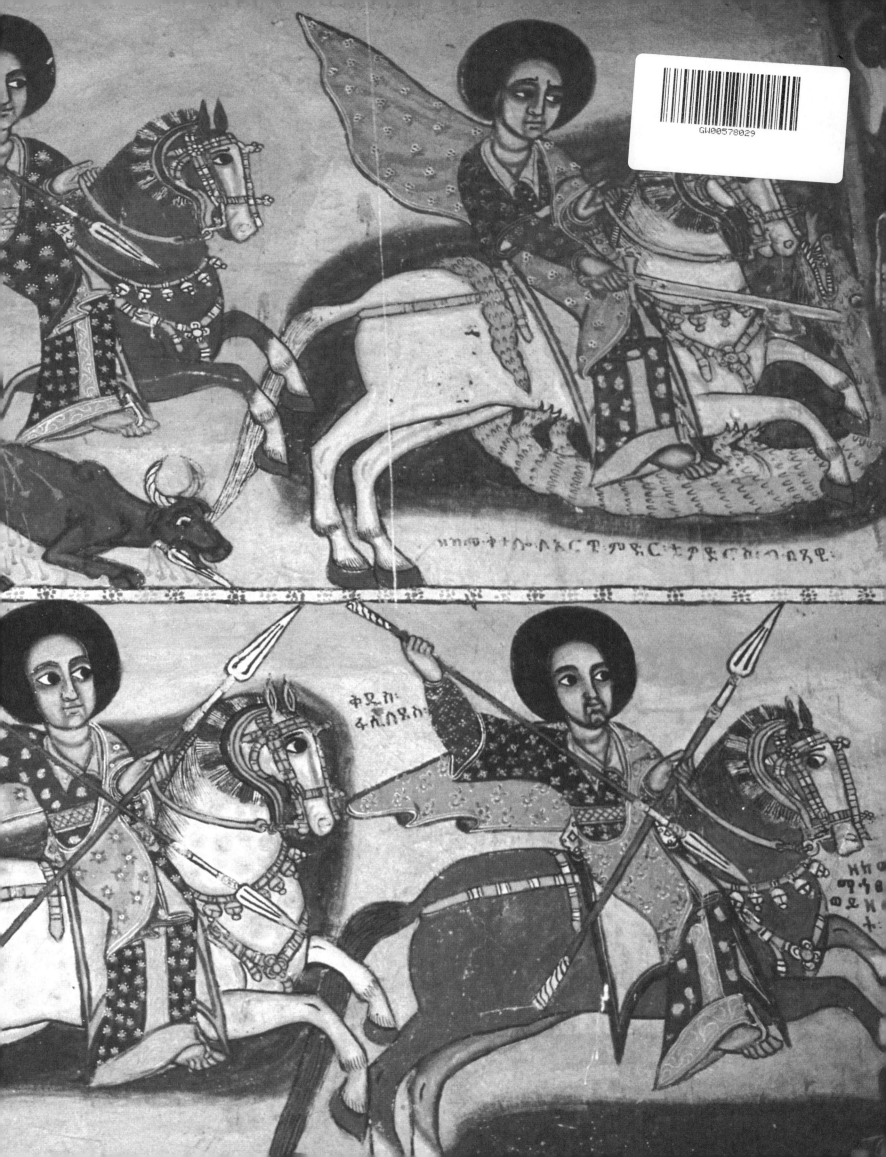

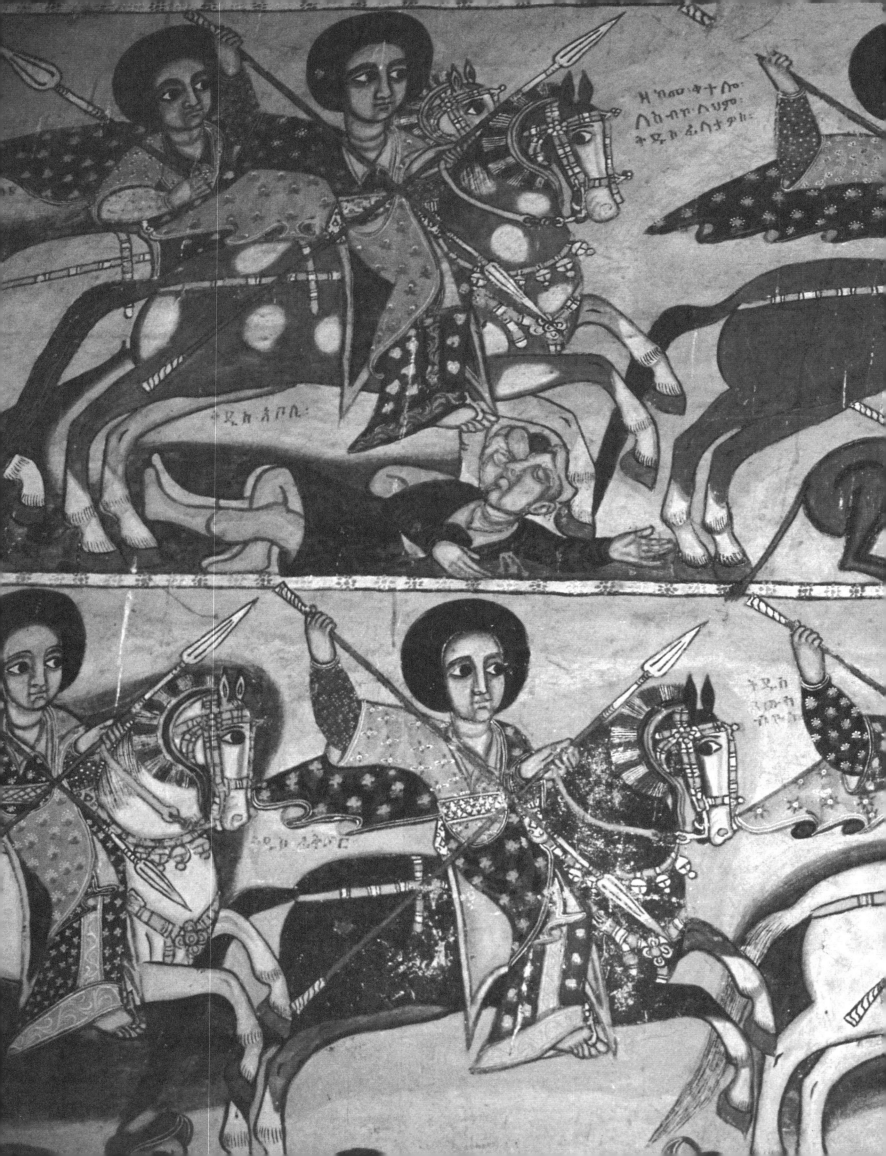

FOREWORD

Ethiopia has a proud and long history extending to the known beginnings of humankind. The fossils of our species' earliest known ancestor was found in the Danakil Depression in north-east Ethiopia. The Axumite Kingdom was one of the great civilizations of the ancient world and has left behind the mystery of the great stellae found at Axum. In the late Middle Ages great religious civilizations flourished in many parts of the country, particularly at Lalibela where churches hewn out of massive monolithic rock testify not only to great faith but also to great architectural skills.

And in the former capital of Gondar many magnificent castles speak of the same legacy. All these would be enough to make Ethiopia a fascinating place to visit and travel through, but Ethiopia has so much more to offer. Here you can find virtually all the faces of African culture and its landscapes and much of its wildlife. You can travel through high meadow lands reminiscent of Europe or trek across even higher moorlands — in the Simien and Bale mountains — and see unique forms of Afro-Alpine plants, which here grow to an astonishing size. You can explore great rivers and lakes including Lake Tana, the source of the majestic Blue Nile whose valley is one of the world's greatest, longest and deepest gorges. You can discover the savannahs and wetlands of our western region and visit the far south, which teems with wildlife and is home to fascinating ancient cultures.

In the great Rift Valley a necklace of beautiful lakes lies beneath the splendid panorama of the Bale Mountains. And in the arid east, the walled city of Harar speaks of other old civilizations and great faiths, such as Islam. Many kilometres north of there lies the Danakil Depression, one of the world's most inhospitable but nonetheless dramatic landscapes which is also one of the hottest places on earth. Yet it is home to proud and independent Ethiopian people who have learned to live with their environment, even to benefit from it. Wherever you go on your journey through Ethiopia, as this book so amply illustrates, you will find many things to enjoy and marvel over, and you can at all times be sure of the warm hospitality of the Ethiopian people.

The Government of the Federal Democratic Republic of Ethiopia extends its warm welcome and wholehearted support to visitors interested in our fabulous tourist attractions and to the investors needed as partners in the further development of our tourism resources.

Meles Zenawi
Prime Minister

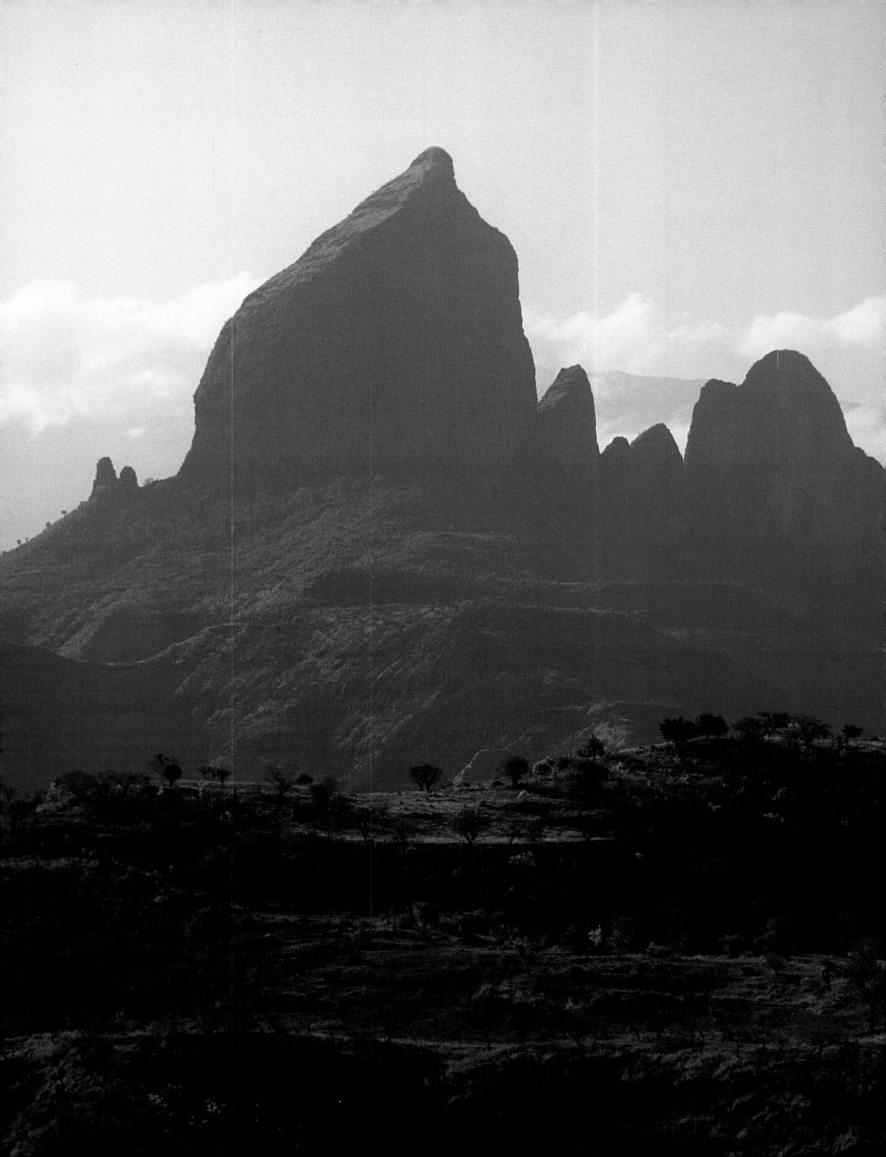

· JOURNEY THROUGH ·
ETHIOPIA

· MOHAMED AMIN · DUNCAN WILLETTS · ALASTAIR MATHESON ·

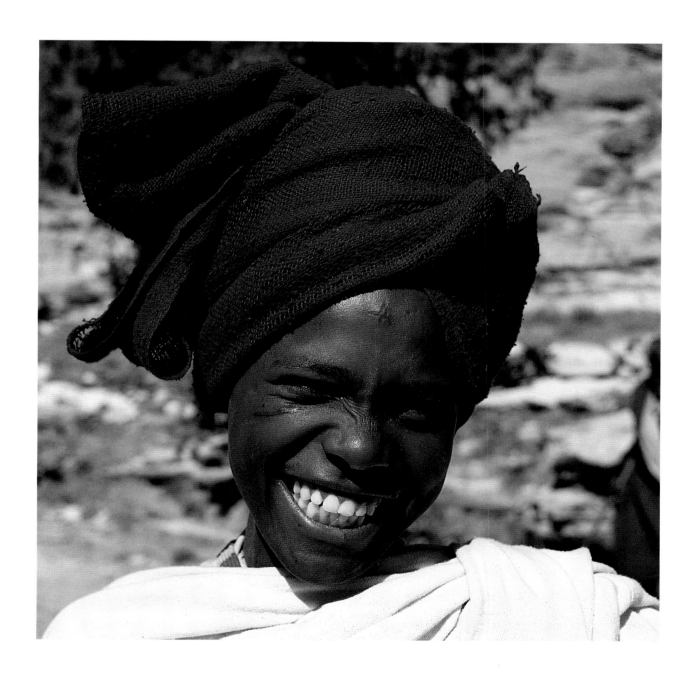

Produced by Camerapix for the
ETHIOPIAN TOURISM COMMISSION

First published 1997 by
Camerapix Publishers International,
PO Box 45048,
Nairobi,
Kenya.

© Camerapix 1997, 2004

ISBN 1 90 4722-03-2

This book was designed and produced by
Camerapix Publishers International,
PO Box 45048,
Nairobi, Kenya.

For
Ethiopian Tourism Commission
P.O. Box 2183
Addis Ababa, Ethiopia
Website: http:www.tourismethiopia.com

Text by: Alastair Matheson
Edited by: Brian Tetley and Richard Pankhurst
Design: Craig Dodd
Production Director: Rukhsana Haq

Colour Separations: Universal Graphics Pte Ltd, Singapore
Printed by: UIC Printing Press, Singapore.

*End-papers: Detail of a mural in a Lake Tana monastery. Half title: Mist rainbow arches
over the thunderous cascade of the Tissisat Falls, where the Blue Nile plunges into one of
the world's greatest canyons. Page 2: Jagged outcrop in the dramatic and stunning Simien
Mountains. Author Rosita Forbes, who visited the area in 1934, described such peaks as
'chessmen in a game played by the god'. Title page: Smiling Tigrayean boy from Ethio-
pia's northernmost region. Contents: Decorated ceiling inside the rock-hewn church of
Abune Yamaata in Tigray.*

CONT

የኢትዮጵያ ቱሪዝም ኮሚሽን
ETHIOPIAN TOURISM COMMISSION
ይሱፍ አብዱላሂ ሱክር
YUSUF ABDULLAHI SUKKAR
ኮሚሽነር
COMMISSIONER

☎ OFF. 15 06 04
 51 31 72
FAX: 251-1-51 38 99
E-Mail: Tour-com@telecom.net.et

✉ 2183
ADDIS ABABA
ETHIOPIA

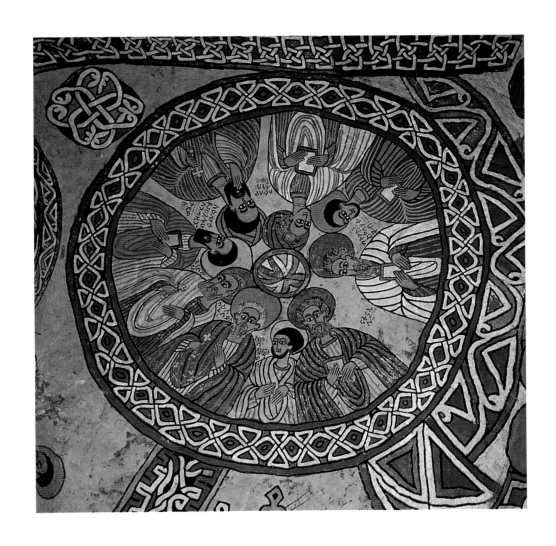

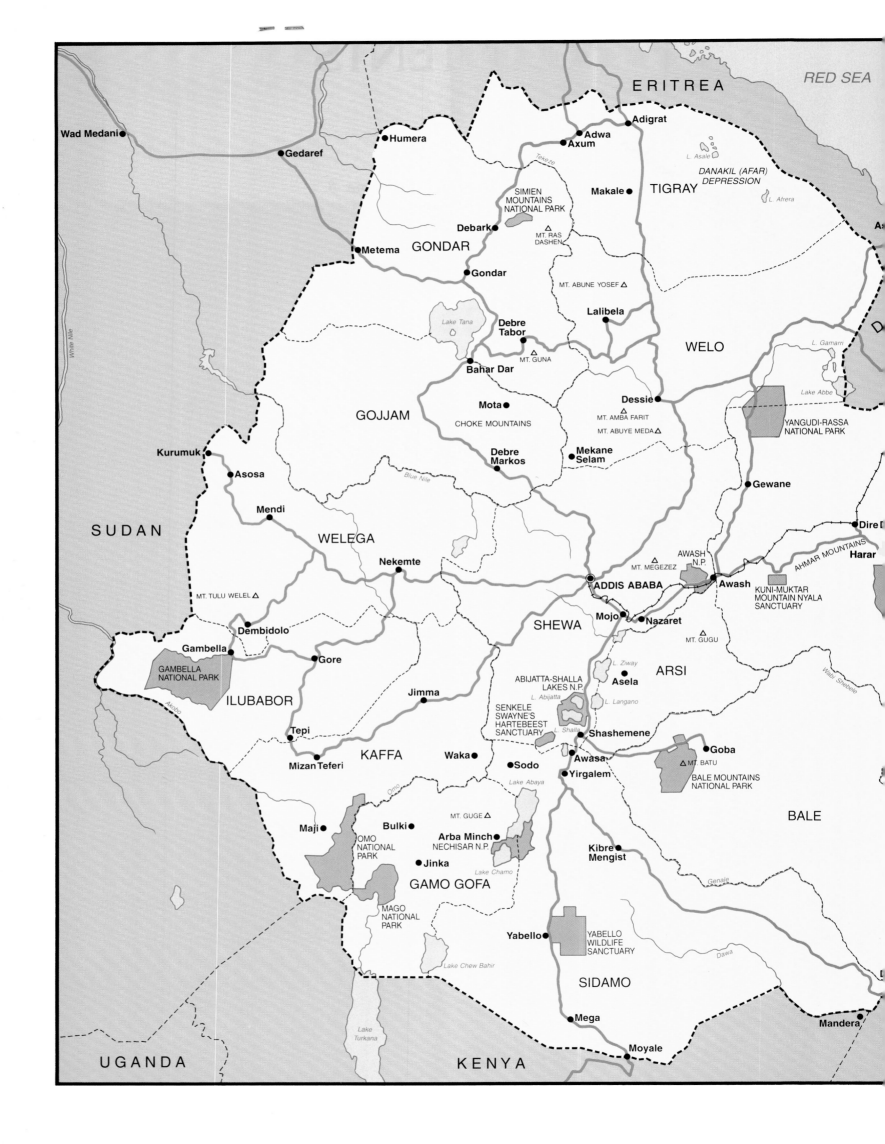

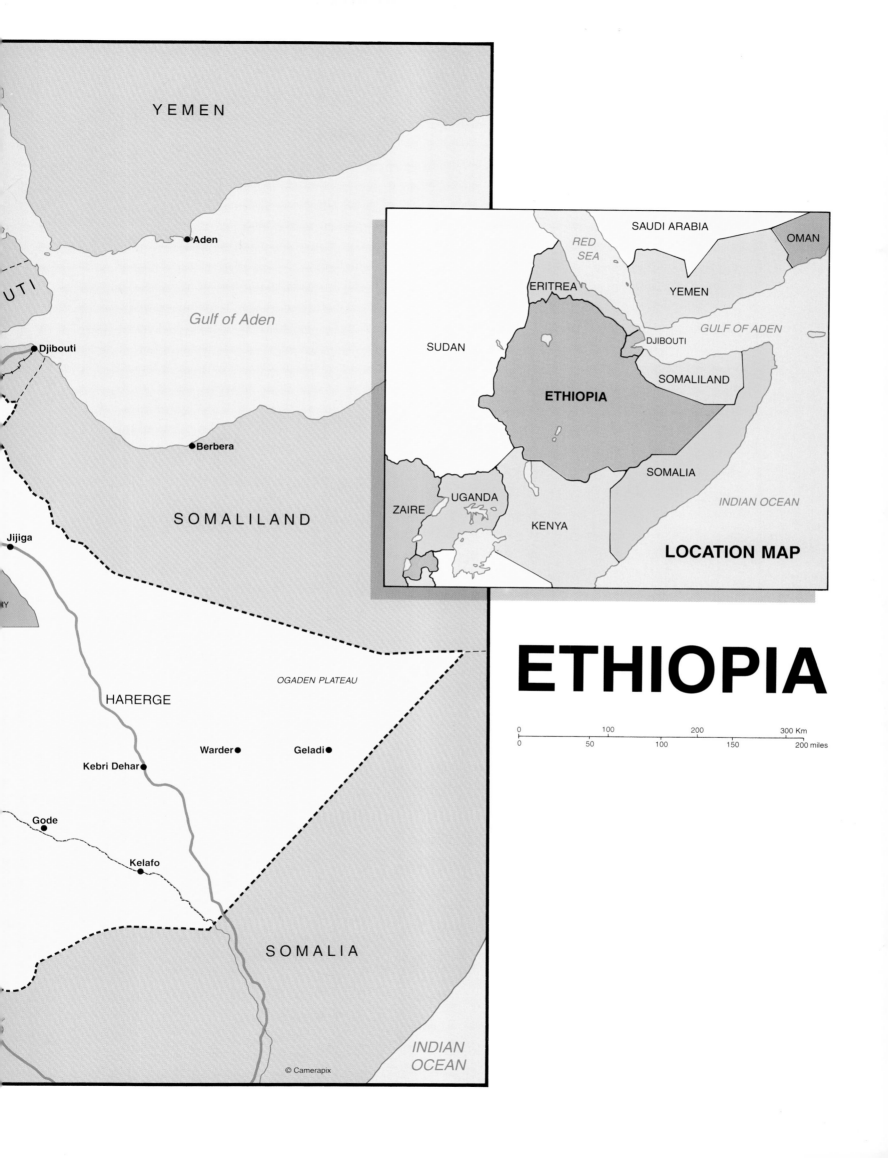

ETHIOPIA

YEMEN

Aden

Gulf of Aden

Djibouti

Berbera

SOMALILAND

Jijiga

HARERGE

OGADEN PLATEAU

Warder ● Geladi ●

Kebri Dehar ●

Gode ●

Kelafo ●

SOMALIA

INDIAN OCEAN

© Camerapix

LOCATION MAP

SAUDI ARABIA

OMAN

RED SEA

ERITREA

YEMEN

GULF OF ADEN

SUDAN

DJIBOUTI

ETHIOPIA

SOMALILAND

SOMALIA

ZAIRE

UGANDA

KENYA

INDIAN OCEAN

0		100		200		300 Km
0	50		100		150	200 miles

1 JOURNEY THROUGH ETHIOPIA

Previous pages: From a vantage point in these dramatic hills near the end of the last century Emperor Menelik II and consort looked down on the battlefield of Adwa as his massed armies met and defeated an Italian invasion force in an epic battle.

Few countries in the world possess such a wealth and variety of ancient legends and fascinating attractions as Ethiopia. This land-locked country of 1,235,000 square kilometres (476,833 square miles) is twice the size of France and shares borders with Djibouti, Eritrea, Kenya, Somalia and the Sudan. Ethiopia's outlets to the sea are at Massawa and Assab, in Eritrea, and Djibouti port, in the Republic of Djibouti.

Ethiopia is a country split diagonally by an act of nature — the cleavage known as the Great Rift Valley, which stretches from the Dead Sea between Israel and Jordan and down the length of East Africa to enter the sea in Mozambique. It enters Ethiopia from the Red Sea through Eritrea in a 'Y' formation north of the border with Djibouti, then runs southward, producing a chain of small lakes beyond Addis Ababa, to leave the country at Lake Turkana (formerly Rudolf) and enter Kenya.

At the northern end of the Ethiopian Rift lies Afar in what is known as the Danakil depression, a barren, scorched landscape which millions of years ago was 'home' to mankind's ancestors. The famous 'Lucy' fossil remains were found in 1974 in the Afar country of the Danakil and dated back scientifically by US palaeontologist Donald Johanson who claimed this find disproved earlier theories that early man could only have developed later than 3.5 million years ago.

The discovery chalked up yet another 'first' for the country which gave the world coffee, pioneered growing *teff*, and the 'false banana' *enset*. It was also the first place in Africa to make Christianity a state religion.

However, it was only twenty years later, in 1994, that scientists dug up the fossilized remains of a chimpanzee-sized ape from 4.4 million years ago at a site seventy-five kilometres (45 miles) south of where 'Lucy' was found. According to Ethiopian anthropologist Berhane Asfaw, who was a member of the scientific team, 'these fossils represent the oldest human ancestor ever found'.

The latest find, consisting of seventeen bone fragments and teeth, has been given the scientific name of *Ardipithecus ramidus*. Initial examination indicates that this creature lived in a wooded environment, causing US scientist Tim White, also a member of the team who found 'Lucy', to express surprise at discovering a human ancestor who lived in such an environment. Many scientists still cling to the belief that humans evolved only *after* their ancestors left the forests to live in the grasslands. Today Ethiopia has a population estimated at over fifty-seven million, more than three million of whom live in Addis Ababa and there are eighty-three languages besides Amharic, the official language which has many different dialects. Amharic has its own alphabet. English, French, Italian and Arabic are also widely spoken in the towns. According to the last

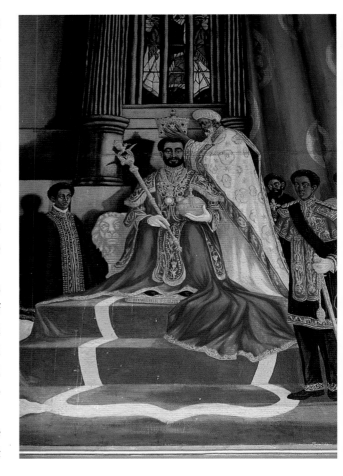

Above: Painting of the coronation of Emperor Haile Selassie in 1930, now kept in St George's Cathedral, Addis Ababa.

Opposite: Religious paintings in the ancient church of Ura Kidane Mehret which stands on the Zeghe Peninsula overlooking Lake Tana.

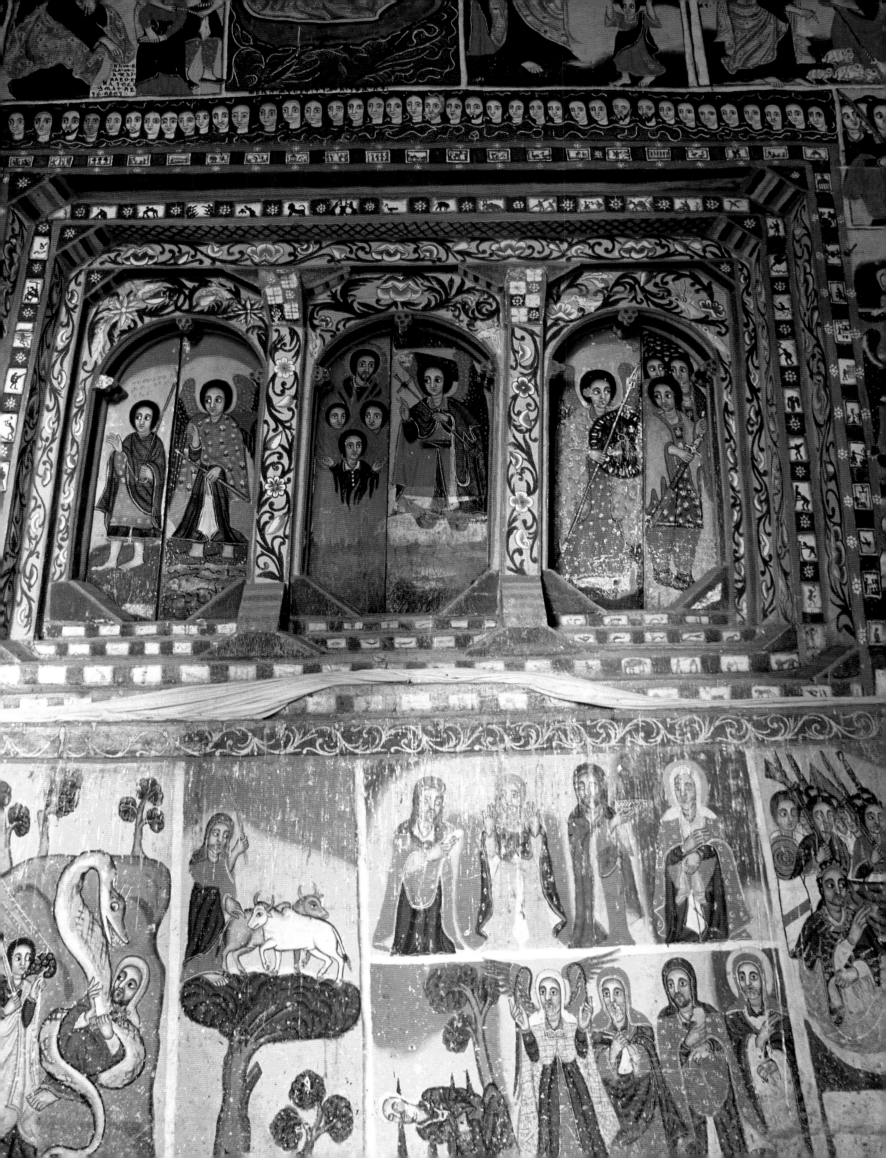

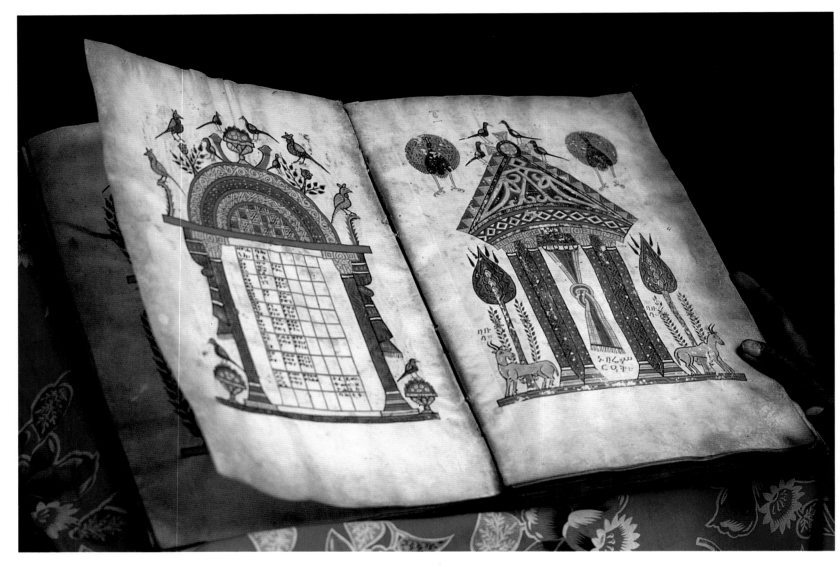

Above: The work of dedicated monks, ancient hand-illustrated manuscripts form part of Ethiopia's treasury of religious art, accumulated over the centuries. One of the oldest is now preserved in a book at Lalibela.

population breakdown, which included Eritrea, there were more than twelve million Oromo of Cushitic origin, representing twenty-nine per cent of the total population, about twelve million Amharas of Semitic origin, twenty-eight per cent, and four million Tigrawi also of Semitic origin, representing ten per cent. Minority groups, including some Nilo-Saharan speakers, number fourteen million — thirty-three per cent — and are classed as 'others'.

By far the largest religious group is the Ethiopian Orthodox Church (forty-five per cent), followed by Sunni Muslims (thirty-five per cent) and those with traditional beliefs (eleven per cent). An additional nine per cent are listed as 'others'.

Religion has always been a major influence in Ethiopia. Certainly no country in sub-Saharan Africa can trace its origins as far back. Ethiopia is mentioned thirty-three times in the Bible and many times in the Qur'an.

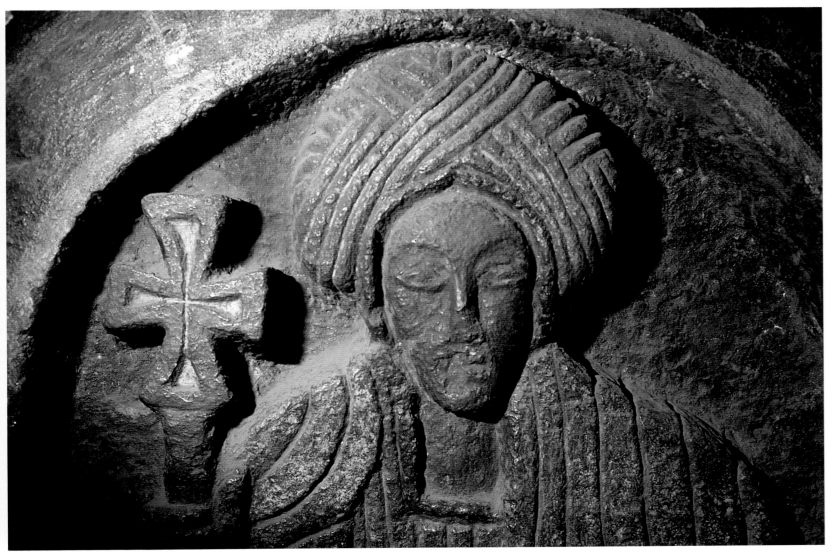

Above: Stone carving inside the 12th-century rock church of Beta Golgotha at Lalibela.

Overleaf: This astonishing mural decorates the ceiling of Gondar's Debre Birhan Selassie Church.

Perhaps this is the reason why so many visitors retrace the 'historic route', drawn by colourful stories and fantastic tales to the land once known as Abyssinia. Throughout the ages, the rocky ramparts surrounding its 2,500-metre-high (8,000ft) central plateau prevented countless invaders from ever penetrating far beyond the lowlands of the Red Sea coast. Thanks to their rugged mountain fastness and their courage, Ethiopia's highlanders remained unconquered for centuries, and most of their historic records and buildings were preserved for posterity.

Some twenty-five peaks rise above 4,000 metres (13,200ft), the highest being Ras Deshen 4,543 metres (14,538ft). The major river is the Blue Nile (Abbay), which runs from the largest lake, Tana, for 1,450 kilometres (906 miles) to join the White Nile at Khartoum. Others are Awash, Wabi Shebele, Tekeze, Genale-Weyb, Omo and Dawa.

Ancient Egyptians, Romans, Greeks and Persians all tried to occupy

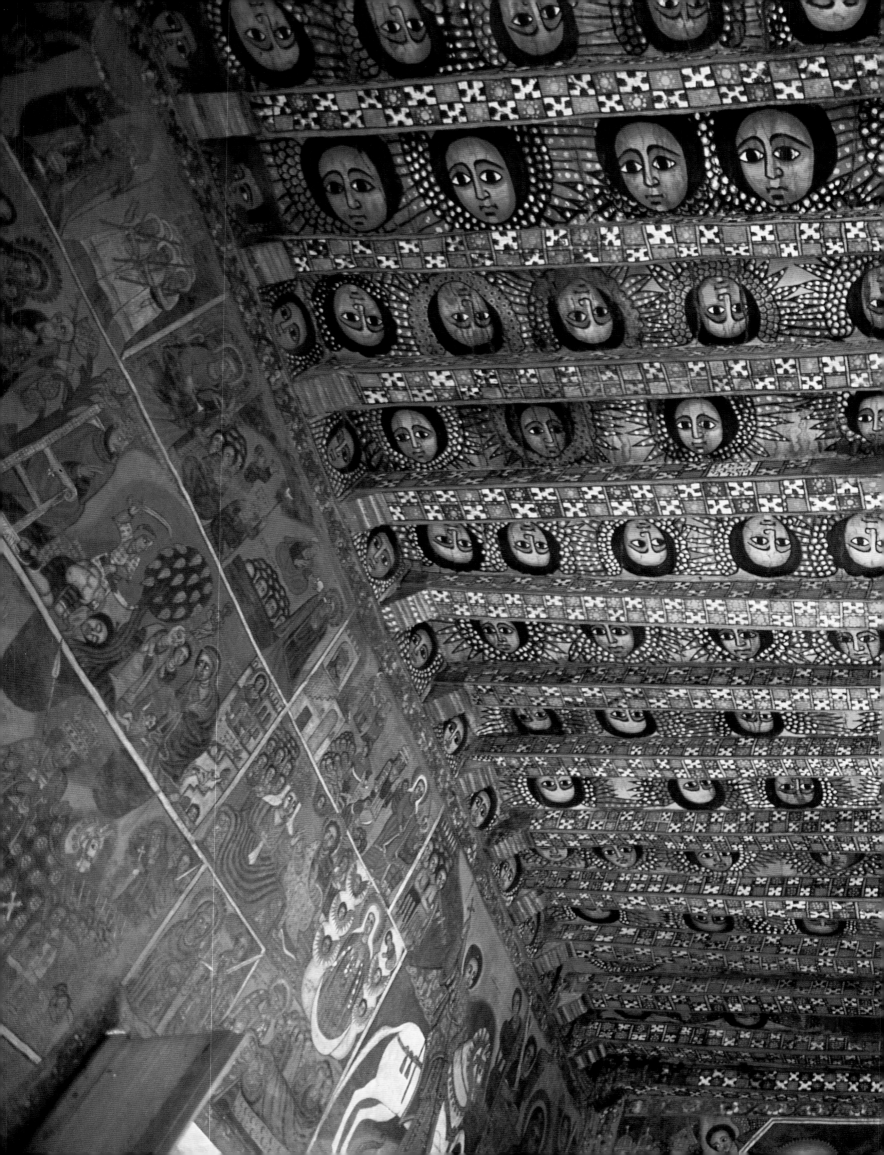

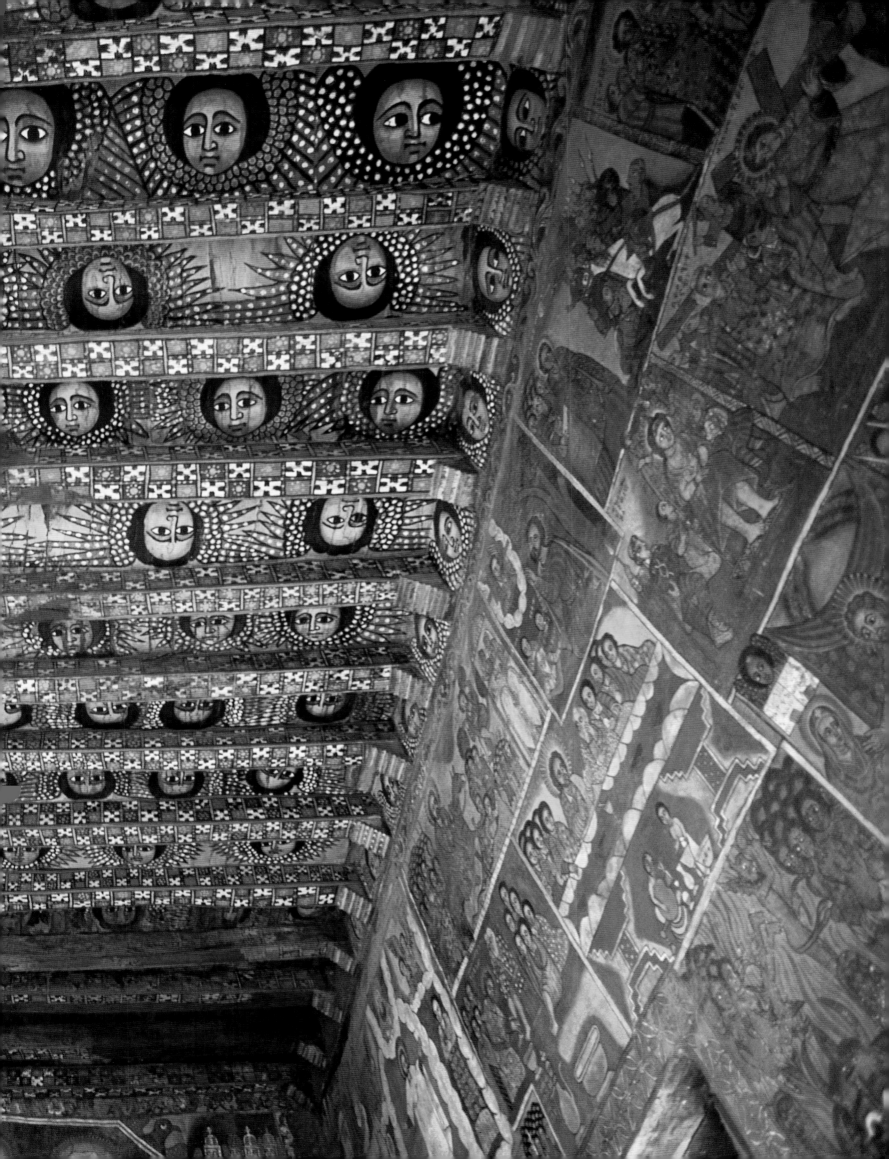

Opposite: Golden light bathes a mosque in remote Asaita — in the former Sultanate of Aussa — near the mouth of the Awash River close to the Djibouti border in the Danakil Desert.

Above: Rocky path at Gishen, near Dessie, leads to the staircase to the 'Place of the True Cross'.

what has been called 'the Roof of Africa'. More recently, in the 16th and 17th centuries, Turkish troops, Portuguese adventurers and priests were more successful in gaining tenuous footholds for a time, followed later by British, French and Italian military expeditions. They all came, but never conquered; all, that is, save the Italians who occupied and colonized Eritrea, but even then only for a short time.

Yet, despite a humiliating defeat at Adwa in 1896, Italian Fascist troops returned to seize much of Ethiopia in 1935. Benito Mussolini's military pretensions, however, held sway for only five years. His surrender to the World War II Allied forces restored Emperor Haile Selassie to his throne. He was the last of a long and ancient line. With his overthrow during the 1974 revolution, the Solomonic Dynasty which is said to have survived — with some interruptions — from the days of Makeda, the legendary Queen of Sheba, and her son Menelik I, came to an end. Haile Selassie

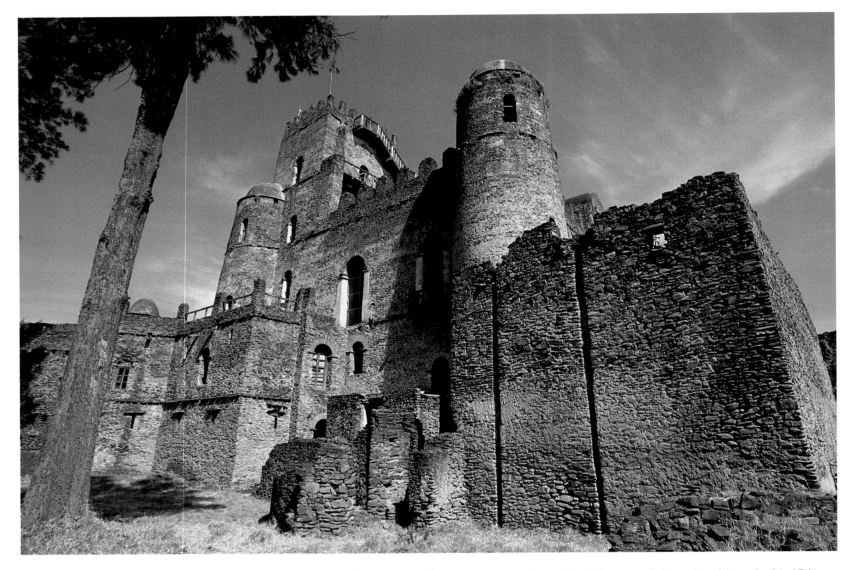

Above: Made from rough-hewn basaltic rock, this 17th-century castle was the first to be built by Emperor Fasilidas in Gondar.

claimed to be the 225th emperor in that line. But whereas invading armies never made any lasting conquests, Christianity reached Ethiopia peacefully as far back as the early 4th century AD and has been firmly established as the Orthodox Church for the last 1,600 years.

About AD 340 two young Syrian Christians made their way into Ethiopia's highlands after their ship had been captured in the Red Sea. On reaching the Kingdom of Axum, the ruler took a keen interest in them and made one of them, Frumentius, his secretary and treasurer. As the years passed, Frumentius assiduously gathered for prayer other Christians among Axum's foreign trading community.

After many years spent spreading Christianity in the Axumite Kingdom, Frumentius went to Egypt where he reported his efforts in Ethiopia to the Coptic Patriarch of Alexandria, who rewarded him by consecrating him as a bishop. On his return to Axum, the Syrian Christian

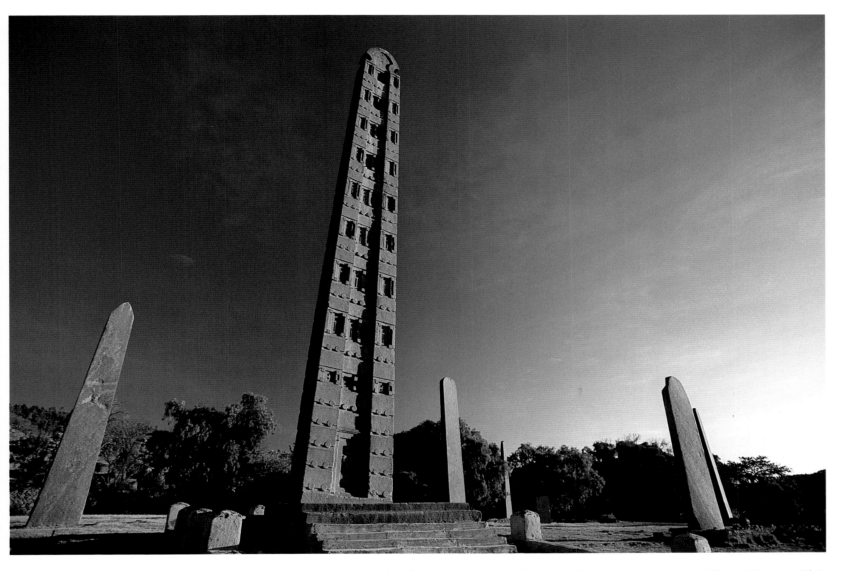

Above: Lone 23-metre tall obelisk or stele at Axum where once six similar huge monoliths stood, each carved from single pieces of granite, hauled from a nearby mountain.

redoubled his efforts and succeeded in converting King Ezana. This explains the close ecclesiastical link between the Ethiopian Orthodox Church and the Coptic Church in Egypt. Centuries after Frumentius, it remained the rule for the *abuna*, head of the Ethiopian Orthodox Church, to be Egyptian. This continued until Haile Selassie, on his return to the throne after the Italian surrender, decreed that the *abuna* would always be an Ethiopian.

It was not until the 16th century that a serious challenge appeared to the Orthodox Church's version of Christianity. This came from distant Portugal where the Roman Catholic hierarchy had become intrigued by fanciful tales of a very devout priest-king whose realm was under siege by Muslim invaders.

European Catholics had been familiar with the name 'Prester John' since AD 1165 when Pope Alexander III received a letter from Ethiopia

purportedly signed by a ruler of that name. In the letter, which it later transpired was a fake, he asked that an altar and a sacred grove of trees (*chaparral*) be provided for Ethiopian priests in the Church of the Holy Sepulchre in Jerusalem. In his letter 'Prester John' claimed that he led a vast army for the purpose of defeating what he called 'the snake of Islam' and said that the 'true religion' had been brought to his country by Saint Thomas.

Thus the half-priest, half-monarch of Abyssinia became a legendary figure in the European courts for at least four centuries after Pope Alexander had replied to the letter in 1177. The main debate revolved around the exact location of this Christian enclave. Pope Alexander addressed his letter in reply to 'My dearest son in Christ, John, illustrious and magnificent King of the Indians.' Others referred to the Ethiopian holy man as 'John of the Indies'.

In those days all the lands surrounding the Indian Ocean were seen by geographers as part of a vast India. Until Islamic armies occupied large areas of the Middle East, it was possible for many travellers and others from Syria and the Levant to reach Ethiopia by way of Arabia and across the Red Sea.

Later, however, these Islamic forces blocked the way from the Mediterranean for long periods, but accounts kept reaching Europe about the so-called 'Prester John' and his wondrous deeds. As centuries went by a fanciful explanation for the seeming immortality of this saint-like character was that his country contained a magic 'Fountain of Life' and that those who bathed in its waters were restored to youth. Court gossip had it that 'Prester John' had bathed in this fountain eight times and was really 562 years old. Eventually those who had spent much time trying to piece together the reports emanating from Ethiopia, separating what seemed to be fact from obvious fiction, concluded that Prester John was only a title given to a succession of Ethiopian monarchs, in addition to the local title of *Negus*, King.

In the 15th century, Portugal's Prince Henry the Navigator declared that his greatest ambition was to 'have knowledge of the land of Prester John'. Caravels from Lisbon sailing down the West African coast often carried criminals from Portuguese jails who were dropped off at various points with orders to search for 'Prester John'; those who succeeded would be pardoned. Not surprisingly, none ever returned.

By the 16th century Portuguese navigators were more knowledgeable about global geography than most other sailors, having already rounded Africa's southern tip and sailed into the Indian Ocean. A mission from Portugal which landed on the Red Sea coast in 1520 was a well-organized

Above: Ethiopia's unique, intricate religious crosses follow a centuries-old tradition of religious craftsmanship.

Above: Precious bronze hand cross, a sacred relic kept in the Church of Saint Mary of Zion, Axum. The ' dove's wings' signify it was made at Lalibela.

and equipped fourteen-man expedition led by Ambassador Rodrigo da Lima. After braving the 720-kilometre-climb (450 miles) to the highland plateau, they finally met the current 'Prester John', Emperor Lebna Dengel, also known as Dawit II, who was living with his Christian army in one of the many encampments he used on his travels with his 'court'. It appears to have been somewhere in Shewa near what is now Addis Ababa.

The Portuguese, who had heard all the fantastic stories of this 'long sought-after King of the Eastern Christians', found the kingdom fell far short of the fabled accounts. They saw no 'palace of translucent crystal' with a roof studded in gemstones. Nor any sign of a reputed massive table of emerald rock which could seat 30,000 people and which held the power to prevent drunkenness, so that clerical guests remained sober, no matter how much liquor they drank.

Instead of a tranquil realm where there was no poverty, sin or crime, the opposite was the case. Although the 'prester', or priest-king, did seem to be a man of saint-like qualities and though the land was crammed with well-attended churches on almost every hilltop, violence was the order of the day. Pride and greed prevailed.

That, at least, was the grim picture portrayed to the outside world by the pen of Father Francisco Alvarez. The Portuguese priest, given the missionary task of investigating the king's religious convictions, also kept a meticulous journal. In it he bluntly debunked the kingly attributes claimed by previous travellers. The mission found that two other Portuguese had previously reached the kingdom, but had been prevented from returning home and had died there.

Although he praised the *Negus* for his holiness, Alvarez described his lieutenant as 'an ugly-looking rogue, obviously suffering from an eye disease and seated on an ill-made string bed' while the 'palace' was 'a great barn of a place, packed with rank upon rank of natives squatting half-naked on the beaten-earth floor'.

It spoke volumes for the effectiveness of this 'Prester John's' iron rule that in the six years Father Alvarez spent in the kingdom he was able to visit the ancient town of Axum, once one of the world's most powerful city-states, and measure the height of the obelisks that have stood or lain there from time immemorial. And to study, with amazement, the designs of the fabulous rock-hewn churches of Lalibela.

It seems that his only regret was that in Axum, which was the centre of her empire, he had been unable to find the hidden treasures of the long-departed Queen of Sheba. Ambassador da Lima also failed in one purpose of his diplomatic mission, which was to convert King Lebna Dengel or any

top-ranking courtiers to lasting Catholicism. No sooner had this Portuguese mission left by the same route they had come than a new and much more serious threat to the Ethiopian Orthodox Church arrived in the shape of a Muslim army, led by a Muslim general, Ahmed bin Ibrahim al Ghazi, later nicknamed Gragn — 'the left-handed'. His well-armed force included many Turkish troops, also dedicated to conquering Ethiopia for Islam.

Far better armed than the Christian troops, Gragn's forces devastated the countryside and destroyed many churches, including that at Axum. Before Lebna Dengel died in 1540, his followers sent frantic appeals to the Portuguese, now firmly established in India, to send troops. Reinforcements led by a young Portuguese officer, Dom Cristovaõ, came to the rescue of the besieged kingdom. Dom Cristovaõ was none other than the son of Admiral Vasco da Gama, the famous navigator who had taken his caravels round the Cape of Good Hope and had called at Mombasa and Malindi in what is now Kenya on the way to India.

Several years of fierce fighting took place in the mountain country of what is now northern Ethiopia until Gragn was killed on the shores of Lake Tana and his soldiers dispersed.

But Ethiopia's earliest history is rooted farther north. The ancient town of Axum, which was one of the very first capitals of Semitic culture in northern Ethiopia, was founded about 1000 BC and is the first stage in Ethiopia's famous 'Historic Route'. The earliest capital was actually at nearby Yeha. The Axumite Kingdom was known as 'the most powerful state between the Roman Empire and Persia'. Much earlier, records show that the Egyptians knew the area to lie somewhere south in 'the Land of Punt', also known as 'the Land of the Gods', and, from around 3000 BC, they had obtained gold, ivory, fragrant woods and slaves from there. Later, Egyptian ships sailing to India and back called at the Red Sea port of Adulis, which served as Axum's main outlet to the sea, just south of modern Massawa. Axum went into decline between the 7th and 8th centuries AD, when power moved south to another remarkable site — Roha, later named after its inspired ruler, King Lalibela.

The project he supervised 800 years ago — eleven remarkable churches, hand-carved out of the living bedrock some distance south-east of Axum — remains today for all to see. Described as 'a creation of angels', Lalibela has been preserved as one of UNESCO's 'World Heritage Sites'. However, the very advanced architectural technology used suggests these churches were built by more earthly beings. This explanation is based on a close examination of Father Alvarez's voluminous narrative of his visit to Lalibela in the 1520s. Lalibela is the second stage of the 'historic route'.

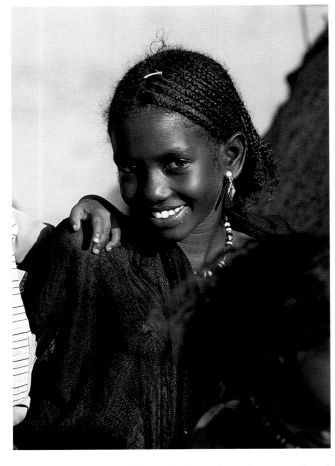

Above: Young Afar girl near Asaita, where these proud and independent people have learned to survive in one of the world's harshest environments.

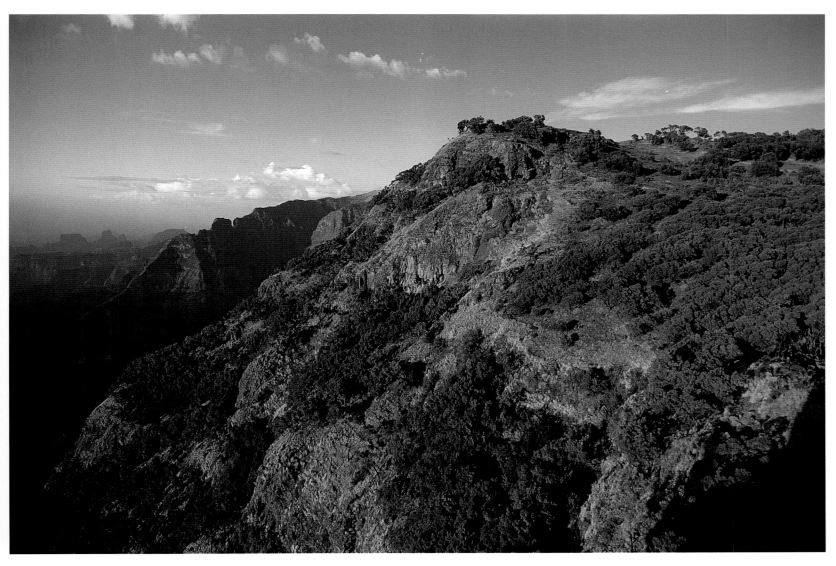

Above: Afro-alpine flora finds a craggy foothold on a rock bluff in the stunning wilderness of the Simien Mountains.

Overleaf: Scarred and dissected by countless deep ravines, tumultuous forces shaped the dramatic landscape of Ethiopia's Simien Mountains.

In the breathtaking Simien Mountains, which lie south of Axum and north-west of Lalibela, most of the country's endemic animals are found in the Simien Mountains' National Park's 179 square kilometres (111 square miles). The Walia Ibex with its fantastic set of horns, the Simien fox and the Gelada baboon are unique to Ethiopia.

The country's highest mountain peak, Ras Deshen 4,543 metres (14,538-ft), is on the edge of the park. The jagged peaks, deep ravines — some of which take two days to cross — and contorted rock formations are a stark reminder of the time, millions of years ago, when the African continent was still forming. The Simiens are a graphic example of the effect of these tumultuous forces on the surface of the earth. White-hot basaltic lava once covered what is now Ethiopia to a depth of 3,000 metres (9,840ft).

South-west of the Simiens stands the city of Gondar, the third stage of the 'Historic Route', with its 17th-century fairy-tale castles, the first of

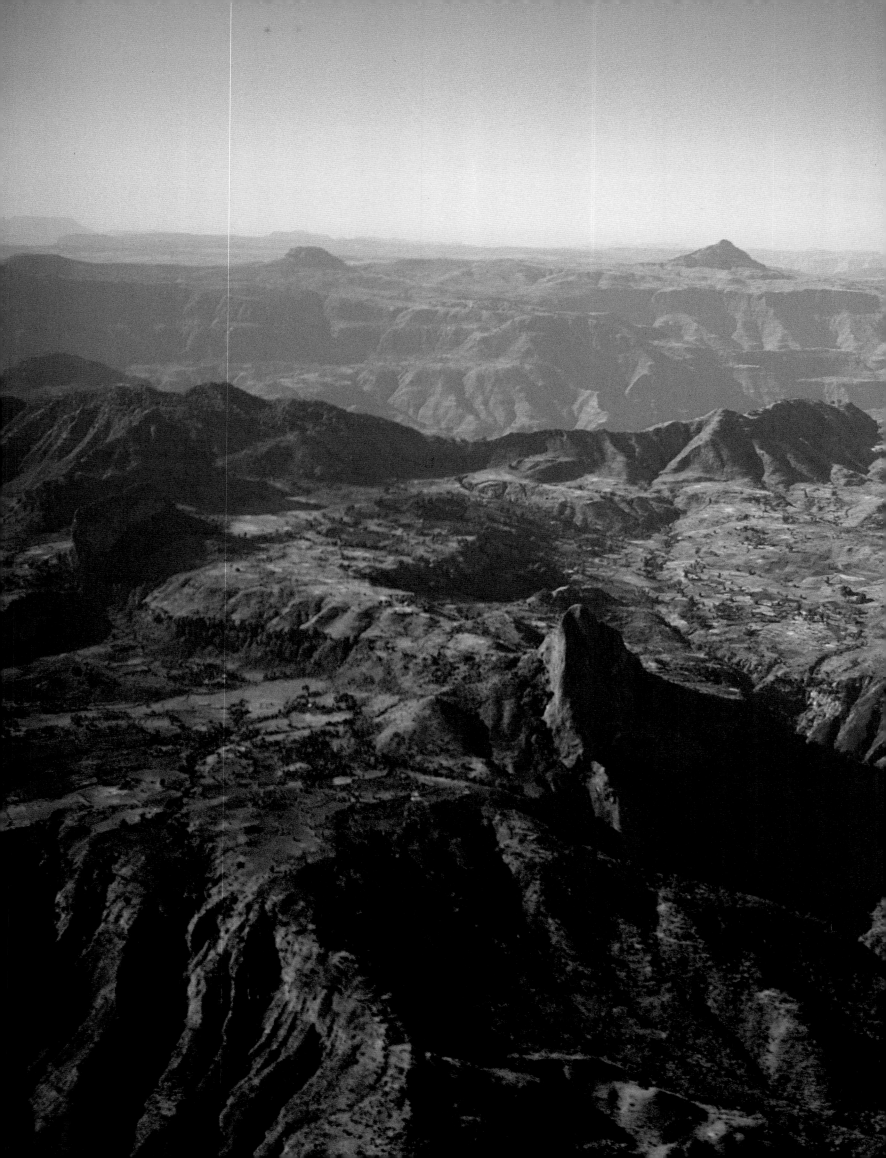

which was created on the orders of another historic Ethiopian ruler, Emperor Fasilidas (1632-1667). During the intervening years after Lalibela's decline, partly due to its isolation in the mountains, Ethiopia's rulers favoured 'mobile courts', as in the days of Negus Lebna Dengel. But finally they settled at Gondar, which stands at an altitude of 2,200 metres (over 7,000ft) just north of Lake Tana. It remained Ethiopia's capital until 1855. By then more castles with crenellated towers had arisen, some with a unique Indian flavour — all conjuring up images of knights in shining armour.

In its churches, Gondar's works of art focus mostly on religious themes. In many monasteries on the islands of Lake Tana this religious-inspired art dates much further into the medieval period. Scrolls found there go back many centuries.

Lake Tana, Ethiopia's largest sheet of water covering 3,600 square kilometres (1,389 square miles), forms the headwaters of the Blue Nile, or *Abbay* as it is known in Ethiopia. Many explorers attempted to reach what they thought was the main source of this historic river, including Scotsman James Bruce, whose detailed record of his travels in Abyssinia, *Travels to Discover the Source of the Nile,* has become a classic.

Bruce went further to find the real source of a small river which flows into the lake. Before the Blue Nile joins the White Nile, which flows from East Africa, it runs for 800 kilometres (500 miles), most of it through one of the world's deepest and most dramatic gorges, and another 650 kilometres (406 miles) inside the Sudan.

The Tissisat Falls, just a few kilometres after the river leaves Lake Tana, is one of the country's major attractions. Tissisat — 'smoke of fire' in Amharic — is made up of a series of falls more than forty-five metres (145ft) deep. Above the falls the Blue Nile measures 400 metres (1,280ft) wide when in flood.

Over the centuries the country has had many capitals, from Yeha, Axum, and Lalibela, and long periods of encampments, including 'the Era of the Princes', Gondar, Ankober, Debre Tabor, Mekdela to Mekele and others. But it was some centuries before the present capital, Addis Ababa, was founded by the country's 19th-century ruler, Emperor Menelik II.

During the early part of his reign several sites served as temporary capitals, following an ancient tradition, and Menelik could not decide which site to make permanent. He built a palace at Addis Alem as part of a plan to create 'a southern Axum'. Now more than a century old the building is still in good condition and is used as a church.

Addis Ababa has a cosmopolitan atmosphere. Menelik II moved ever southwards until he reached the Entoto Mountain, where he set up a

Above: The red haemanthus is common in the hill country.

Opposite: Not far from where it leaves Lake Tana, the Blue Nile plunges over the Tissisat Falls into a 700-kilometre-long gorge on its way to the Mediterranean.

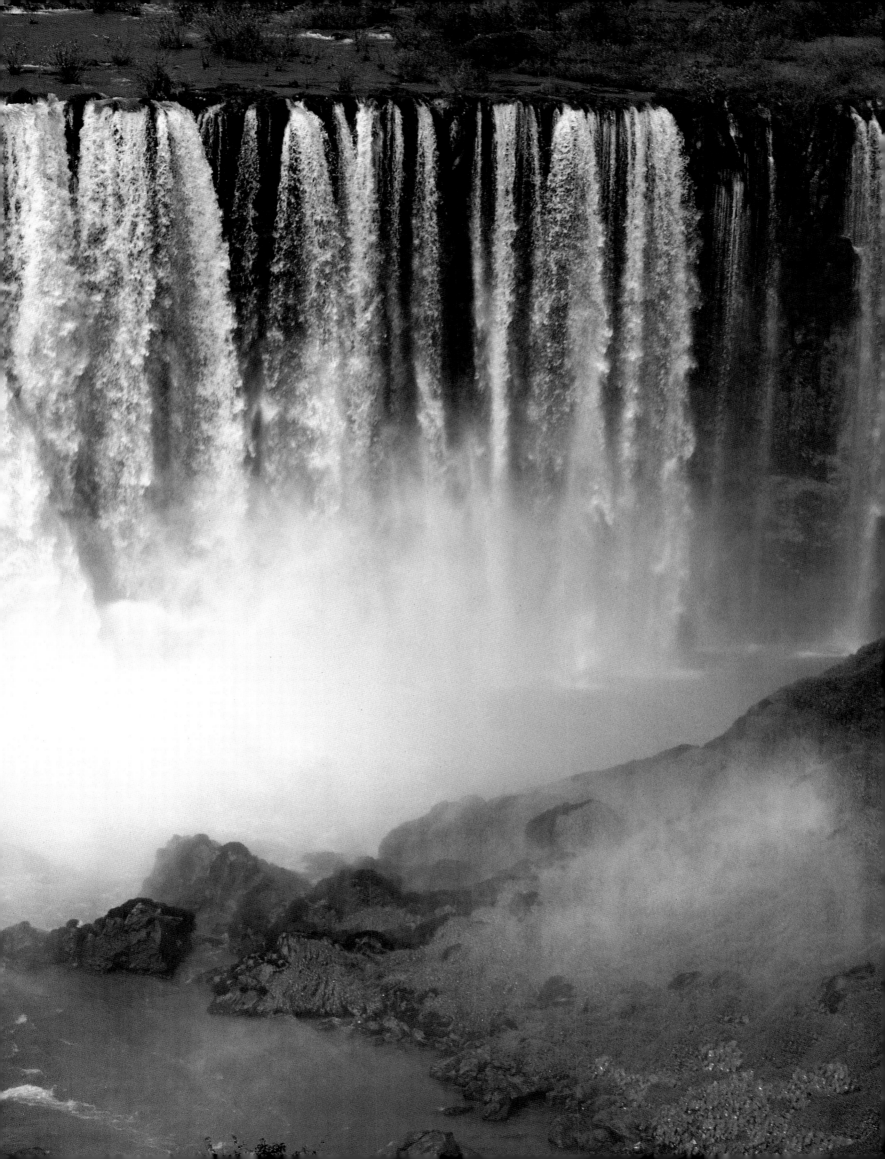

military camp. Strategically it was a strong position, but after some years Menelik decided he no longer had any need for such an exposed position and strong fortifications. He moved a few kilometres down the southern slopes of Entoto Mountain to establish Ethiopia's present capital, which his wife, Empress Taytu, named Addis Ababa, Amharic for 'the New Flower'. It was formally established in 1886.

At an altitude of 2,500 metres (8,000ft) Addis Ababa is the third highest capital city in the world, after La Paz and Quito in South America. Its clear, invigorating highland air makes for a pleasant, temperate climate (average temperature 26°C (61°F), except for the main rainy season from July to September when it is cool and damp.

Addis Ababa has many 'centres'. Its streets have been haphazardly laid out, except for one main highway, Churchill Avenue, stretching from the Railway Station to City Hall, the latter built in 1965 and opened by Britain's Queen Elizabeth II.

Newer, tall buildings overlook mud and wattle dwellings and here and there luxury villas lie amid squalor. A popular attraction is the Mercato (market), said to be the largest and busiest between those of Cairo and Johannesburg.

Several royal palaces have been built in the city, the newest standing opposite the Africa Hall, and the headquarters of the United Nations Economic Commission for Africa (ECA). With the decision to make Addis Ababa the headquarters of the ECA and, in 1963, of the Organization of African Unity (OAU), the city has become Africa's diplomatic capital. More than eighty foreign embassies and consulates are based there and regular summit meetings by Africa's Heads of State and Government take place in the imposing Africa Hall.

The only railway line in Ethiopia links Addis Ababa with Djibouti, a Gulf of Aden port. The line runs for 785 kilometres (487 miles), much of it through the Harerge Region. The idea of building a railway line to give Addis Ababa a direct access to the sea and the outside world was conceived in 1887 by a Swiss engineer, Alfred Ilg, who was the technical adviser to Emperor Menelik II. The decision to undertake this expensive and difficult engineering enterprise was not finalized for many years, and involved three European powers — Britain, France and Italy — as well as Emperor Menelik. At that time France held the enclave of Djibouti while Britain had British Somaliland, adjoining Djibouti. Italy then had two colonies bordering Ethiopia — Eritrea in the north and Italian Somaliland in the south. All three countries competed for favours and concessions out of Menelik II.

The 'Scramble for Africa' had just begun and the European powers

Above: The first church built in the Addis Ababa area, Debre Maryam, overlooks the capital from Entoto Mountain.

were busy trying to carve up the continent for themselves. Britain, France and Italy all hoped to gain 'spheres of influence' in Ethiopia and saw the railway as a potentially lucrative project. Each hoped for a monopoly to 'freeze out' the other competitors. Haggling went on for years, even after building had started in 1897. Each of European competitors argued in favour of an 'international railway', so that none would have the advantage over the other two. The British saw France as their main rival in the 'scramble' for this area of Africa, and so Britain supported Italy's determined opposition to France's plans to extend its influence beyond Djibouti, thus keeping the French out of Ethiopia.

Eventually, in 1906, the three agreed to draw up and sign a tripartite convention and, after pointedly leaving Emperor Menelik out of the discussions, did not invite him to be a signatory, much to his anger. The outcome was that France gained control of the railway line, thus having the

'ace card' by ownership of the rail terminus at Djibouti, and begged the necessary funds from a French bank. After the railway crossed the desert and the plains it began the long climb up the Ethiopian Central Plateau, reaching about halfway to Addis Ababa, where a new town, Dire Dawa, grew up around the railhead. But there the rail rested.

The French railway engineers constructed a well-designed town on the edge of the small original settlement of Arab-style houses. Its asphalt streets and running water were amenities then unknown anywhere else in Ethiopia. But due to a financial 'hiccup' Dire Dawa remained the end of the line for ten years — until the builders found the funds to resume work. Finally, twenty years after construction began, the metre-gauge railway reached the capital in 1917. By then however Emperor Menelik, who strove so hard to see his dream fulfilled, was dead.

Whether by accident or design, Addis Ababa stands more or less at the centre of this vast sprawling country with its many contrasting landscapes.

Far to the west of the capital are the lowlands of Gambella, the region that borders on the Sudan. No Semitic or Cushitic languages are heard there for it is the land of the Anuak and Nuer, speakers of Nilo-Saharan tongues whose relatives live over the border in the swampland of southern Sudan; posts with such names — foreign to other Ethiopians — as Gog, Pibor, Wushwush, Mangdeng and Dingding. Its main town, Gambella, stands on a minor tributary of the White Nile. The Baro River, fed from the west-facing slopes of this part of Ethiopia, becomes the Sobat River once it enters the Sudan.

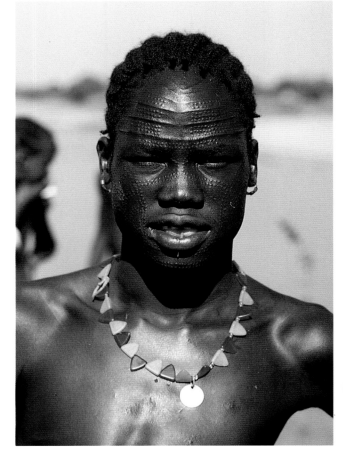

Above: Nuer man at Gambella with traditional scarification on his forehead.

Gambella and the Baro River were once a major Ethiopian outlet to the outside world. Ships from Malakal and even Khartoum would steam up to load and unload their cargoes at the town wharves, now decaying and deserted.

While the Sudan was still an Anglo-Egyptian condominium, Ethiopia had an arrangement to lease space to Britain on the river bank at Gambella to facilitate the two-way traffic. It included Kaffa's coffee, bound for Europe. But when the Sudan became independent in 1956 the arrangement lapsed. Ships no longer call at Gambella and its economic importance, as with Harar once the railway from Djibouti was built, has ceased to exist.

Although Gambella is connected to Addis Ababa by a regular air service, the Gambella National Park, between the town and the border, has few visitors despite the fact that it hosts several wildlife species not found elsewhere in Ethiopia. These include the Nile Lechwe (*Onotragus megaceros*) and the white-eared kob (*Kob leucotis*). The banks of the Baro

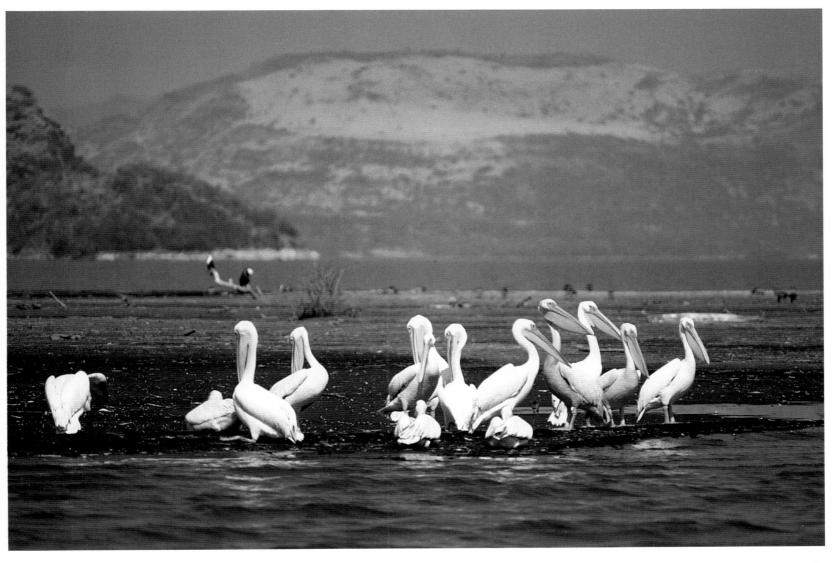

Above: Pelicans and their young in their breeding colony on Lake Chamo, the most southerly of Ethiopia's Rift Valley lakes.

are also rich in birdlife. Like some Nilotic people of neighbouring southern Sudan, the Nuer people of both sexes favour cicatrization, an 'adornment' causing bumps in various patterns on their brows and bodies. They and their Anuak cousins have little contact with such highland peoples as the Oromo, Gimirra or Gurage. The Gimirra, or Bench, have suffered severely over the centuries from slave-raiders, large numbers having been captured and shipped overseas.

Ascending east from Ilubabor to the western wall of the Rift Valley the traveller arrives in 'coffee country', the place where the beverage originated. Before coffee ever reached the Americas it went right around the world in an easterly direction — first crossing the Red Sea to Yemen and Arabia, where its name was translated into the Arabic *qaweh*. It was popular throughout the Middle East, where alcohol was taboo, as a mild stimulant, then through the Far East and eventually across the Pacific

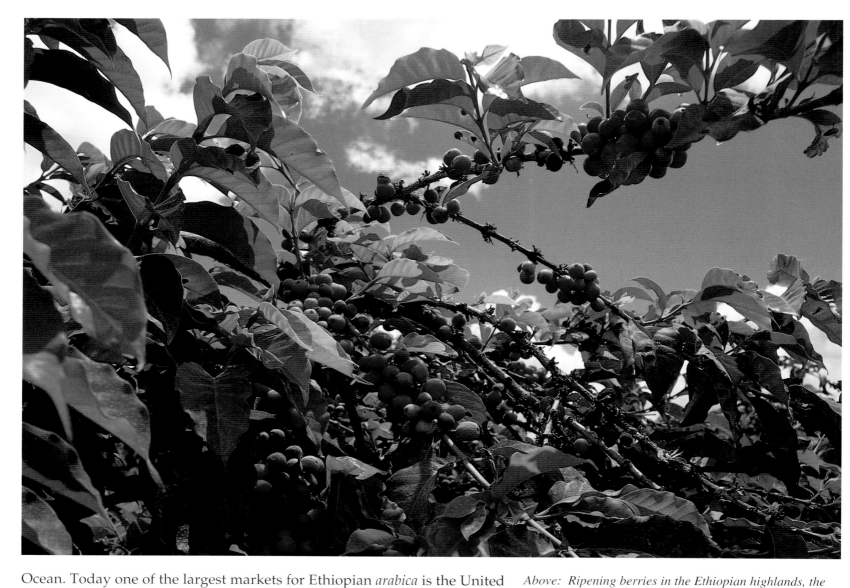

Above: Ripening berries in the Ethiopian highlands, the endemic home of the coffee tree.

Ocean. Today one of the largest markets for Ethiopian *arabica* is the United States. Those who cannot face a new day without a cup of coffee may be surprised to know that in its birthplace in Ethiopia's Kaffa Region — from which it gets its name — the berries were originally only eaten, never roasted and ground for a drink. Only since the thirteenth century has coffee been made into a hot drink. Even today, in the remoter parts of Kaffa people crush the berries or chew them after mixing them with ghee (clarified butter).

Many old legends surround the origins of coffee. Most popular is the one about the 'dancing goats'. The story goes that, while watching his charges, a goatherd was amused to see them dancing around excitedly after eating from the coffee bushes growing profusely there. Curious, he ate some of the wild 'cherries' himself, attracted by their bright red colour when ripe. He found them most stimulating — even intoxicating when

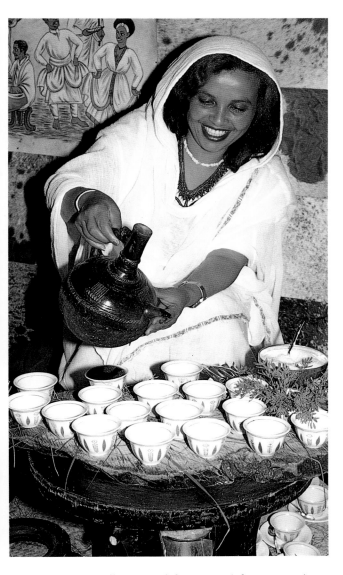

Above: Serving coffee is an elaborate social ceremony in Ethiopia.

chewed in a large quantity. A monk from the local Orthodox monastery came to hear of the goatherd's experience and told his fellow brothers about the strange effect of the berries. According to the legend, the monasteries all around became the most pious in the country as the monks went about their devotions almost nonstop — going without sleep for long periods. However, the fact is that the Ethiopian Orthodox Church opposed coffee drinking.

Today Ethiopia is a leading exporter of high-quality *arabica* coffee. Most of the crop still grows wild in Kaffa and parts of neighbouring Sidamo, where the soil, climate and the 2,000-metre (6,600ft) altitude create an ideal environment for its cultivation. Coffee is Ethiopia's main source of foreign exchange. Kaffa's capital, Jimma, is the main collection centre, before coffee goes for processing and grading.

East of Jimma the bed of the Rift Valley rises to form a chain of lakes. Since most are fairly close to Addis Ababa, they are popular weekend resorts for the city population, who enjoy the facilities for water-skiing, sailing and other water sports in lakes such as Langano which are free of bilharzia, a parasitical and often fatal waterborne disease. The variety of birdlife at these Rift Valley lakes makes them a paradise for bird-watchers, with masses of pelicans, flamingos, fish eagles and cormorants.

The Sidama people and others living in the southern segment of the Ethiopian section of the Rift Valley occupy some of the most delightful areas in the country, with greenswards of meadow interspersed with patches of forest. Their carefully crafted beehive-shaped houses of wicker-work or grass show their origins which they share with the Gurage. These Cushitic peoples have a common diet, *enset*, 'false bananas', so called in English as their leaves bear a resemblance to banana leaves, even though they grow more vertically. They yield no edible fruit, but the roots are ground into flour.

Health experts have long been concerned at the lack of protein in *enset*, after the flour has been fermented and made into a sour-tasting porridge or into a waffle-type bread. There has been a campaign to make *enset* more nutritious by adding other edibles into its making. In traditional Ethiopian cuisine, meat is a staple food — and very popular.

Beef is eaten cooked, dried or raw in all parts of the country. Mutton dishes supplement the diet at higher altitudes, along with goat meat, while camel is eaten in the desert lowlands. Fish, too, is popular among the people living near lakes. Nile perch, tilapia and catfish are all delicious. The eastern wall of Ethiopia's southern Rift Valley is formed for some length by the magnificent Bale Mountains where the Bale Mountain National Park, covering 2,400 square kilometres (1,488 square miles), is

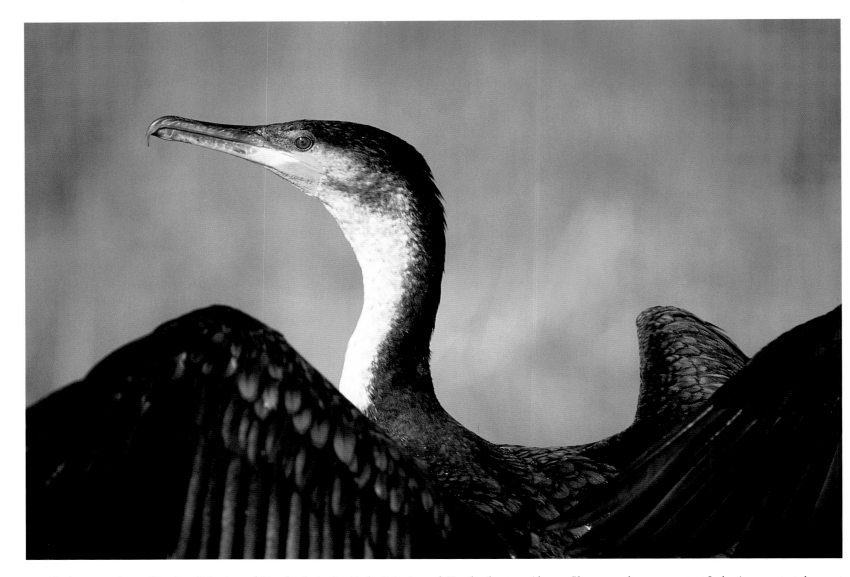

much larger than Simien National Park. It is in Bale National Park that Africa's highest all-weather road rises some 4,000 metres (13,200ft). The park is one of the few places in Ethiopia where the rare and shy mountain nyala, an antelope endemic to Ethiopia, may be seen. The park also has thirty-three other species of mammal, including the Simien wolf, which, despite its name, exists in far greater numbers in Bale than in the Simiens.

The park, with its bracing mountain air, is ideal for hiking or climbing and horses are available for long or short rides in the mountains. The one and only road through the park gives motorists some breathtaking views.

An impressive display of Islamic devotion takes place twice a year in this remote and unspoiled region when thousands of pilgrims pass through Bale on foot to worship at the shrine of Shek (Sheikh) Husen at a spot near the Webi Shebelle River. Ethiopia's 'Historic Route' does not end at Addis Ababa — for some distance to the east of the capital, perched

Above: Sharp-eyed cormorant at Lake Awasa stretches out its wings to dry in the sun.

at the end of a spur projecting from the central plateau, lies the old walled city of Harar dating back to medieval times, until recently capital of a vast region stretching from the Somali border to Djibouti in the north. Harar is a city redolent of the Middle Eastern world. Its history has been almost as violent and bloody as that of the north, but there the centuries have been marked by wars between rival Muslim factions and against the Christian Orthodox Church.

Five massive gates in the walls of the city centre stand testimony to the need for strong defences against past invaders. It was long the custom for the gate keys to be kept overnight only by the city's commander.

Just as Axum thrived commercially, with the port of Adulis as its link to the outside world, so did Harar when it used the well-worn trade route to Zeila port on the Gulf of Aden. In the old days it was common to have caravans of up to 5,000 camels carrying cargoes between Harar and the coastal ports. Even today camels still plod the tarred road leading up to Harar from the railway town of Dire Dawa. Although initially it had been planned for the line to pass through Harar in view of its economic importance, the French dropped the idea, arguing that the altitude and mountainous terrain would make it too costly.

The result was that, despite its long history as a major trading centre in the Horn of Africa, Harar's influence declined and Dire Dawa, fifty-four kilometres (33 miles) down in the lowlands became the 'New Harar'.

Menelik decided to bring Harar and the surrounding countryside into the Ethiopian Empire in 1885, but it took him another two years to overcome opposition from the local emir. Eventually he had to fight his way in to occupy what for three centuries had been an independent and fiercely theocratic state.

Harar first came into formal existence as a local capital about 1520 but was soon subjected to a series of invasions and raids from opposing Muslim factions. The first occurred only a few years later when Ahmed Gragn —'the left-handed' — occupied Harar and made it his base for a series of devastating raids into northern Ethiopia. The wily Muslim general then indulged in a bloody war against the ruling *Negus*, Lebna Dengel. Gragn's campaign of plunder and destruction created havoc in the Christian centres of Shewa and Axum and continued after Lebna Dengel's death until Portuguese troops, based in India, came to the rescue.

After a series of fierce battles between the Portuguese, led by Don Cristovaõ da Gama, and Gragn's Turkish and Somali troops, Gragn was killed by King Gelawdios. Although after that defeat his army dispersed, Gragn's widow, nephew and other family members, retained his military base in Harar in the face of strong opposition. It was during this period

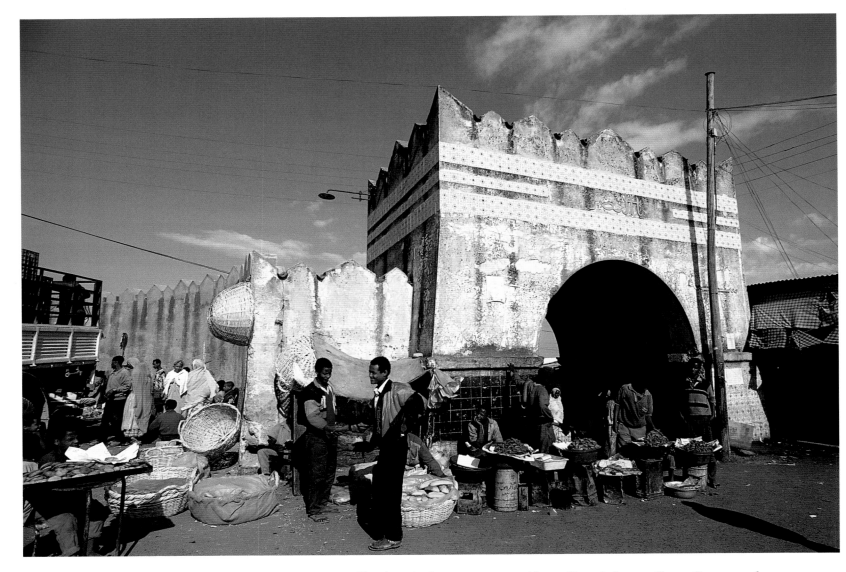

Above: Harar's famous Shewa Gate, one of seven entrances to the walled city.

that the city was provided with the massive walls that in later years repelled frequent attacks, especially by Oromo invaders. Several centuries later, now united in diversity, most Ethiopians live in the fertile highlands, where the central plateau rises from 2,000 to 3,000 metres (6,600-9,900ft) high. In 1994, following the Constituent Assembly's vote, later ratified by parliament, to grant the country's various ethnic groups the right to secede if more than half the voters were in favour of secession, Ethiopia introduced a federal system based on state administrative divisions. The new states have been rearranged drastically on a more ethnic basis than before. The first state is the old Tigray and the last is the city of Addis Ababa.

Foreign visitors are often intrigued by the promise of 'Thirteen Months of Sunshine' in most tourist brochures. For Ethiopia still follows the thirteen-month Coptic calendar, instead of the twelve-month Gregorian

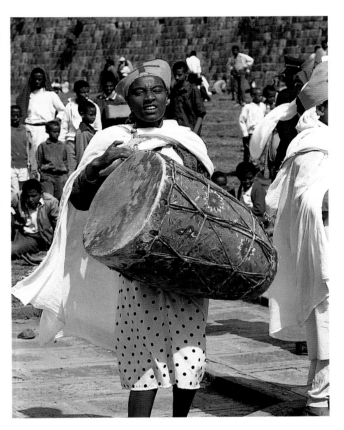

Above: Woman drummer celebrates the festival of Meskal — 'Finding of the True Cross' — in Addis Ababa.

calendar used in most parts of the world. Twelve months each consist of thirty days. The other five days of the year make up the thirteenth month. Ethiopia is also seven years and eight months behind that of the Gregorian calendar, so that 1990 was only 1983. Twelve public holidays are observed in Ethiopia, with the New Year starting on 11 September, followed by *Maskal* ('the Finding of the True Cross') on 27 September. The next holiday is Christmas on 7 January, after which comes a very important and colourful religious occasion, *Timkat* ('Epiphany') on 19 January. The defeat of the Italians at the Battle of Adwa is observed on 2 March and Islam's *Ramadan* in March. Another holiday, 6 April, celebrates the overthrow of Mussolini's armed occupation of Ethiopia, and is called Patriots' Victory Day. Easter and Labour Day (1 May) are also celebrated, as is the downfall of the Mengistu regime. Two other Muslim holidays are *Id al Adha* and the birthday of the Prophet Muhammad.

Visitors have much to savour in the antiquities that bear visual testimony to Ethiopia's eventful past. And today Ethiopia is one of Africa's most accessible countries, thanks to the wide connections forged by the national carrier, Ethiopian Airlines. Long-established, the airline is acknowledged as one of the finest on the continent and has become one of Ethiopia's best ambassadors.

The green, yellow and red colours of its modern fleet are familiar sights at the world's airports — from London's Heathrow to Beijing International Airport, and from Murtala Muhammad Airport in Lagos to Johannesburg's Jan Smuts Airport.

Aviation history was made in Ethiopia in August, 1929, when the first visiting aircraft — a small French Potez 25 — made a triumphal landing on a plain outside Addis Ababa. To mark this exciting event a special postage stamp was printed, bearing the portraits of the ruling Empress Zauditu and Ras Tafari, who was to become Emperor Haile Selassie.

Not long after, Ethiopians began to train as pilots. In those days the only reliable means of communication was the railway linking Addis Ababa to the sea at Djibouti. 'Roads' were subject to frequent washaways during the rainy season and constant erosion.

However, the establishment of an aviation industry was delayed by the Italian invasion in 1935. But after Mussolini's fascist troops had been driven out one of the first developments was the formation of the Ethiopian Air Force.

A decade later, in September, 1945, the fledgling commercial airline began operations. With the co-operation of American's Trans-World Airlines (TWA) Ethiopian Airlines grew from strength to strength and, years later, adopted the slogan, 'Bringing Africa Together'. International flights

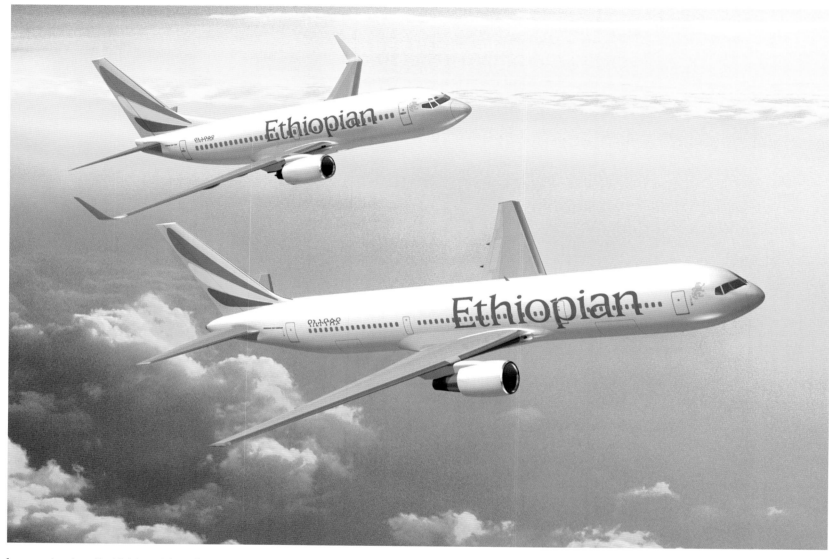

Above: In 2003, Ethiopian Airlines modernised its visual image with a new contemporary look, whilst retaining the green, yellow and red of the national colours in a simplified feather motif displayed on the tail of all aircrafts.

began in April, 1946, with scheduled service to Cairo, in what was then a record time of ten hours. A year later another aeroplane flew to Bombay via Aden. The domestic network, operated initially by Dakota DC3s, soon covered Ethiopia and the 1950s saw an ambitious all-round expansion programme. International flights were operated by two new thirty-six-seater Convair 240s. At first the high altitude of Addis Ababa Airport — about 2,400 metres (8,000ft) — presented a problem. The thin air limited the load which planes could carry on take-off. One temporary solution for flights needing a heavy load of fuel was to fly east to Awash to refuel to capacity for the long haul. Another innovation was to fit the Convairs with rockets so that they could leave Addis Ababa fully fuelled by means of a jet-assisted (JATO) take-off. After the Convairs came two Douglas DC-6Bs and by 1960 a pilot training centre had been set up in Addis Ababa so that Ethiopians no longer had to go overseas for training. With

the arrival of the jet-age Ethiopian Airlines introduced two Boeing 720Bs and a new colour arrangement on the aircraft with the single word ETHIOPIAN in large letters on the fuselage. In 1984 Ethiopian Airlines became the first national carrier in Africa to take delivery of three Boeing 767 Extended Range aircraft, followed a year later by five Twin Otters for the domestic network. By the end of the 1980s Ethiopian had bought two high-wing ATR-42s, a Franco-Italian product for medium-range service, and two Lockheed L-100 freight planes. The fleet grew again in 1990 and 1991 with the acquisition of four Boeing 757 jets.

A priority at this time was to make the airline slimmer, fitter and better able to compete in the increasingly competitive aviation market.

At the time of Ethiopian's 50th anniversary in April 1996, the route network stretched from Europe (London, Frankfurt and Rome) to China (Beijing) and Thailand (Bangkok). The Middle East and Indian sub-continent were well represented, and the airline's African routes reached Senegal and Ivory Coast in the west, Cairo in the north, and Johannesburg and Durban in the south.

Another notable leap was made in July 1998 when Ethiopian launched a twice-weekly service to Washington – its first destination in the Americas – and flights to New York followed shortly after.

In 2001 and 2002 Ethiopian acquired two B767-300 and one B737 aircraft to implement the sustained route development and service improvements, but the Airline took another giant step in 2002 when it signed an agreement to acquire 12 airplanes over the next four years. The six Next Generation B737-700s and six B767-300ERs were planned to replace the existing two B737-200s and the two B767-200s, and to significantly modernize and enlarge Ethiopian' s medium and long-haul fleets.

With around 45 international and 30 local destinations from Addis Ababa, Ethiopian is the only airline to fly daily east-west services across Africa and its domestic route network is one of the swiftest most pleasant and practical ways to explore this ancient and exciting land. The prestigious routes to Paris and Stockholm joined the international route network in 2003.

Recent developments have concentrated on further improvements in customer service, with the introduction of the 'Cloud Nine' Class, combining comfort and luxury of First Class with the relatively lower Business Class fare. With the start of night operation out of Addis Ababa in October 2002, Ethiopian now offers customers convenient daytime arrival at, and departure from, their home countries, minimum connecting times for those continuing their journey to other Ethiopian destinations, as well as a wider selection of flights for their connections beyond the Ethiopian Airlines network.

With all the improvements and new aircraft coming on-stream, Ethiopian Airlines decided it was time to modernise its image in 2003 when the Airline introduced a bright and graceful new corporate logo which now proudly adorns its new fleet. At the same time, Ethiopian introduced a new motto of 'Africa's link to the world' to replace its long-running 'Going to great lengths to please' tagline.

For those spending time in the country, the high rugged mountains, deep and forbidding gorges, green hills, rushing streams and wide flowing rivers, lakes, forests and deserts, and a multitude of colourful and fascinating cultures, make Ethiopia truly one of world's greatest, if still relatively little known, tourist attractions.

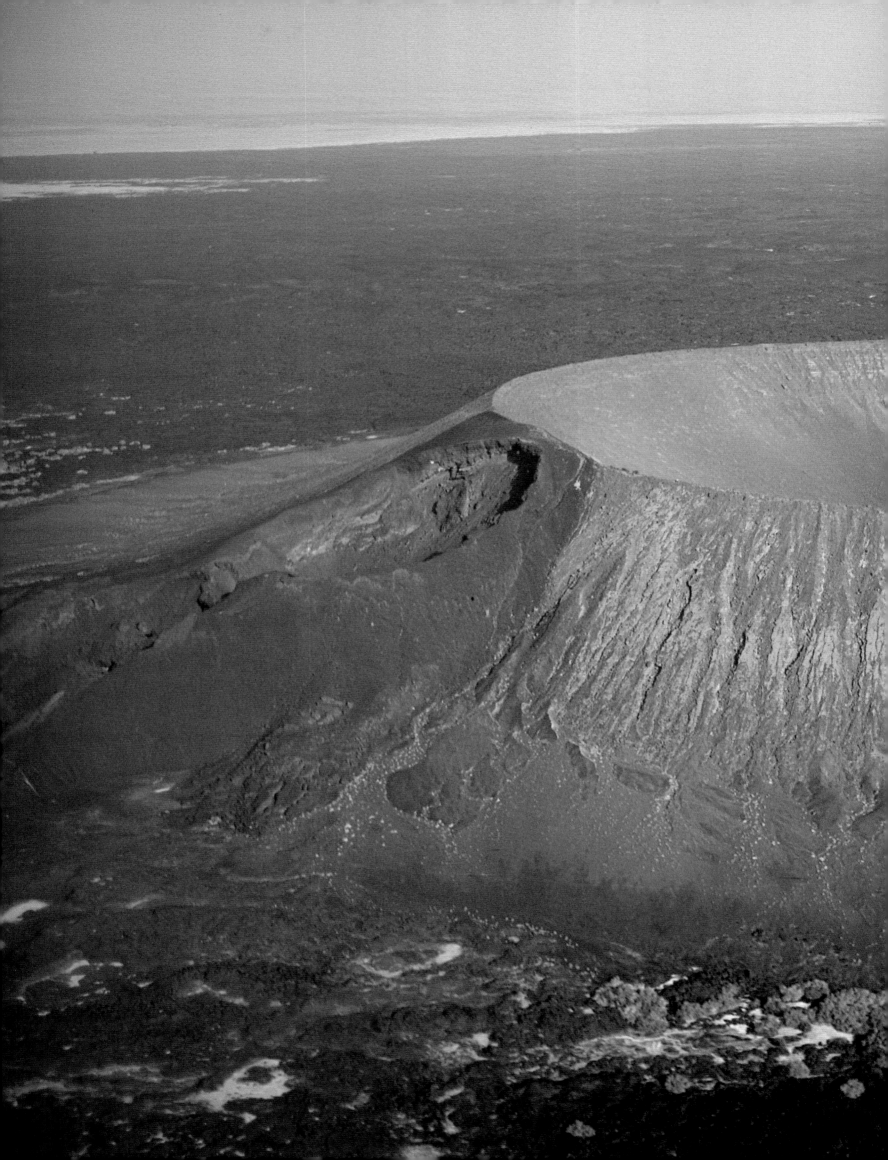

Previous pages: Symmetrical crater of Jira volcano rises out of the Danakil Desert overlooking Lake Abhebad which is fed by the Awash River.

The Afar area where the Ethiopian Rift Valley meets the Red Sea is one of the most inhospitable parts of the earth. Millions of years ago, when the massive trench first opened up to become the Great Rift Valley, the Red Sea gushed into what is today the 'Afar Triangle' — more than 500 kilometres (312 miles) wide at its base, only fifty kilometres (30 miles) at the apex — and a huge lake was formed. At that time all that appeared above water level was a row of hills which archaeologists now call the 'Danakil Alps'.

Slowly the inland sea receded to leave behind today's barren desert, some of it called the Danakil (Dolool) Depression, still below sea level. Three small saline lakes on the Djibouti border remain as a reminder of the huge lake.

After the Rift Valley floor settled down a long chain of volcanoes formed and, in the Danakil, some are still active. The far end of this chain ends on the borders of Rwanda and Zaire where two huge volcanoes continue to spew up lava and flames.

Recent geological research has linked the crystalline block which forms modern Ethiopia to a far larger basaltic rock layer that once stretched all the way from Brazil's high plateau in the west, through Africa, to India's Deccan Plateau.

The basaltic bedrock of modern Ethiopia was part of a vast southern continent known, before it split into South America, Africa and the Indian subcontinent, as Gondwanaland. Africa forms its largest intact remnant. Before the Red Sea emerged to wrench it away, the Arabian Peninsula was part of Africa.

To exist in this moonlike landscape, where the temperature often soars to 50°C (122°F), demands the utmost resolve and courage. It is why the lean and hawk-nosed Afar, a fierce and proud warrior people, live a nomadic existence.

Like most African nomads, the Afar diet is mainly meat and milk, but in the few fertile areas along the river banks they grow some maize, tobacco and dates. Many of their palm-fibre and grass-matting dwellings are dome-shaped, like igloos. Huts are arranged in family groups, surrounded by thorn hedges or mud walls to protect the people and their livestock from rival clans and wild animals.

There is some sparse vegetation along the banks of the Awash, the only perennial river, the final stretches of which were only properly charted in 1933, when the hardy Ethiopian-born British explorer, Wilfred Thesiger, fulfilled his ambition by reaching the end of the Awash's 1,200 kilometre-long (740 miles) course where it empties into crocodile-infested Lake Abhebad, one of the 'puddles' straddling the Djibouti border. Amid

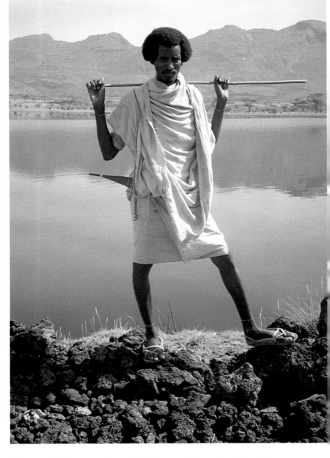

Above: Afar warrior with his traditional rhino-horn handled dagger in the Danakil.

Opposite: Scorched soda flats of the Afar Desert in the Danakil Depression.

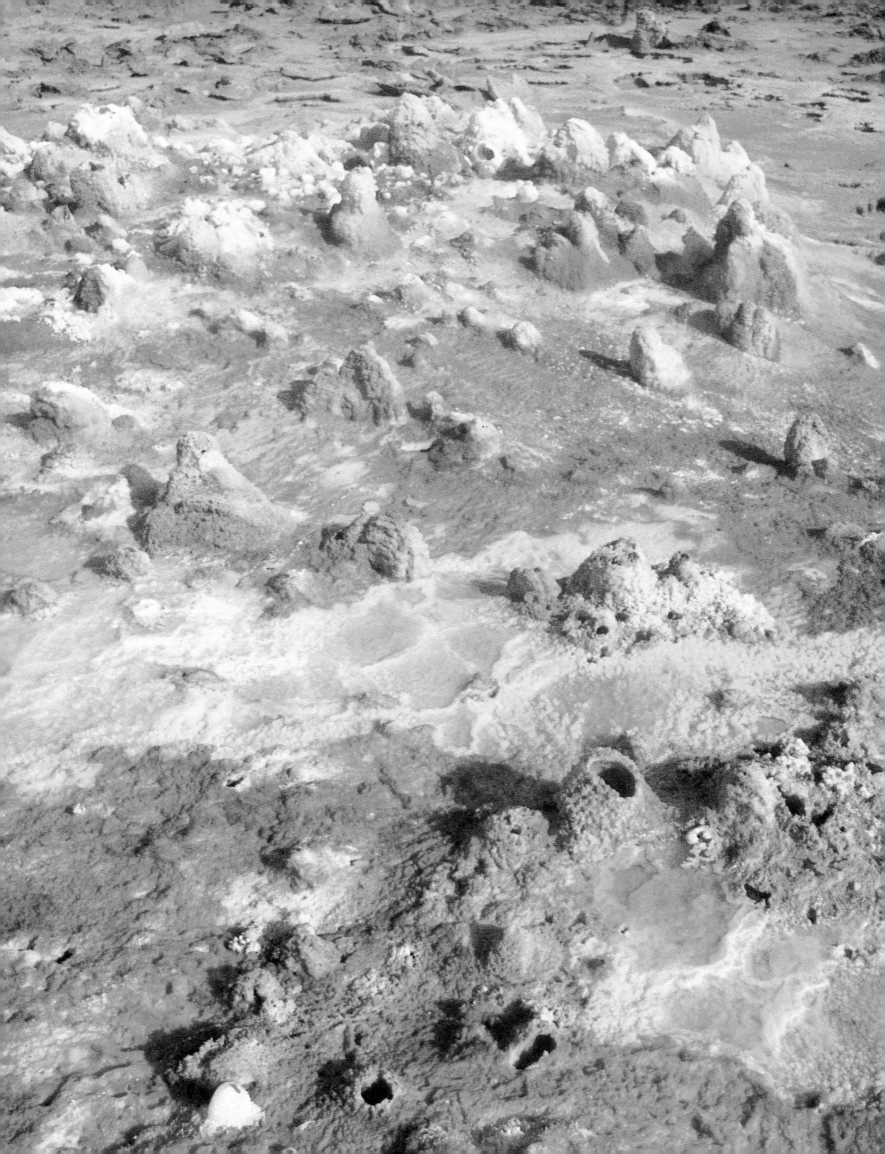

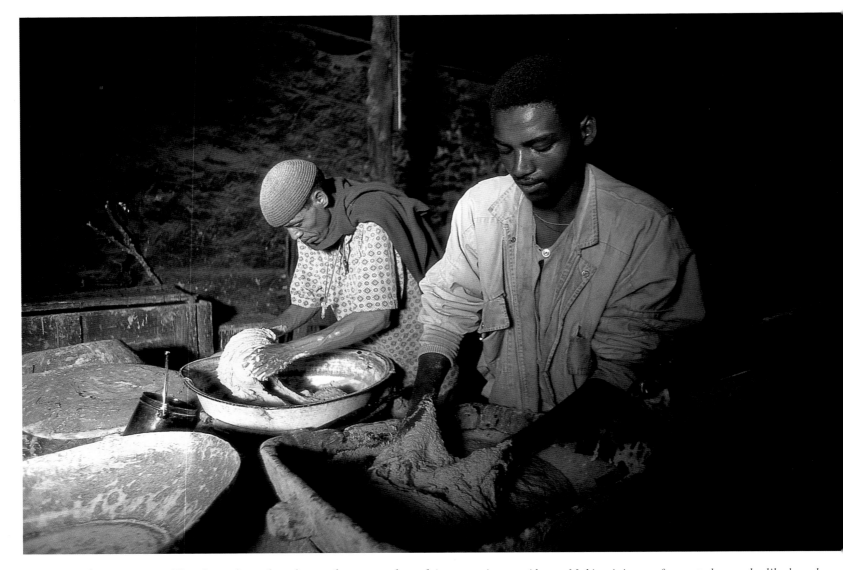

Above: Making injera, a fermented pancake-like bread made from teff, a locally grown grain, and water.

extinct volcanic cones Thesiger found a dense forest and, to his surprise, received a friendly welcome from the local chief, Muhammad Yayu, the Sultan of Aussa. His palace was on the Asayta plains, a fertile area in stark contrast to the surrounding salt lake and sulphurous springs of the Danakil Desert, described by Thesiger as 'a dead world of calcined rock and caustic water'. Since then changes have taken place in the remote Aussa Sultanate.

Some thirty years after Thesiger, when German photographer Dieter Plage was bold enough to visit the Danakil, he found that another Sultan had grown acres and acres of cotton plantations, irrigated from the Awash and worked by people from the Tigray highlands. But even then Plage found it safer to film from a helicopter than face the tribesmen. When he did pluck up the courage to get out of the helicopter beside a geyser, spurting out boiling sulphur, he thought his end had come. For he used a

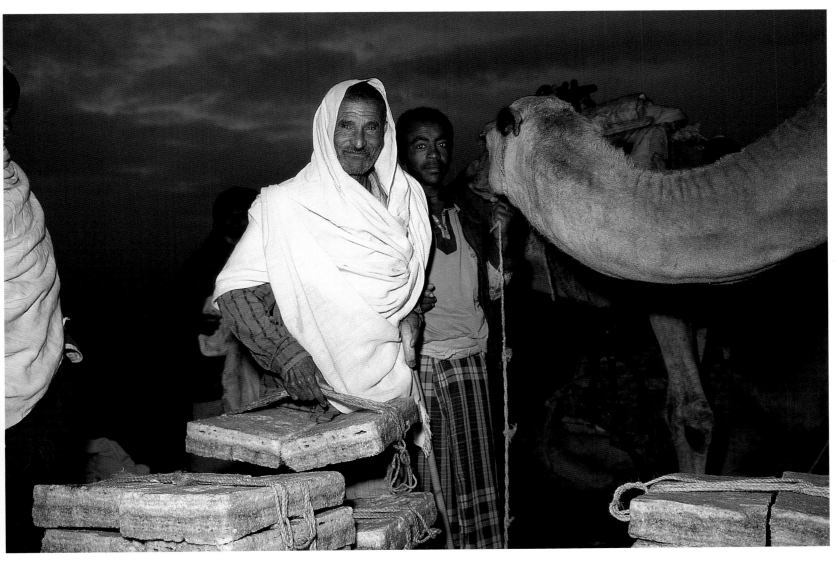

Above: A trader selling salt bars from the Danakil Depression — a sight unchanged for centuries.

trick to get a Danakil man at the geyser to peer into the camera to see another tribesman and the camera button was 'accidentally' pushed by Plage, who writes: 'A Danakil had photographed another Danakil! There was a roar of rage and the victim pointed his rifle at me. I gathered from his gestures that his companions were demanding that I be thrown into the boiling basin ten feet away.'

The photographer beat a hasty retreat until another Danakil told the interpreter that Plage would escape this horrible fate if he threw his camera into the bubbling cauldron. Displaying seeming reluctance, Plage picked up only the box of the camera and threw it into the geyser. The Danakil appeared satisfied.

It was on the edge of the Danakil Desert, in November, 1978, at a place called Hadar, that the fossilized remains of the oldest direct human ancestor were discovered. Palaeontologists were able to reconstruct

Overleaf: Seasonal river cuts through sand and soda flats in the Danakil Desert to discharge itself into Lake Abhebad.

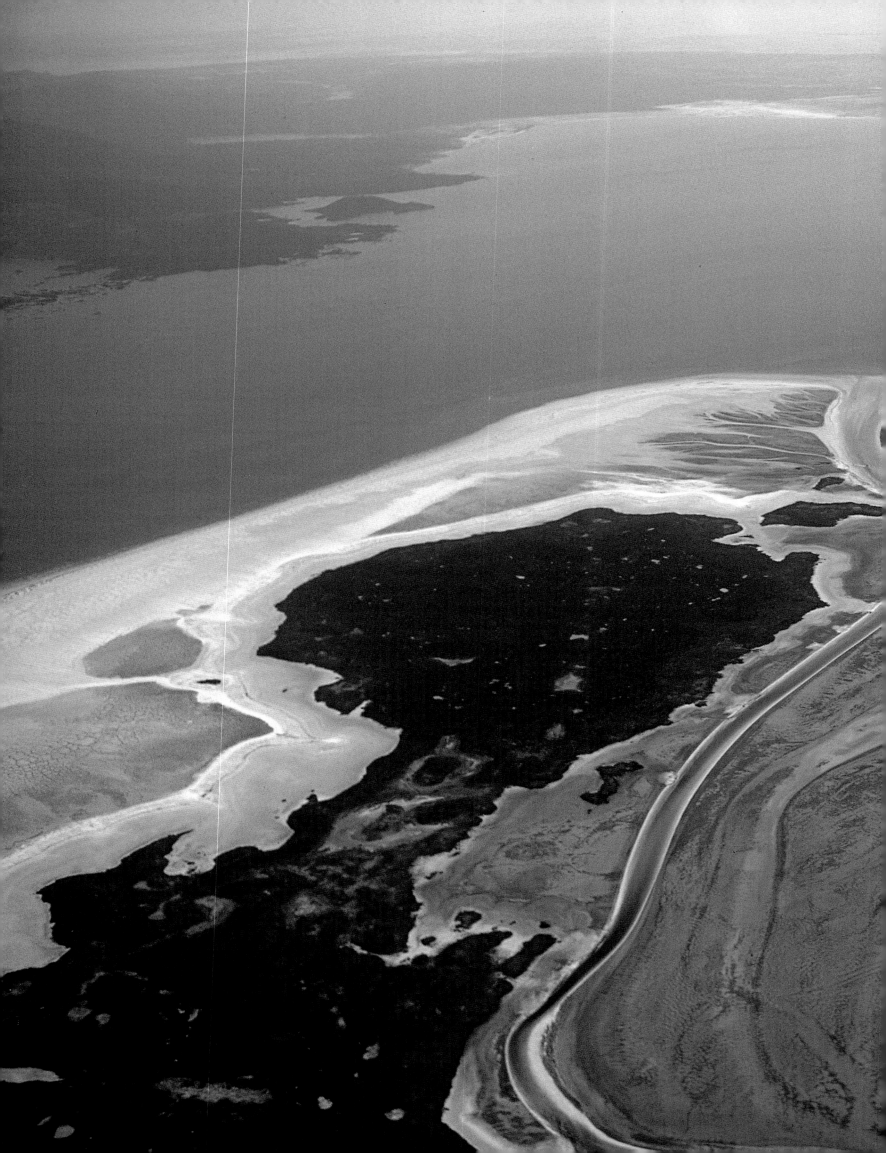

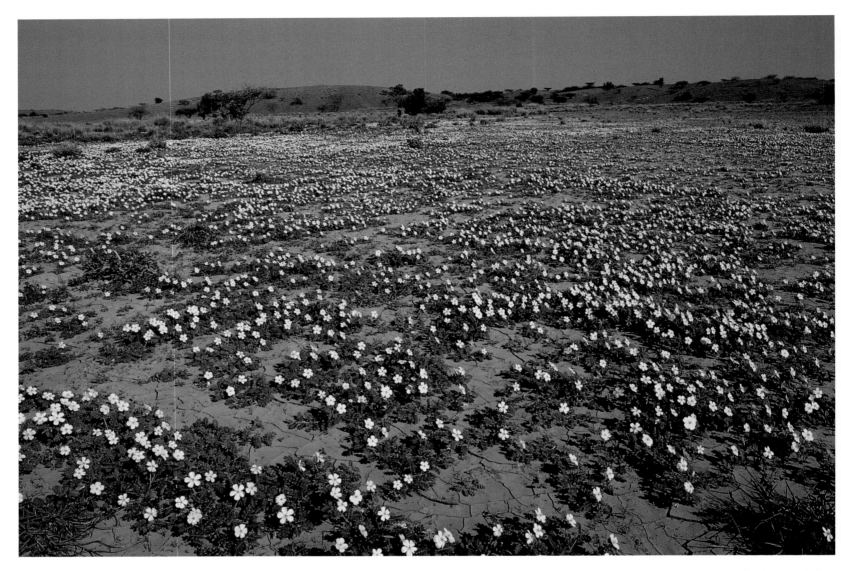

Above: Whenever brief rains fall, overnight the Danakil bursts into a desert meadowland of brief but colourful blooms.

almost the whole skeleton of a single female who walked upright 3.5 million years ago. The discovery, in what had very long ago been the bed of the lake, caused great excitement among the international scientific community. In turn, it focused the limelight on a young little-known US palaeontologist, Dr Donald Johanson of Chicago. On his second field trip to the area, Johanson had gathered numerous fossils of pigs, monkeys, elephants and an extinct species of horse, as well as other creatures which lived several million years ago. But the fossilized bone he picked up at random on 30 November, 1974, seemed to belong to a hominid.

In his book, *Lucy — The Beginnings of Humankind*, after confirming the origin of his find in the scorching desolation of Hadar, Johanson recounted his remarkable discovery.

'There was virtually no bone in the gully, but as we turned to leave, I noticed something lying on the ground, partway up the slope.

Above: Ornate Muslim grave at Asaita in the Danakil.

'"That's a bit of a hominid arm," I said to Gray.

'"Can't be, it's too small. Has to be a monkey."

'I shook my head. "Hominid."

'"What makes you so sure?" Tom said.

'We knelt to examine it.

'"Much too small," said Gray again.

'I shook my head. "Hominid."

'"What makes you so sure?" he said again.

'"That piece right next to your hand. That's hominid too." '"Jesus Christ!" said Gray. He picked it up. It was the back of a small skull. A few feet away was part of a femur — a thighbone. "Jesus Christ!" Tom said again. We stood up and began to see other bits of bone on the slope; a couple of vertebrae, part of a pelvis — all of them hominid. An unbelievable, impermissible thought flickered through my mind. Suppose all these

fitted together? Could they be part of a single, unbelievably, extremely primitive skeleton? No such skeleton had ever been found — anywhere.

'"Look at that!" said Gray. "Ribs!"

'"A single individual?"

'"I can't believe it," I said. "I just can't believe it."

'"By God, you'd better believe it!" shouted Gray. "Here it is. Right here!" His voice went up into a howl. I joined him. In the 100-degree heat we began jumping up and down. With nobody to share our feelings, we hugged each other, sweaty and smelly, howling and hugging in the heat-shimmering gravel, the small brown remains of what now seemed almost certain to be parts of a single hominid skeleton lying all around us.'

The scientific team set about scouring the area for other parts of the same skeleton and succeeded in finding two pieces of jaw. The muddy-brown Awash River was not far from the site and, together with masses of sediment and gravel, they took everything to the river bank and sorted through every piece minutely on a long plastic sheet.

That night no one slept in the camp and a cassette player blared out songs by the Beatles. Their favourite was *Lucy in the Sky With Diamonds.'* To the team of scientists among a remote tribe of nomads, the Afar, this remarkable discovery was worth far more than diamonds, and so the 3.5 million-year-old human ancestor was that night dubbed 'Lucy'. Despite its unscientific label, 'Lucy' has become a famous name among the world's scientists, although the skeleton's taxonomical label is *Australopithecus afarensis.*

Soon Ethiopians, thrilled by the news from the Awash Valley, gave 'Lucy' their own Amharic name *'Dinkenesh'*, which translates in English as 'you are wonderful!'

But that was not the only surprise which Ethiopia was to spring on the world. Twenty years after the 'Lucy' find an even earlier specimen of man's ancestry came to light, the fossilized remains of a chimpanzee-like creature dating back almost 4.5 million years.

'These fossils represent the oldest direct human ancestor ever found,' declared Ethiopian anthropologist Berhane Asfaw as he announced the news in Addis Ababa.

'The discovery takes us one major step closer to the common ancestor of Darwin's theory that humans evolved from an African ape,' he added. The highly-significant find was named *Australopithecus ramidus*, and some scientists were quick to claim that it was the long sought-after 'missing link' in the Darwinian theory of evolution (after closer inspection the finders changed the taxonomy to *Ardipithecus ramidus — ramidus* means 'roots' in the Afar language). Just as Johanson's eye caught sight of a

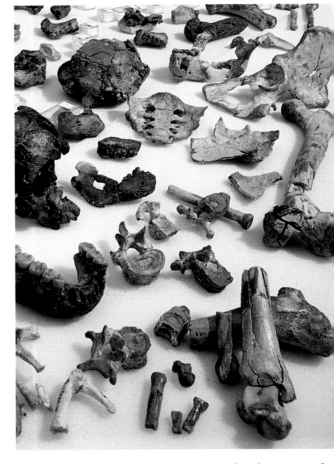

Above: Among the wealth of prehistoric fossils uncovered near Hadar in the bleak and inhospitable Danakil Desert were the 3.5 million-year-old remains of 'Lucy', one of humankind's earliest progenitors. Her skeleton was discovered by an American-led team of palaeontologists in 1974.

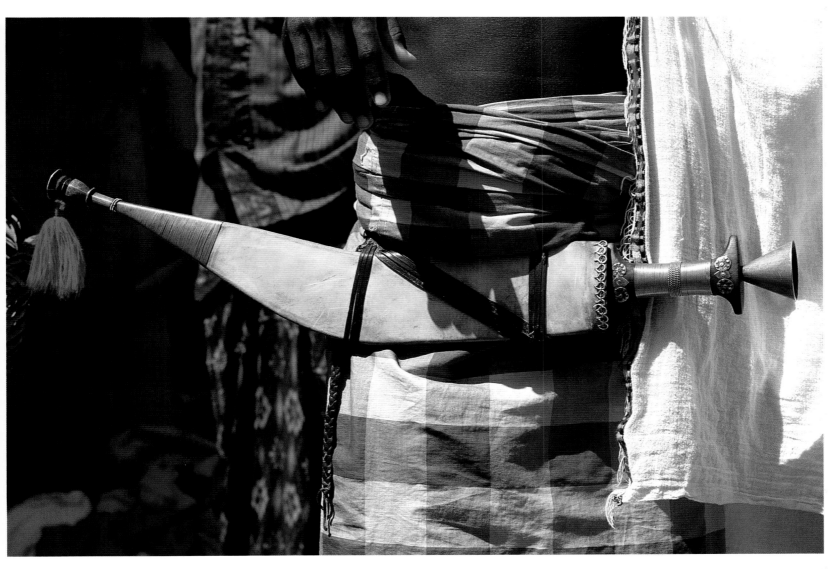

Above: Finely made leather scabbard with its intricate stitching holds traditional Afar warrior dagger, its handle made of carved rhino horn.

single bone sticking out of the Hadar gravel, so it was the glint from a single fossil tooth that alerted the Aramis team of scientists. They unearthed the seventeen fossilized remains at a place called Aramis, also in the Awash Valley, seventy-five kilometres (46 miles) south of Hadar, where Lucy was found. Although Dr Johanson was not in the team, one of his closest associates on the Hadar expeditions, was present.

Tim White, from the University of California at Berkeley, expressed surprise that a human ancestor lived in what 4.4 million years ago was a forest environment. Many scientists believed that humans evolved from apes only after they had left wooded areas to live in open grasslands. The discovery now provided evidence that the first stages of human evolution took place in forested areas.

Commenting on the *ramidus* fossils, the authoritative scientific journal, *Nature*, noted: 'They represent the remains of a species that lies so close to

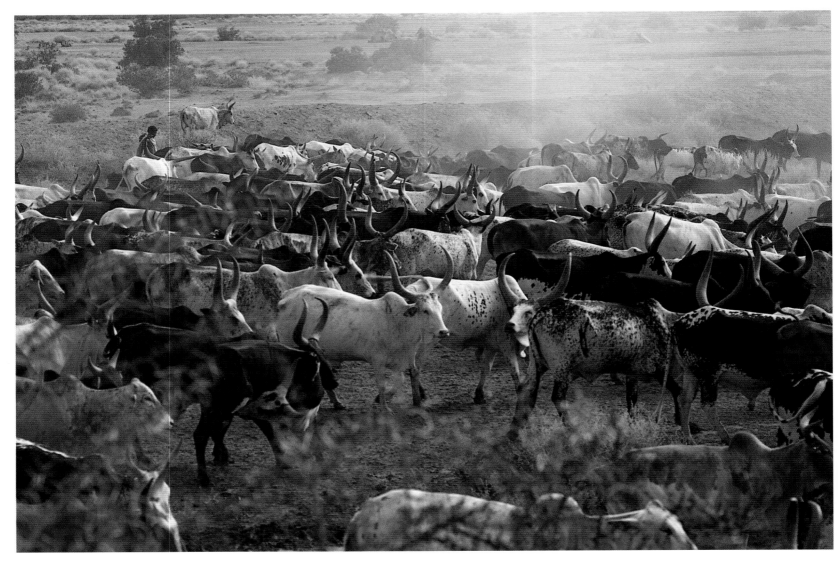

the divergence between the lineages leading to the African apes and modern humans that its attribution to the human line is metaphorically — and literally — by the skin of its teeth', a reference to the fact that traces of skin were found on one of the fossil's teeth. Man's closest relative is believed to have branched off from other primate stock some five to six million years ago.

Measurements show that both Lucy and *ramidus* stood between one and 1.3 metres (4ft-1in) tall, whereas humans average between 1.7 and 1.8 metres (5ft-4in and 5ft-8in). While a replica of the fossilized remains of Lucy is prominently displayed at the National Museum opposite the Addis Ababa University campus, in 1996 the *ramidus* fossils were undergoing intensive analysis for accurate dating and other clues, such as the food it ate.

But this harsh, remote area is not the only place in Ethiopia which

Above: Long-horned cattle belonging to the pastoralist Afar community who roam the arid plains of north-eastern Ethiopia.

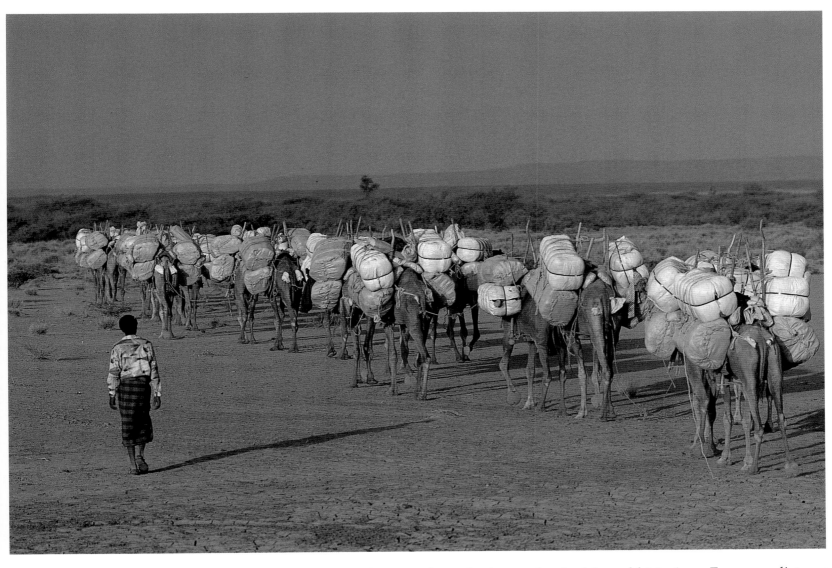

Above: Afar camel train in the border country near Djibouti. Cargoes carried by such caravans often consist of bars of salt, used as a form of currency in such a remote area.

intrigues anthropologists, archeologists and historians. For some distance to the north-west, in the great highland plateau just above the Danakil, lie more fascinating and even more mystical antiquities of an unknown age and meaning.

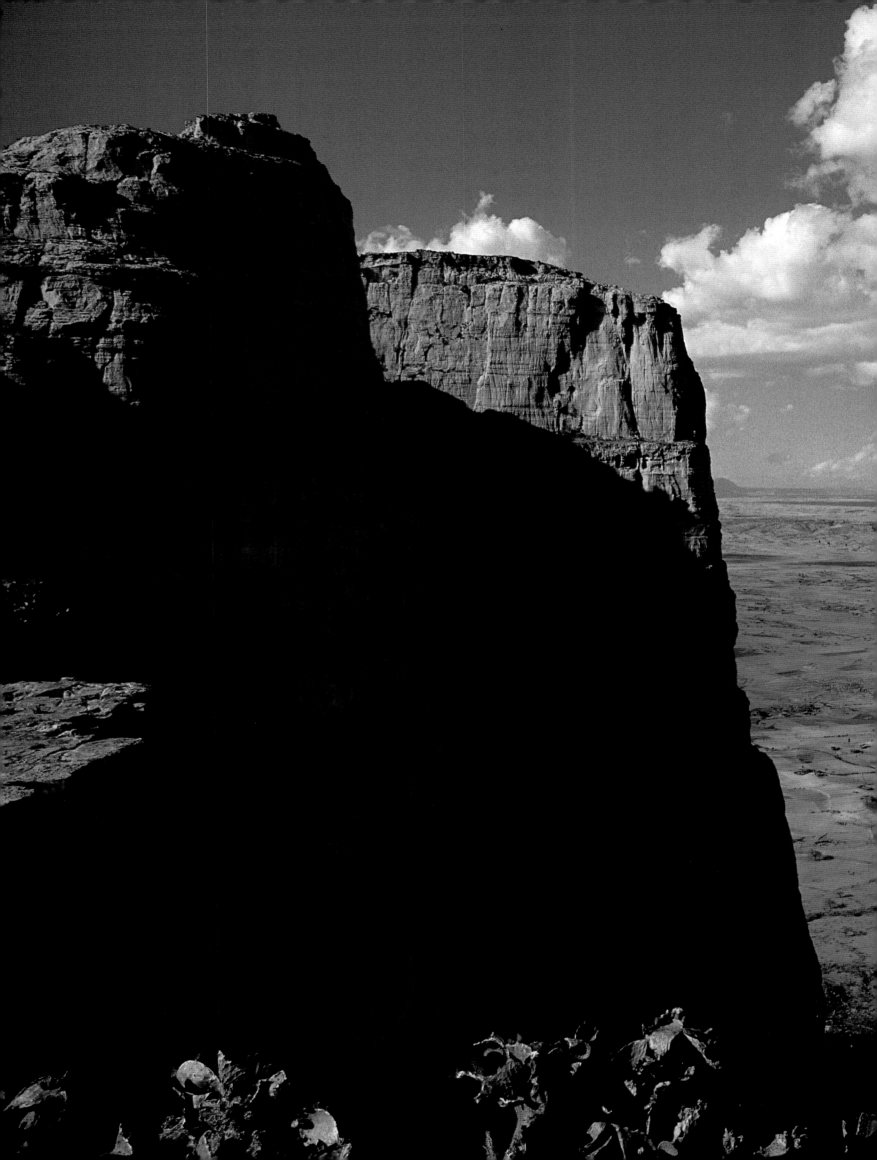

Previous pages: The plains of Tigray from the Korkor Mountains.

While the turbo-prop plane circles the small town of Axum on its final approach close to the Eritrean border in the far north of Ethiopia it is hard to imagine that the random collection of tin-roofed, breeze-block houses, an imposing domed church, here and there other places of worship and some standing stones, was once the busy hub of a state that ranked with Rome, Persia and China as one of the four great kingdoms of the world. As the small aircraft is about to touch down it zooms past two insignificant-looking stone slabs lying flat on the tall grass. They are reputed to be the resting place of the most famous queen in black Africa — the Queen of Sheba (or Saba). And though there is no imposing obelisk or even a mausoleum to mark her memory, the name of Sheba is painted on almost every second sign in Axum's streets.

Set amid a smooth grassy plain, in contrast to the jagged peaks and maze of ravines which virtually isolates it from the outside world, Axum's history goes back more than 2,000 years. It was the centre of one of the first civilizations to adopt Christianity as a state religion.

The Ethiopian town which smacks so much of ancient history is the start of the so-called 'Historic Route' which today is connected by regular scheduled flights to Addis Ababa. The route also takes in such towns as Lalibela, Bahar Dar, Gondar and, away to the east, Harar the fourth most sacred Islamic centre in the world.

Chronologically, before Axum the town of Yeha was the centre of the earliest high civilization in northern Ethiopia. But all that remains of that city-state, established in the mists of time, are the towering, yellow lime-stone ruins of the Temple of the Moon, which dates back to the 5th century BC. The people who built this edifice with its precise-fitting blocks of stone were Sabaeans who migrated to Africa across the Red Sea from south Arabia.

Yeha is famed for its inscriptions and fine objects of bronze and other artefacts which have been excavated since 1909. Some of the church friezes at Yeha bear carvings of the walia ibex, today one of Ethiopia's rarest indigenous animals, living not far away in the Simien Mountains.

When Yeha waned, Axum arose and as soon as it came into being it developed into the nerve-centre of a kingdom which held sway through-out much of the entire Horn of Africa, extending from the eastern Sudan to Berbera in the Gulf of Aden.

Legend has it that eight or nine centuries earlier, before Axum was established, between 200 and 100 BC, Makeda the Queen of Sheba reigned in this region. Her historic journey to the court of King Solomon around 980 BC is recorded in two books of the Old Testament (*Kings* and *Chronicles*). It is also mentioned by Matthew who describes her as 'the

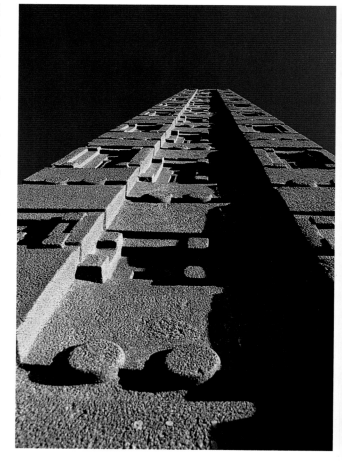

Above: The large stele in Axum is designed to look like a 'house with nine storeys'.

Opposite: The one remaining obelisk in Axum's 'Park of the Stelae' stands 23 metres tall. The 'door' of the 'house' is clearly seen at its base, with nine 'windows' rising above. These obelisks may have served some astronomical function. Short stelae are much older.

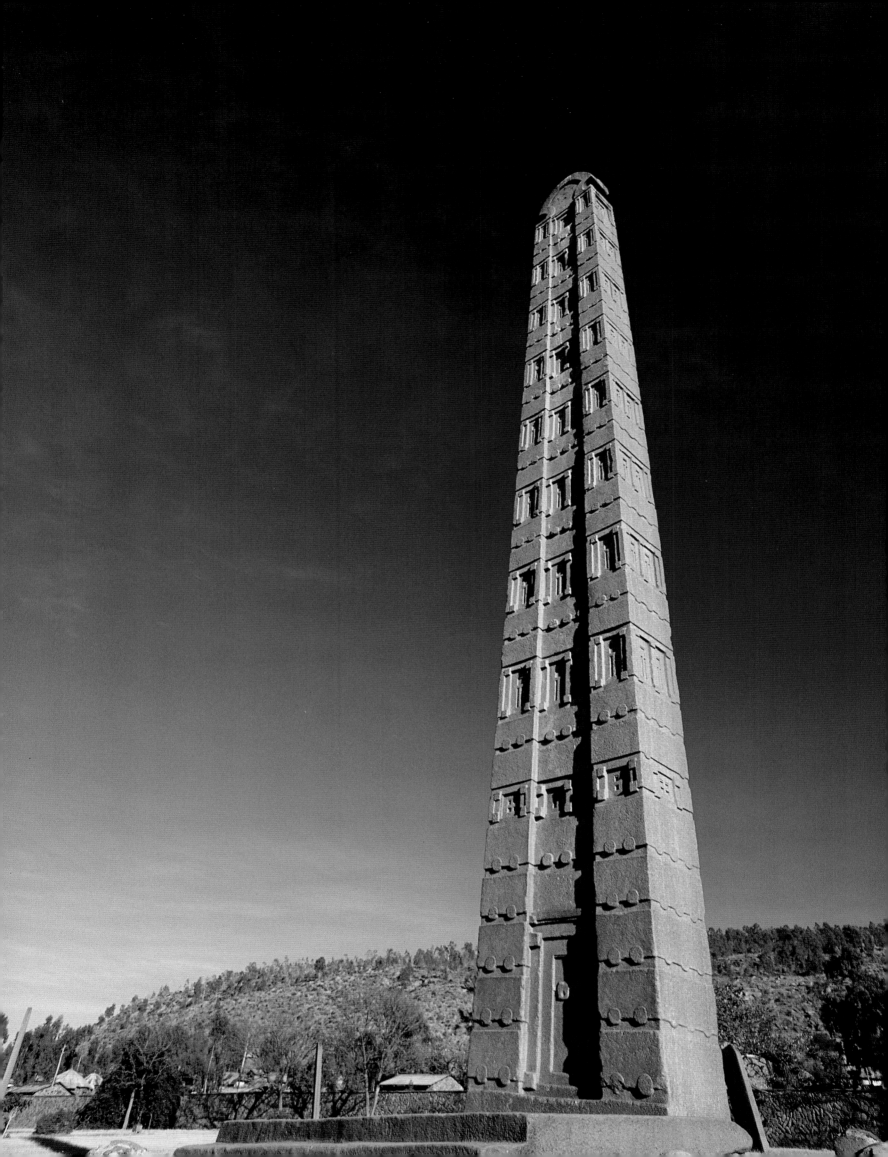

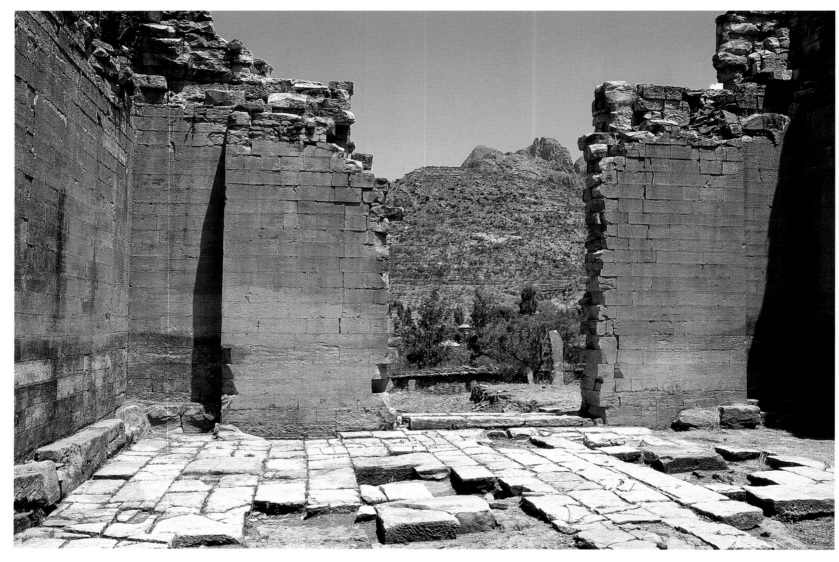

Above: Pre-Christian 'Temple of the Moon' at Yeha, the 5th-century BC centre of the Sabaean civilization which preceded that of the Axumite era.

Queen of the South'. Even now most Ethiopians firmly believe the legend narrated in one of their 14th-century manuscripts, the 'Glory of Kings' (*Kibre Negast*), which told how Makeda, intrigued at the tales she heard of Solomon's great wisdom, wanted to meet the Israelite monarch. Thus she set out with a caravan of over 700 camels and other beasts of burden laden with gold, ivory and other gifts, crossed the Red Sea into Yemen and eventually arrived in Jerusalem.

According to *1 Kings 10:1-10*, her gifts included '120 talents of gold' for the king, as well as precious stones and a large quantity of spices. In return Solomon gave her 'all she desired', including a palace for the duration of her stay. She spent much time seeking wisdom from the king, asking him many hard questions.

'When she came to Solomon, she told him all that was on her mind. And Solomon answered all her questions; there was nothing hidden from

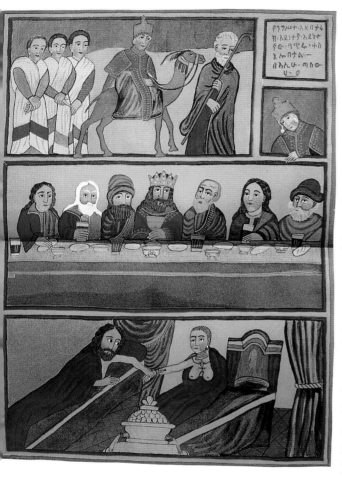

Above: 19th-century Ethiopian painting depicting the legend of Solomon and Sheba.

Solomon which he could not explain to her' *(2 Chron. 9:1).* The *Kibre Negast* takes over from there to claim that Solomon so admired the queen's intelligence and beauty that he wanted a child by her. The legend goes on: 'It so happened that King Solomon fostered a desire to know Queen Makeda as man and woman. To fulfil this wish, he gave a great feast to which the queen was invited. They partook of rich and delicious dishes and drank to their hearts' content till daylight turned to darkness.'

As it was late for the queen to return to her palace, she accepted the king's invitation to stay at his palace, but only on condition that he took a vow not to dishonour her. He agreed on condition that she should reciprocate with an oath not to take anything from the palace without his permission. And though Sheba objected to the innuendo, she consented to the condition.

According to the *Kibre Negast* they slept in beds placed on opposite sides of the royal bedchamber. During the night the queen awoke and feeling thirsty moved towards a jar of water the king had placed at his bedside.

The old Ethiopian legend continues: 'The instant she took hold of the container, Solomon, who had pretended to sleep, caught her arm and reminded her that she had broken her word. She said that the oath did not apply to water, but the king answered that there was nothing on earth more precious than water. Overwhelmed, Queen Makeda agreed to free him from the oath. . . . Thus Solomon was able to work his will upon her.' That night King Solomon dreamt that he would have a child by the queen and on her departure for home he handed her a seal which he asked her to give to the baby if it were a boy. When she reached Eritrea, she gave birth to a son whom she named Menelik (originally Bin Ha Malik).

Strangely, whereas one legend states that on her journey Sheba travelled via Yemen, copies of an 1895 painting — which depicts the story of Makeda's visit to King Solomon — now sold to tourists in Addis Ababa show the queen in a boat with many retainers sailing past two pyramids and the Sphinx, implying that her journey was through Egypt, and not Arabia.

Muslims have their own version of Queen Belqis's visit to Jerusalem to meet King Suleiman, Belgis being the Arabic name for Sheba and, Suleiman the Arabic for Solomon. The version, in one of the *Hadithi* used in mosques, makes out that there was a 'battle of wits' between the two and that major disputes raged between Israel and Sheba.

The *Kibre Negast* states that Makeda brought Judaism to Ethiopia and from her return it became the country's official religion until Christianity took its place early in the 4th century. When Menelik came of age and was

told his father was King Solomon of Israel he demanded to go and see him in Jerusalem. With his mother's consent Menelik travelled by land and sea and, according to the *Kibre Negast*, when he met Solomon, he handed over the seal his mother had given him. The king recognized it at once.

The *Kibre Negast* records that young Menelik spent some time in Israel learning the Laws of Moses from the High Priest and was later named David II by Solomon. Having hoped the youngster would succeed him as ruler of Israel, the Israelite king was most reluctant to see Menelik return to Africa. But the legend says that Solomon finally allowed his first-born son to leave, subject to certain conditions. These were that Menelik should take with him the first-born sons of Israel's high officials as well as people from each of the twelve tribes of Israel.

One recent researcher maintains that this was how the ancient Semitic tribe, the Falasha, first travelled to Ethiopia, passing through Egypt and

Above: Ruins of what is believed to be the Queen of Sheba's Palace. Remnants of stone flooring are all that remain. Locals at Axum claim the Queen was buried in the shadows of the palace.

then following the valley of the Nile tributary, the Tekezze, up to the high plateau, north of Lake Tana, where they remained (in recent years the majority of their descendants 'returned' to Israel, the last group leaving in 1991).

At this stage the *Kibre Negast* legend introduces the sacred Ark of the Covenant, the special gold container in which the stone tablets inscribed with the Ten Commandments were kept. The Ark had been in Jerusalem for centuries, but the old legend states that, unknown to Menelik, some of his party stole it from its holy resting place in the Temple because they did not want to be separated from it. When he learned of the daring theft King Solomon was so enraged that he rode with his retainers to Egypt, hoping to retrieve it, but he was too late.

Some scholars have long suggested that the reason why the Ark is not mentioned at all in the Old Testament after King Solomon's reign was to keep the theft a secret to avoid public panic.

In his book on the search for the Ark of the Covenant, *The Sign and The Seal*, Graham Hancock claims that it was kept for years on Elephantine Island, near Aswan, Egypt, then brought south to an island on Lake Tana and thence to Axum, where it remained until the town came under siege. It was then, he records, believed to have been moved south again to an island on Lake Ziway until its return to Axum where the sacred box is kept in the Church of Saint Mary of Zion, closely guarded by a monk who denies entry to all callers.

However, the priests there do bring out ancient ecclesiastical crowns and crosses for visitors to see. And replicas of the Ark of the Covenant — known as tabots — are kept in many Orthodox churches in Ethiopia which, wrapped in coloured silk, are brought out for all religious festivals. But the real one, if it is at Axum, is never shown to anyone.

Soon after Menelik returned from Israel to Axum his mother abdicated for her son to become King of the Axumites. With some interruptions the dynasty is said to have lasted almost 3,000 years until 1974 when a revolution overthrew Emperor Haile Selassie, who claimed to be 225th in the Solomonic line.

Relics claimed to be connected with the long-departed Queen of Sheba are everywhere in Axum — even the town reservoir, covered in bright green algae, is known to all as 'the Queen of Sheba's Bath', while a ruin on the road to Gondar outside the town is Sheba's 'palace'. Only the floors and a few walls remain. The flagstones on the floors are quite intact and so is a flight of steps with close-fitting stones, as are two brick ovens.

Just across the road from the 'palace' ruins stand a number of small stones and in the grass where cattle and goats graze contentedly two large

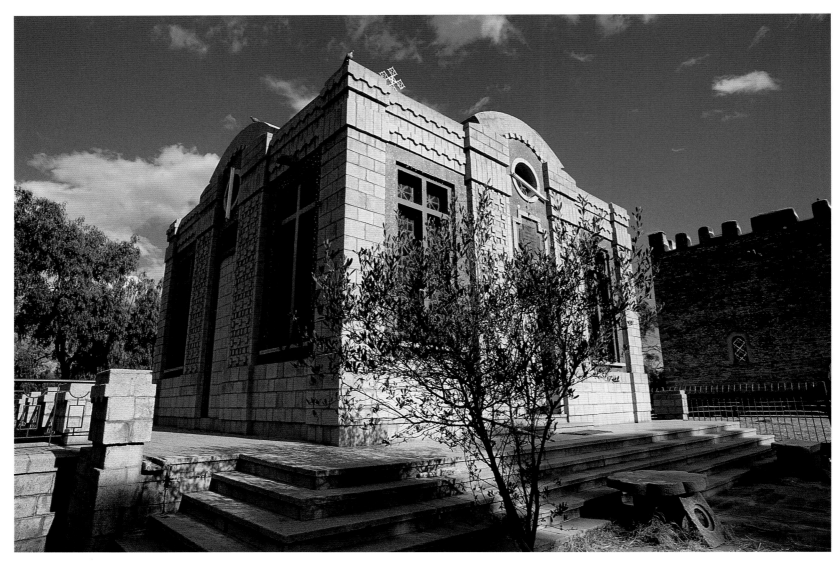

granite slabs are said to be the spot where the queen was buried in the 10th century BC. Axum is renowned for the world's tallest monoliths, or obelisks, which experts say were erected to mark the passing of some ancient royal personages. Archaeologists compare them to Britain's Stonehenge and to smaller ones in Yemen and Egypt — all believed to function as some kind of solar or astronomical measuring device.

There is also a theory that the tablets in the Ark of the Covenant are akin to meteorites or some other objects from space — possibly radioactive. Significantly, across the Red Sea, in what was once part of Sheba's ancient empire, is Mecca where the Ka'abah, a revered black stone which is Islam's holiest shrine, is also said to be of meteoric origin. Originally, Axum had more than sixty of these giant pieces of solid granite, as well as 246 smaller sharp-pointed standing stones believed to have been erected much earlier than the tall ones. In medieval times seven of the tallest

Above: Modern chapel of St Mary of Zion at Axum is said to contain the sacred Ark of the Covenant, but no one but the Orthodox priest who serves as the chapel's custodian is allowed to enter the building. The chapel, which replaced the earlier building raised during Emperor Fasilidas's reign, was opened by Emperor Haile Selassie in 1965, accompanied by England's Queen Elizabeth II.

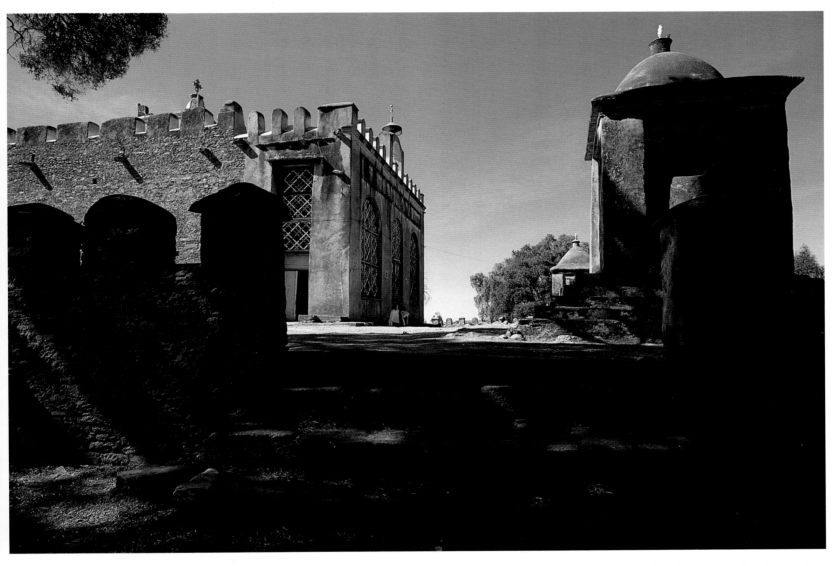

Above: The original St Mary of Zion chapel built in the reign of Emperor Fasilidas was reputed to be the previous hiding place of the Ark of the Covenant.

obelisks stood in what is today known as the 'Park of the Stelae' — another word for obelisk — just north of the modern town square. Since then four have crumbled completely and three remained until only a few years ago.

The largest and heaviest of all, thirty-three metres (106ft) high and 600 tons in weight, now lies in four pieces where it fell — possibly as it was being erected. The only stele still standing, a few metres away, is twenty-three metres (74ft) high.

The second largest of these intricately-carved stone pillars was stolen in 1937 on the orders of Mussolini, who wanted it raised in Rome to commemorate the first anniversary of the Fascist Italian occupation of Ethiopia. It stands in the Italian capital, outside the UN Food and Agriculture Organization (FAO) headquarters, where the Ministry for Italian Africa was housed during the Fascist regime. After the Second World

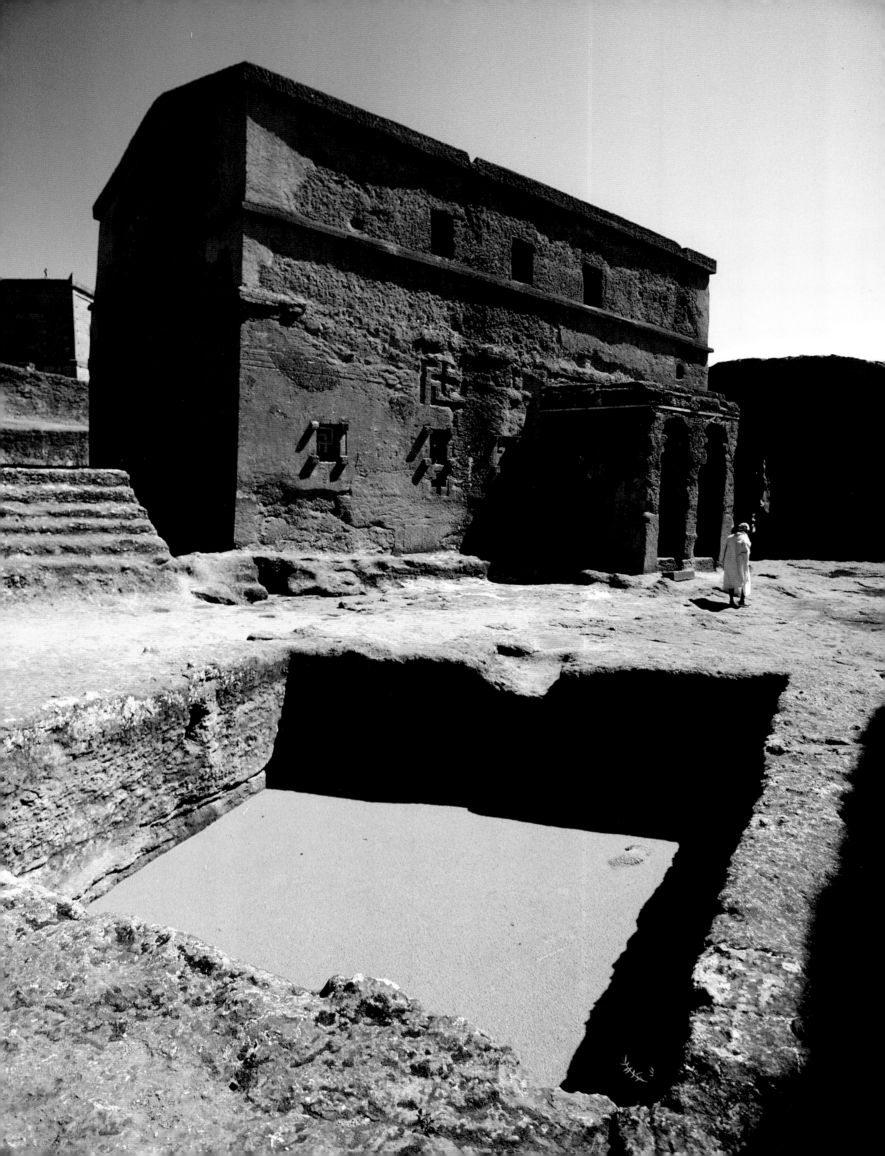

Opposite: Beta Ghienetta Maryam, the House of the Virgin Mary, a free-standing church hewn from stone, guards the 'Pool of Fertility' — a pond covered with algae — where barren woman bathed in the hope of conceiving.

Above: Two Maltese crosses are among the elaborate works of art which adorn the interior of the House of the Virgin Mary.

War, under a 1947 peace treaty between Italy and the United Nations, the Italian Government agreed to return — at its expense — all works of Ethiopian art, religious objects, archives and other material of historical value. While most other looted items were returned within the eighteen-month-time limit, the massive obelisk has never been sent back in spite of repeated Ethiopian demands for its restitution.

A recent attempt to recover the ancient monument so that it can once again stand beside the solitary single stele was organized by a German filmmaker, Lutz Becker, who made an outstanding documentary, *The Lion of Judah*, about Haile Selassie's days as emperor.

Becker wrote: 'Of the tourists who come to Rome, only a few are aware of the obelisk's significance, and most Italians who pass it do not know where it came from. Like so many old monuments in Rome, it is taken for granted, expected to stay there for ever.'

Lutz described the huge granite slab as 'a rare and wonderful symbol of Ethiopia's ancient civilization, and of African spirituality, which remained in the holy city of Axum for perhaps 2,000 [3,000] years'.

There, a fifteen-man team of British, American and Ethiopian archaeologists, led by Cambridge Professor David Phillipson, has been engaged on a research project seeking to uncover more of Ethiopia's prehistory. According to Professor Phillipson as much as ninety-seven per cent of Axum's history is 'still shrouded in mystery'. His team has excavated graves of ancient kings in the vicinity of the lone giant obelisk that still stands.

The northern town, seen as the cradle of Ethiopian civilization, was a flourishing trading centre when Jesus was preaching in Palestine. Then Axum's connection with the outside world was through the port of Adulis, a few kilometres south of modern Massawa. Ships from Egypt, Arabia, India and other ports in the orient called regularly to take on gold, obsidian, ivory, incense, spices, rhino horn, hippo hide, tortoise shell, hides, elephants and live monkeys, as well as slaves from the interior.

Into Adulis, and then by an eight-day journey to Axum, came such imports as wine, olive oil, glassware, cups, clothing, knives, axes and linen. The fact that some Axumite people knew the Greek language is testified by the Greek inscriptions, still legible, beside writing in the Sabaean language on carved granite slabs. In fact, Axum, now a small sleepy town blissfully unaware of its glorious past, once served, through Adulis, as the bridge between Africa and Asia.

Christianity came to the Axumite Kingdom in the early 4th century AD when two Christian youths from Syria, Frumentius and Aedusius, were found on a ship on the Axumite coast. They were taken to the emperor in

Axum. When they became older, they were employed in the royal court, where Frumentius eventually became the king's secretary and treasurer. Soon he was preaching the Christian message to the Axumites. A new ruler, Ezana (Abreha), later sent Frumentius to Alexandria with instructions to bring back a bishop from the Egyptian Coptic Church. Instead of an Egyptian bishop, the Patriarch of Alexandria decided that Frumentius himself would be more suited to minister to the people of Axum, since he knew their language and culture and had already converted many. So Frumentius was appointed the kingdom's first archbishop, with the ecclesiastical name of *Abuna* Selama ('Father of Peace'). In AD 330 Christianity was declared the state religion and Frumentius spent the rest of his life converting the people from Judaism or paganism.

After Ezana's rule, the Ethiopian Orthodox Church continued to recruit Axumites to the Christian faith. One outstanding ruler of the fifth-century was King Kaleb, remembered by the complex vaults erected during his thirty-year reign.

The ruins are found to the west of Axum, where there is an impressive panoramic view of the Adwa Mountains, near the scene of Emperor Menelik II's victory over the Italian army which in 1896 invaded northern Ethiopia from the Italian colony of Eritrea.

Still accessible today are underground vaults believed to to be the tombs of King Kaleb and his son, King Gabre-Meskel. Steep steps made of large blocks of neatly-carved stone, which fit together precisely without any mortar to hold them in place, lead down to a labyrinth of galleries containing what appear to be coffins.

Coins minted in the reign of King Kaleb are among the thousands of Axumite gold, silver and bronze coins unearthed since that period. But Axumite currency, first issued from Axum in the first century AD, had been in circulation long before King Kaleb.

Emperor Ezana had two different sets of gold coins. Those before he was converted to Christianity carried pagan symbols, the sun and the moon. On later coins, issued after Ezana had become a Christian, the cross appears prominently, proof that at this time Christianity was accepted as the official religion in Axum. In fact King Ezana was the first sovereign in the world to engrave a cross on his coins. Ancient Roman and Indian coins, denoting trade links even back then, have also been found in Axum's ruins.

Once Axum went into total decline in the ninth century, coinage disappeared from Ethiopia for almost 1,000 years. When coins did reappear they included 'thalers' (dollars) from far-off Austria — old Maria Theresa dollars, introduced to Ethiopia in the 18th century, which remained as

Above: Ethiopian Orthodox priests celebrate Timkat at Lalibela, the most important festival in the Orthodox Calendar.

Above: Colourfully clad members of the Orthodox Church celebrate the Timkat festival.

legal tender until 1945. Now they are collectors' items. Although by the 9th century Muslim armies had occupied the entire area of the Middle East and Axum was almost encircled, no longer having access to its former markets, the Arabs do not seem to have made any attempts to attack the city. This was despite the fact that in the previous century Axumite forces had raided Jeddah and Islamic forces had retaliated by burning the port of Adulis.

However, the Prophet Muhammad always maintained friendly relations with Ethiopia and it is recorded that when he fled to Medina many other Muslims sought asylum from persecution in Ethiopia. One group which sailed across the Red Sea in AD 615 included Muhammad's daughter, Ruqiyya, and also his future wife, Habiba, who were welcomed by King Armah in Axum.

Many of these Muslim refugees remained in the Axumite kingdom and when they died were buried in the small town of Negash, now in modern Tigray. Many Ethiopian Muslims regard the town and its mosque as the second most sacred place of Islamic worship.

Ironically the sovereign who undid all the groundwork which the Queen of Sheba laid down to make herself a powerful and wealthy empire was another legendary woman — Queen Yudit (or Gudit, Judith).

But Queen Yodit, who was said to be pagan or Jewish, saw the Christian stronghold of Axum, which had previously been an outpost of Judaism, as a suitable target for attack. Her troops rebelled against the Christian rulers and throughout the latter half of the 9th century they laid waste the Axumite countryside, destroying every church, monastery and Christian monument they could find, including those in the Axum area. During this period of Jewish rule large groups of Christians fled south to escape the mass slaughter, and with them went the centre of power.

It was during the Jewish rule that the Ark of the Covenant is said to have been smuggled south to Lake Ziway for safe-keeping. Some legends describe Queen Yodit as a 'monster' who hated all the trappings of Christian civilization which had evolved in Axum after the conversion of King Ezana. She was joined by those who strictly observed the Jewish faith and customs but who were not Falasha (in Ge'ez, the ancient language still used by churches, *Falasha* is the plural of *Falasi*, which means 'one who forsakes one's native land, or simply 'emigrant').

According to Belai Giday, an Ethiopian historian, Queen Yodit ruled the Axumite kingdom for forty years, after which two other Jewish monarchs held power for another thirty years. For the whole of this period the Christians who remained in the kingdom suffered severely and had hardly any holy places left to worship in.

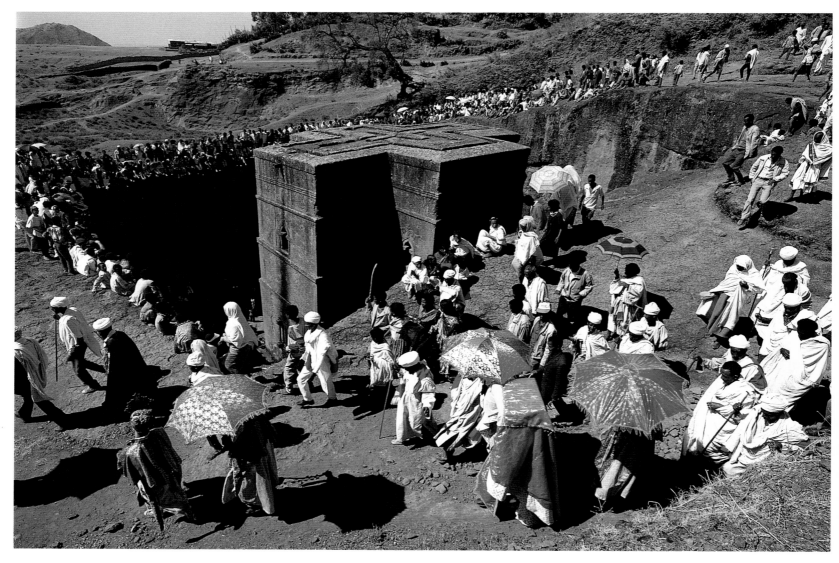

Today Orthodox priests explain to visitors that the reason many of their churches do not admit women is because of the damage done by Queen Yodit centuries ago. And such monasteries as the remote 'retreat' of Debre Damo not only refuse entry to women visitors but also ban any female animals sold for slaughter. Axum is a focal point of the autonomous federal state of Tigray. The Tigrayeans speak a Semitic language, Tigrinya, which developed from Ge'ez, Ethiopia's ancient language which is still used by the Orthodox Church.

For two decades they suffered severely from prolonged drought and famines. Many of the shocking television pictures which were screened about Ethiopia in the 1970s and 1980s were from relief camps in Tigray.

But their history is long and ancient and when Axum declined at the end of the first millennium, a new Zagwe dynasty took over in AD 922 and moved power from Tigray to Lasta where their kings remained in power

Above: Hundreds of faithful surround Lalibela's Beta Gyorgis, the church of St George, distinguished by the cross prominently displayed on its roof, during the Timkat (Epiphany) celebrations.

Opposite: One of the many Orthodox priests at Lalibela displays a cross carved from wood.

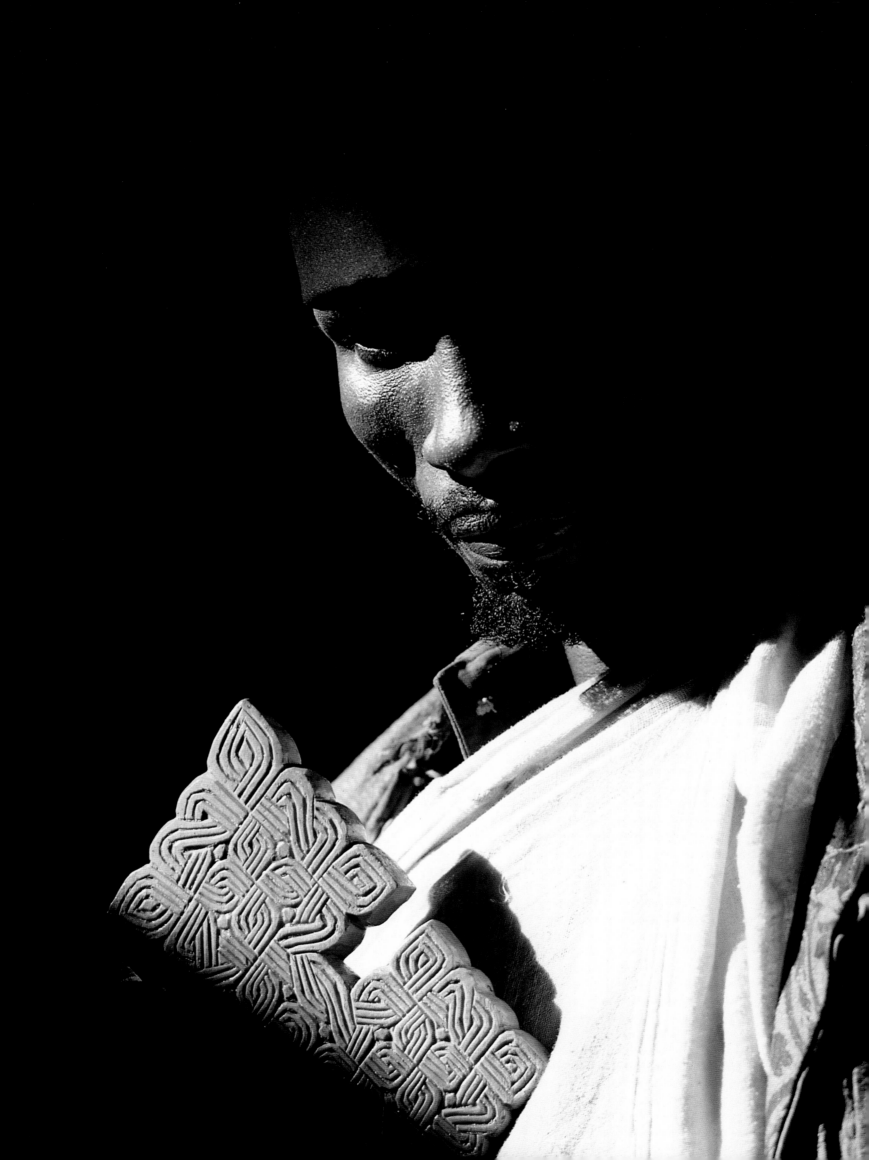

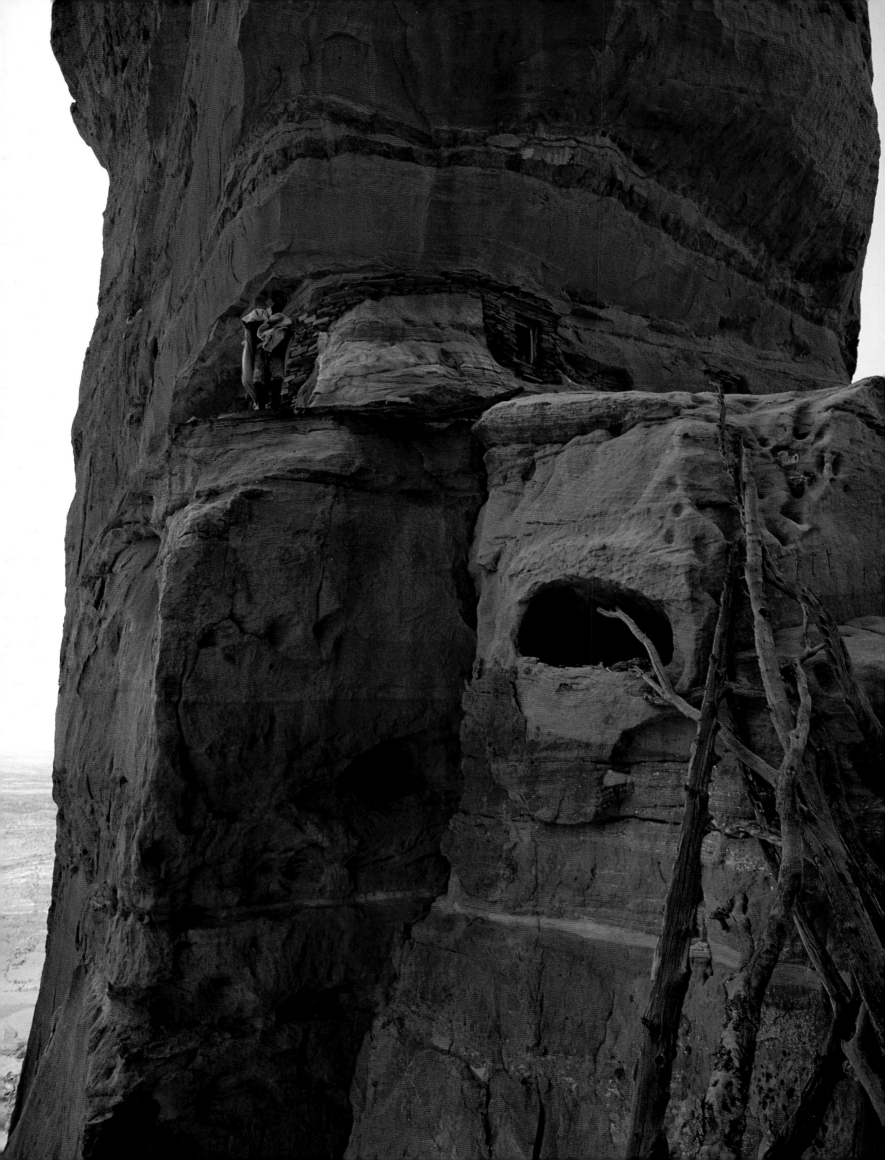

Opposite: High up on a red sandstone pillar the incredible Abune Yemata church in Tigray is almost impossible to reach.

for the next 300 years or so. Among them was Lalibela, who literally carved his name in Ethiopian stone. His projects — the eleven world-famous rock-hewn churches of Roha, later named after him — are standing more or less intact to this day. Far off the beaten tracks, about 240 kilometres (148 miles) south-east of Axum, Lalibela is a remote settlement below a flat-topped mountain. There, the carefully- crafted churches carved out of the bedrock, described as an 'eighth wonder of the world', are now listed by UNESCO as a World Heritage Site.

In fact, in neighbouring Tigray alone there are at least 120 rock churches, probably just as fine, and much older. But they are widely scattered and not at all easy of access. What is unique about Lalibela is that the clusters of eleven churches are accessible to visitors in one day.

The name Lalibela is the Agaw word meaning 'bees recognize his sovereignty' and relates to one of the many legends about the king. According to one, soon after he was born his mother found Lalibela in his crib surrounded by a swarm of bees. Recalling the superstition that bees could foretell the future, she called out: 'The bees know this child will become king!'

And so he did, after beating his sibling rivals for the high office when he returned from a long stay in Palestine. While in Jerusalem, says the Lalibela legend, he was carried by the angels to heaven, where God told him to go back to Roha and build churches of a type never seen anywhere in the world.

To account for the amazing speed with which the holy places took shape the people of Roha claim that while humans worked on the churches in daytime angels worked on them at night.

Father Francis Alvarez, the Portuguese priest whose mission reached Ethiopia in 1520, made his way out of curiosity to Lalibela where he measured all the churches, four of which are free-standing and another seven carved out of the red cliffs. He recorded that he had been told that the men who worked on this 12th century wonder included 'white and red men' from Palestine.

The free-standing rock churches at Lalibela are *Beta Medhane Alem*, the Church of the Saviour of the World, *Beta Ghenetta Mariam*, gardens of the Virgin Mary, *Beta Emmanuel*, Church of Emmanuel, *Beta Maskal*, Church of the Cross and *Beta Giorgis*, Church of St George.

According to legend, the latter was built by St George on horseback and wearing full armour. A striking mural of St George slaying the proverbial dragon can be seen in the Church of St Mary in Axum. There are others in Addis Ababa churches. Guides at Lalibela's Church of St George show visitors marks on the church roof which they claim to be 'hoof prints'

made by St George's horse. The most notable feature of the church is the huge cross on its roof, while the church itself is built in the shape of a cross. It rises out of a deep pit away from the other free-standing churches. Some experts have described the Church of St George as 'the ultimate in rock church design', while others consider that Beta Medhane Alem's breathtaking exterior, with its rows of tall pillars, has equal claim. Away from the free-standing rock churches, Lalibela's seven other rock edifices demonstrate various degrees of separation from the surrounding volcanic rock mass. All the walls of the semi-detached Abba Libanos are isolated from the rock face, but its roof merges into the cliff above. By contrast Beta Golgotha and Beta Mikael are more subterranean — although the latter has three exposed façades while Golgotha has only one. The remaining churches within Lalibela itself are *Beta Dengel*, Church of the Virgin, *Beta Selassie*, Church of the Trinity, *Beta Quedos Marcurious*,

Above: Entrance to the Tigrayean monastery of Debra Damo is by rope only.

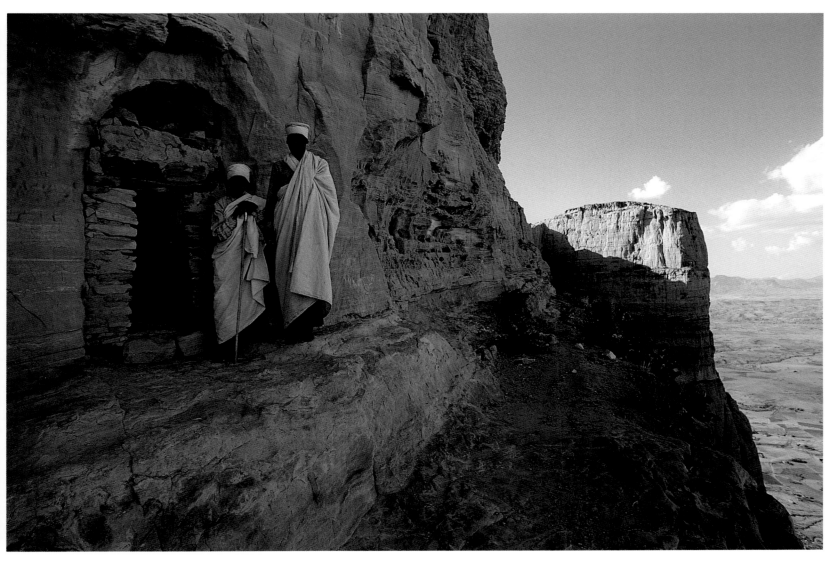

Above: Priests at Abune Yemeta, a clifftop church in Tigray.

Church of Saint Mercury, and Beta Gabriel-Rufael, Church of Gabriel and St Raphael. Legend insists that all eleven churches were built within the span of twenty-four years, but it is more likely that work continued after Lalibela died at the end of his forty-year-reign. His widow has been credited with building Abba Libanos in just one night — with the indispensable help, of course, of angels.

An interesting feature common to all the Lalibela churches is the strictly linear design and the perfect ninety-degree angles. Among the few curves to be found in these buildings are either the crescent symbol of Islam, or of the new moon, and many Maltese crosses. Other symbols in the church windows are St Andrew's crosses and reverse swastikas.

Author Graham Hancock, who spent several years trying to track down the final resting-place of the Ark of the Covenant, suggests that while some artisans from India or the Far East could have helped the local stone-

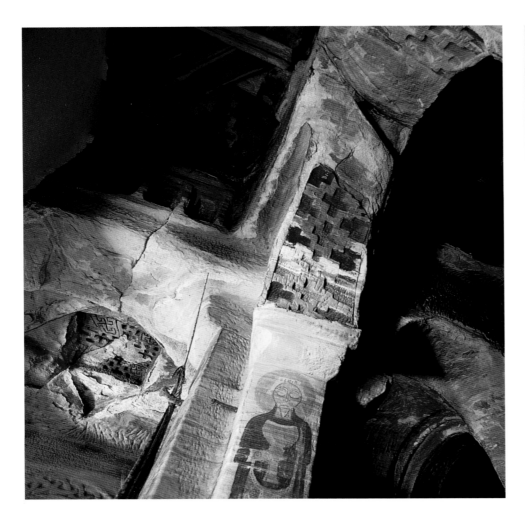

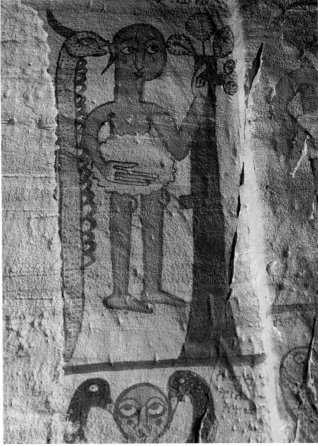

masons, the 'white men' may have been Knights Templars from the Crusades in Jerusalem who travelled to Ethiopia to design the churches.

Until recently visitors to Lalibela used to make the arduous journey by mule (in 1925 the intrepid Rosita Forbes was one of them), when a winding mountain track linked the sleepy village, once the capital of Ethiopia, with a main road at Waldiya.

Now, though, flights by Ethiopian Airlines land on an airstrip just below Lalibela, as its remarkable churches are a major point of interest on Ethiopia's 'Historic Route'. And the British Government has financed a long-term project to construct a major road to run across the 'spine' of the country's central plateau that will pass through Lalibela and another former capital, remote Magdala. The road will connect the town of Debre Berhan in the south to Sekota and on to Adwa and Axum in the north. Magdala is the mountaintop stronghold where in 1868 Emperor Tewodros

Above left: Interior of Maryam Korkor church in Geralta Mountains.

Above: Figures painted on the rock wall of Korkor Maryam church, Tigray.

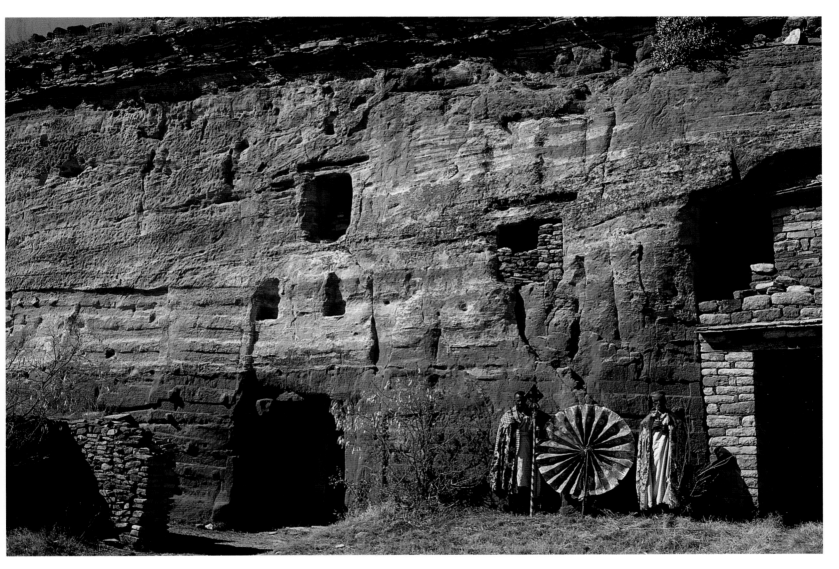

Above: On display outside Debre Tsion church in Tigray is an elaborate fan or parasol, thought to date back to the 15th-century.

(Theodore) fought a powerful British military force of 32,000 men who slogged up and down countless escarpments from the coast, dragging their cannon behind them. Their mission was to free British hostages imprisoned by the Emperor after he felt he had been slighted by Queen Victoria, when she did not answer his letter promptly (in fact, eighteen months later it was delivered). After a fierce battle, British weaponry won the day and, rather than be captured, Theodore committed suicide.

But for those thrilled more by highlands and mountains than ancient history and architecture, northern Ethiopia's Simien Mountain Range, which lies roughly north-west between Lalibela in the south-east and Axum in the north, also offers many magnificent spectacles.

Until roads were constructed in north-western Ethiopia, the Simien Mountains were cut off on the west and north by a single mighty cliff stretching more than sixty kilometres (37 miles). The mountains are also

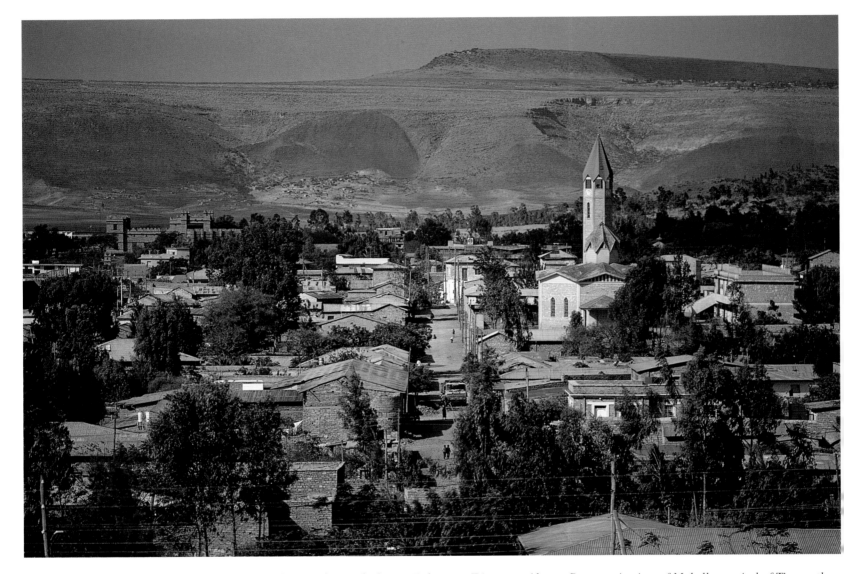

Above: Panoramic view of Mekelle, capital of Tigray, the most northerly region of Ethiopia.

isolated from the north and east by the wide and deep Tekezze River Valley, which skirts round the mountain mass. The river eventually flows into the Blue Nile via the Atbara River. Its valley is believed by some recent researchers to have been the route by which the Jewish Falasha entered Ethiopia, after travelling up the Nile from Egypt, and made their way to the plateau.

In such a land of bare bedrock and few flat stretches, it is strange to find peasants farming the marginally arable soil. In fact, a small offshoot of the large Amhara group from the south penetrated this mountain area in the 16th century, and today their descendants are still farming. But, due to the infertile soil and inefficient cultivation, they have had to move higher and higher up the mountain slopes to produce hardy grains such as oats and barley, with the staple *teff* growing at lower altitudes. This group of devoted adherents of the Christian Orthodox faith have lived for many

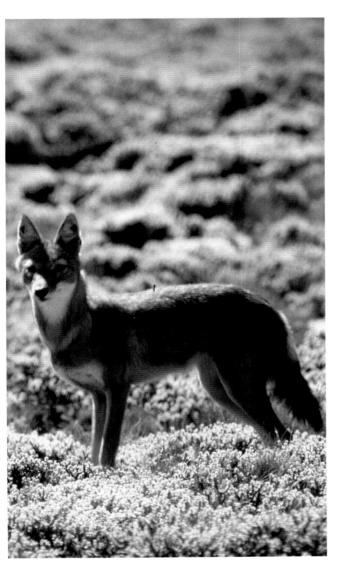

Above: Simien wolf, endemic to Ethiopia, also known as the Simien jackal or Abyssinian wolf, is found in greater numbers in the Bale Mountains than in the Simiens, between 3,000 and 4,500 metres high.

years alongside Muslim farmers, peacefully sharing the same land. They are said to be suspicious of strangers, especially when treated condescendingly, otherwise they are most hospitable when visitors appear friendly. As most Simien Amharas live at high altitudes, barley is their staple food, and not the ubiquitous *teff*. They also make *injera* with barley and eat barley bread and roast barley. Barley is even used for making a mild alcoholic drink resembling thick mud. Generally they eat meat only on holidays, but pork is forbidden to the Amhara there, as it is to their Muslim neighbours. Goats, sheep, eggs and chickens are their main source of protein.

On 'the Roof of Africa' you can see, usually at a distance, three wild animals that exist nowhere else in the world — the crescent-shaped horned Walia ibex (*Capra walie*), Simien wolf (*Simienia simensis*) and a very rare baboon, gelada (*Theropithecus gelada*).

The Simien Mountains and the strange and fascinating world surrounding them have not one Grand Canyon but up to 100 — gorges so deep and steep that it may take as long as two days to surmount them. The deformed landscape originated in bygone days when the Arabian Peninsula was sundered from the African continent in an upheaval on a stupendous scale. The earth's crust was twisted and torn by tremendous pressures. But the cataclysm that produced the Simiens was more recent than those which formed the Alps, the Caucasus and the Himalayas.

Probably the most graphic description of the Simien Range was made by Rosita Forbes. She envisaged the mountain mass as a chessboard in a game being played by the old gods of Ethiopia . . . 'bishops' mitres cut in lapis lazuli, castles with the ruby of approaching sunset on their turrets, an emerald knight where the forest crept up onto the rock, and far away, a king crowned with sapphire and guarded by a row of pawns. . . . In Simien they stand enchanted, till once again the world is pagan and the titans and the earth gods lean down from the monstrous cloud banks to wager a star or two on the sport'.

For mere mortals the Simiens today may be easily reached from Addis Ababa by Ethiopian Airlines' daily flight to Gondar, then by bus or taxi north for 100 kilometres (60 miles) to the village of Debark. A track to the right goes east into the Simien Mountains National Park.

The small park, only 225 square kilometres (86 square miles) in extent, was created not to protect the mountain wilderness that has survived for millennia but its three endangered endemic species. The park starts at about 2,000 metres (6,600 feet) and climbs to more than 4,000 metres (13,200ft), around the range's highest peak — Ras Deshen 4,543 metres (14,538ft). The mountain's name varies from Deshen to Deshan, then

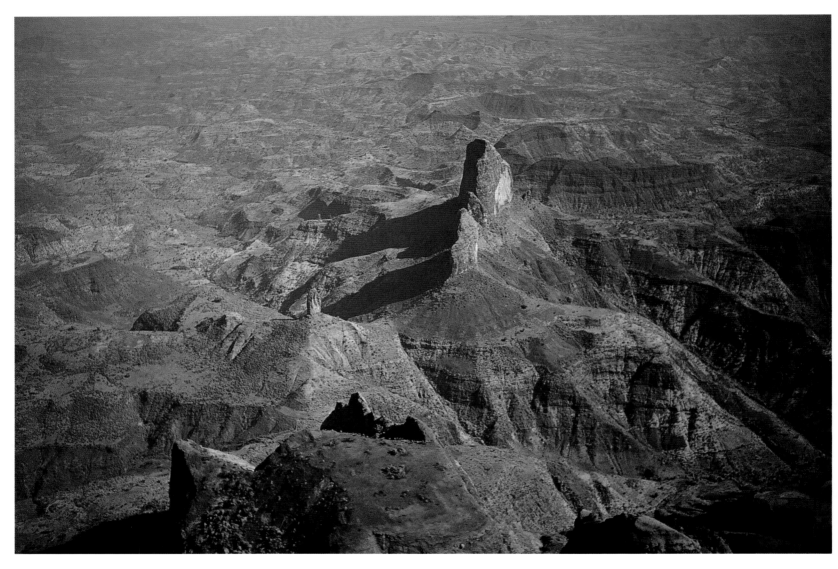

Dashan, Dashen and Dejen. Like Arabic, Ethiopic vowels are extremely variable. Some tourist guide-books claim that Ras Deshen is Africa's fourth-highest peak. But with Tanzania's Mount Kilimanjaro at 5,895 metres (19,340ft), Mount Kenya at 5,199 metres (17,058ft), Mount Stanley at 5,109 metres (16,790ft) in the Ruwenzori —'Mountains of the Moon' — on the Ugandan-Zairean border, and Mount Meru in Tanzania at 4,566 metres (14,990ft), purists argue that the Ethiopian mountain should be considered Africa's fifth highest.

Deshen is not so much a peak as a 'hump' on a high ridge and the climb to the highest point — for those fit enough and able to adjust to the rarefied air — is not difficult. The problem is a 1,525 metre-deep (5,000ft) gorge between the park and the peak. The Simiens are below a permanent snow-line, but the high points are sometimes scattered with snow. Mules are the only alternative to slogging it on foot in the Simiens. Mules,

Above: Jagged pinnacles in the Simien mountain complex.

Above: The globe thistle is part of the high-altitude flora found in the Simiens and Bale.

muleteers and guides can be hired at Debark. As the national park lies within the Afro-alpine zone, daytime temperatures vary between 11.5°C and 18°C (53°F-64°F), but at night it frequently falls below freezing point. The rainfall averages 1,550 millimetres (60 inches) a year. The flora of the Afro-Alpine ecosystem is similar to that of the high East African mountains — giant lobelia rising to ten metres (32ft) or more, groundsel and heather the size of trees draped with strands of lichen or Spanish moss.

There is no similarity to Kilimanjaro and Mount Kenya, however, in the fauna. The goat-like Walia ibex only exists amid the Simien crags, usually grazing on rocky ledges, inaccessible to man or other beast. It weighs about 120 kilos (240lbs) and its unique curved and ridged horns measure almost one metre (39 inches) long. Its thick chocolate-brown coat enables it to endure the freezing temperatures at this altitude. All mature males have a pronounced 'billy-goat' beard on the chin. In the 1990s Ethiopia's Walia ibex numbered no more than about 150, making it not only the rarest animal in the country but one of the rarest in the world. Its cousin, the Nubian ibex (*Capra nubiana*), lives in the same rocky habitat.

It is found not only in Ethiopia, but also in neighbouring Eritrea, the Sudan and the Arabian Peninsula as far north as the Sinai. The Nubian is less sturdy than the Walia and has slimmer legs and horns, although the latter are longer on the Nubian species. Also at home on the same rocky ridges is the dainty klipspringer (stone-jumper) antelope, usually moving around in pairs or in groups of three to four.

A journey on foot from Debark through the Simien Mountains Park and up Ras Deshen takes several days. Although the altitude is not extremely taxing to the body, breathing can be difficult because the chill air is thin, especially during the final scramble to the summit.

Birds are not plentiful since the environment is so inhospitable, but those with large wingspans seem to be in their element, soaring and swooping above the cliffs, as the thermals control their path. The rare lammergeier ('bone-smasher') vulture has probably the greatest wing-span: three metres (9ft-6in). The vultures are said to drop the bones they pick from a carcass onto rocks from a great height — the purpose being to pick out the marrow from the smashed bones. Other birds of prey soaring above the Simiens include augur buzzard, Verreaux's eagle, kestrel and Lanner falcon.

Although the red-hued Simien wolf may be found there, they are more plentiful to the south, in the Bale Mountain complex. They bear a resemblance to the European fox but are larger and have longer legs. They live in the high moorlands between 3,000 and 4,000 metres (9,800ft–12,000ft) and prey chiefly on big rodents, such as the giant mole rat. Baboons exist

Opposite: Small alpine plants take strange but beautiful form as Afro-Alpine giants in the Simien Mountains, their growth charged by the ultraviolet rays of the high-altitude moorlands.

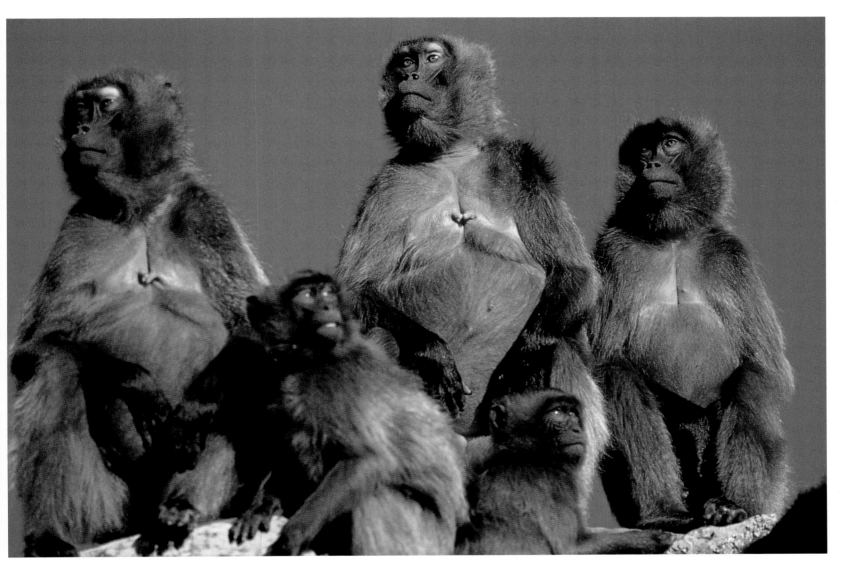

Above: Troop of Gelada baboons in the Simien Mountains. Found only in Ethiopia's high country, their 'sacred heart' — a patch of bare skin on the chest — distinguishes them from any other species of baboon.

in troops all over Africa, but one species is found only in Ethiopia: the gelada of the Simien Mountains and other high, rocky areas to the north and west of the Great Rift Valley. They have a much more striking appearance than the common hamadryas or annubis variety and are easily distinguished by a long mantle of thick, silky hair, a rich chestnut colour, almost like a lion's mane at first glance. The gelada is also known as 'the sacred heart' because of a naked patch of red or pink skin on the chest. Some zoologists say the colour deepens when the baboon is on heat.

Geladas are mostly found on rocky hilltops and escarpments at an altitude of 2,500 metres (8,000ft), often in troops of several hundred. An unusual troop, away from mountaintops, is to be found near the grounds of the Debre Libanos Monastery, only 100 kilometres (60 miles) north of Addis Ababa.

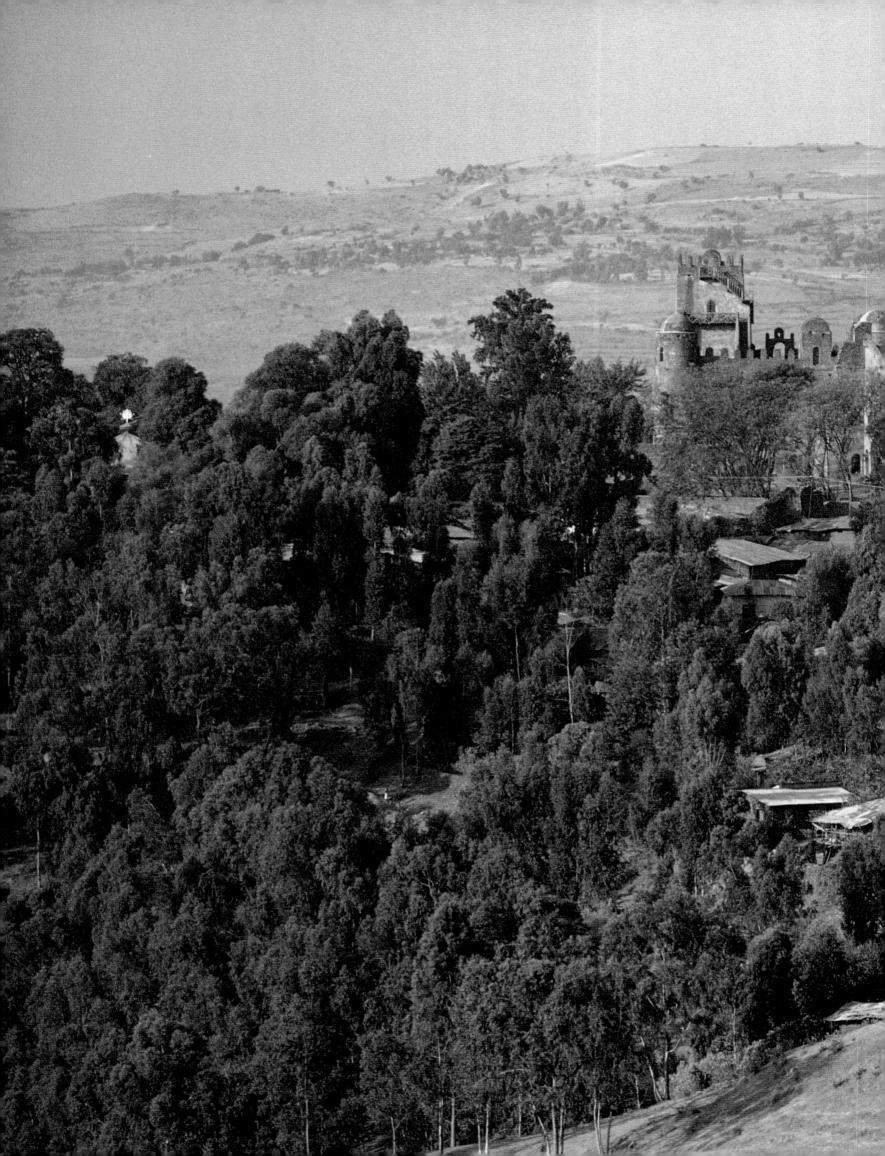

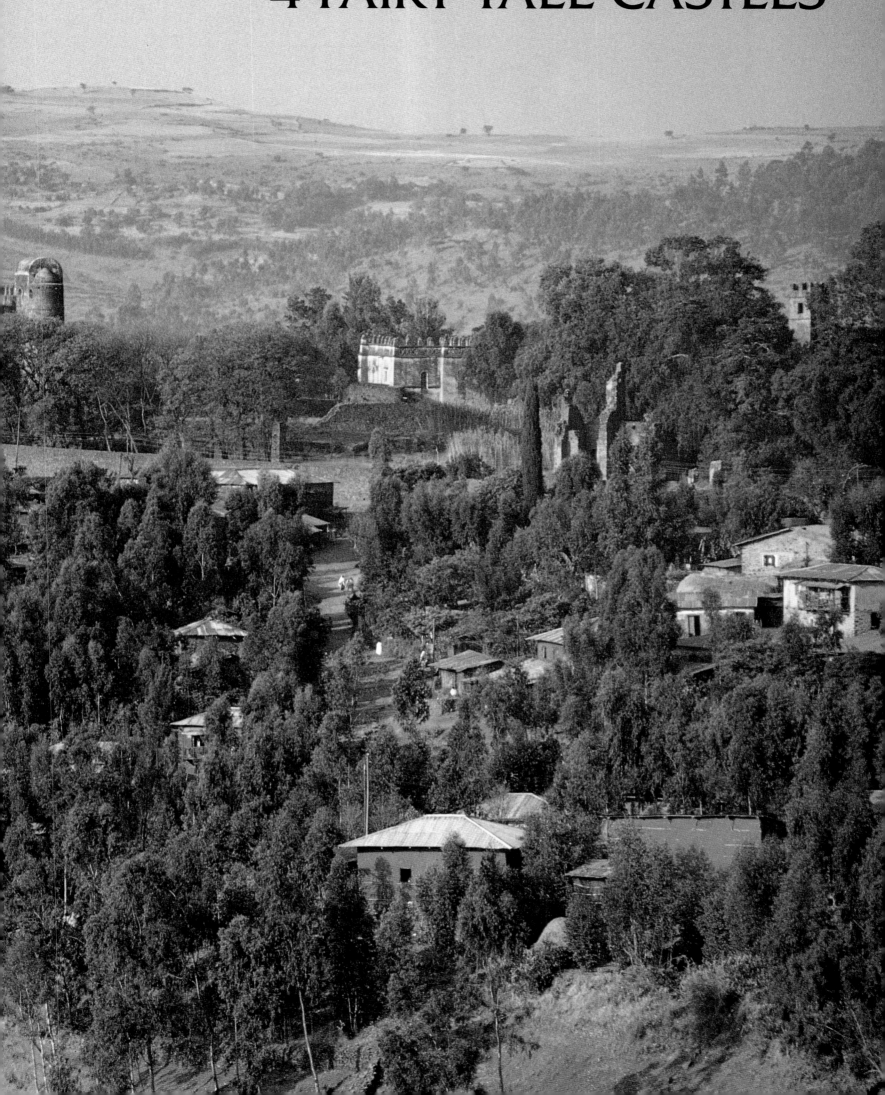

Previous pages: Magnificent ancient citadels dominate the skyline of the 17th-century capital of Ethiopia, Gondar.

South-west of the Simien Mountains lie Lake Tana and Gondar, yet another in a long string of one-time Ethiopian capitals, a town of fairy-tale castles, not quite Disney-style but, nevertheless, dream-like. Just as King Lalibela chose to build a cluster of stone churches, King Fasilidas — Fasil for short — set about erecting crenneisted castles during his reign of thirty-five years from 1632 to 1667, at the beginning of the Gondar Dynasty. His descendants carried on his work later.

Among the significant events that took place between King Lalibela's rule and that of King Fasilidas was the arrival of the first Roman Catholic priests, from Portugal and Spain, and the launching of a new campaign against Ethiopian Christians, this time by a Muslim army led by General Ahmed ibn Ibrahim, nicknamed 'the left-handed'— Gragn.

The systematic carnage, rapine and destruction which Gragn inflicted on Christian communities far outdid the damage Queen Yodit wrought before him. From his Harar base, in about 1525, Gragn set out to destroy every vestige of Christianity to the north and west of the predominantly Muslim city. His large army, composed of Somalis, Turks and other Muslim troops, ranged far and wide, especially in Shewa, the Lake Tana area and Axum.

The campaign began in the reign of King Lebna Dengel and, when the situation became serious, appeals were sent to India for Portuguese soldiers to come to the aid of the Ethiopian Christians. The Portuguese arrived under the command of Dom Cristovaõ da Gama, son of the famous Vasco da Gama, and after many major battles Ahmed Gragn was killed near the shores of Lake Tana. Soon after the Muslim army dispersed. With the danger of further destruction and death seemingly gone the priesthood of the Ethiopian Orthodox Church set about repairing the great damage and building new churches. But peace was still some distance away. By this time King Lebna Dengel was dead and had been succeeded by his son, Emperor Gelawdewos, while in Harar Gragn's widow was still trying to regroup her husband's scattered army, helped by Gragn's nephew, now the Emir of Harar. Determined to end the Muslim threat once and for all, and against the advice of his courtiers, Gelawdewos, went into battle against the emir, saying he wanted to celebrate Easter in heaven. In the thick of the fighting he was shot and fell. To avenge his uncle's death and fulfil a promise made earlier in Harar, the victorious emir cut off his head and took it to Harar for public display. The promise was made to Gragn's widow, who had already married the emir.

In the Gondar area, where the castles were yet to be built, a new crisis developed within the Christian community, threatening to bring about a

Opposite: A cataclysmic upheaval formed the maze of crags and gorges in the Simien Mountains in the north-west corner of Ethiopia, between Axum and Gondar.

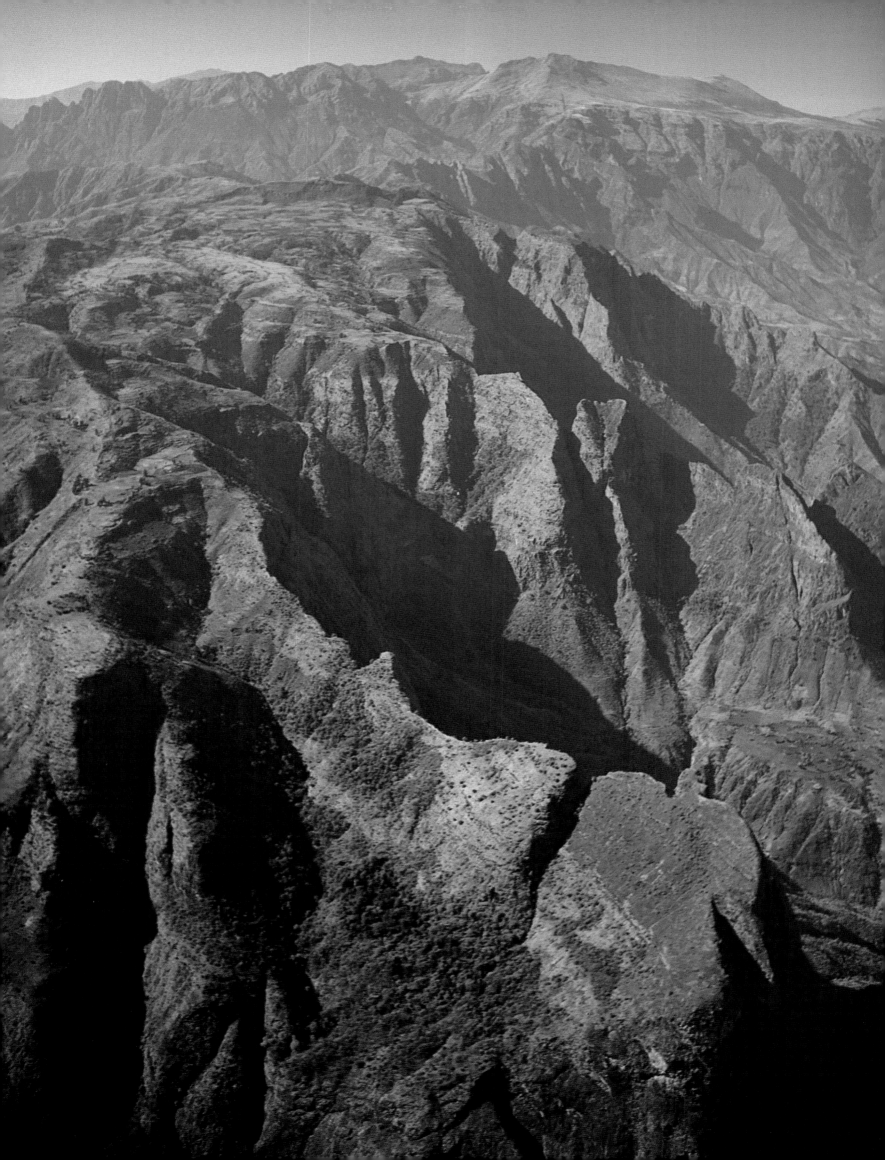

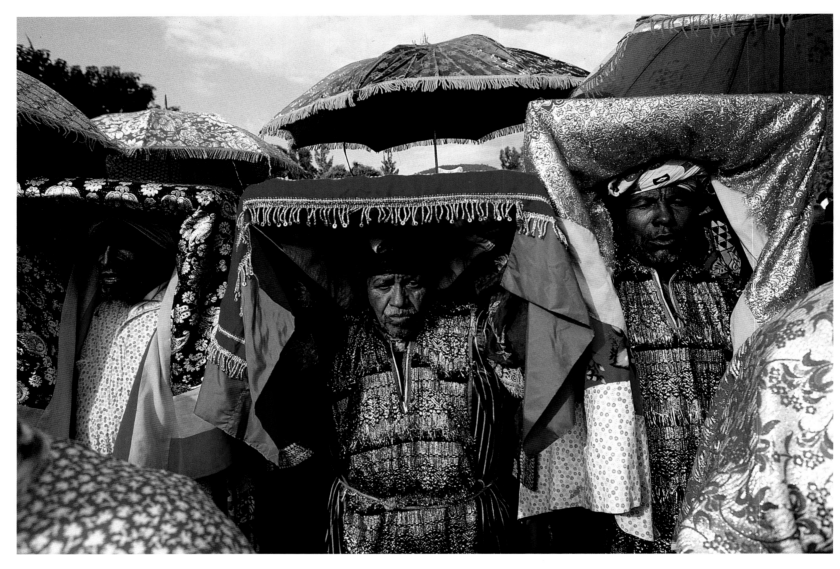

civil war. This stemmed from the activities of the Catholic Portuguese and Spanish clergy, who were now present in large numbers and had succeeded in converting the then Emperor, Susneyos, to the Catholic faith.

Susneyos became fanatical and ordered many Orthodox Christians to join him as Catholics. This led to several rebellions and in 1632 the emperor was forced to abdicate and hand over the throne to his son, Fasilidas, who reversed his father's policy. Later he expelled the Jesuits from Ethiopia altogether, restoring the Orthodox Church to supremacy.

The first castle which Fasilidas built was by far the largest and stands today looking almost new. It has four domed towers at each corner, with a high central tower overlooking the town, from which an orator used to proclaim the king's words to the public. In those days Ethiopian rulers seldom appeared in public. Within the royal compound in Gondar Fasil's

Above: Orthodox celebrants don bright ceremonial garb for the Timkat (Epiphany) festival at Gondar, the most important event in the church calendar.

Opposite: Ecclesiastical accroutrements brought out for the Timkat (Epiphany) festival.

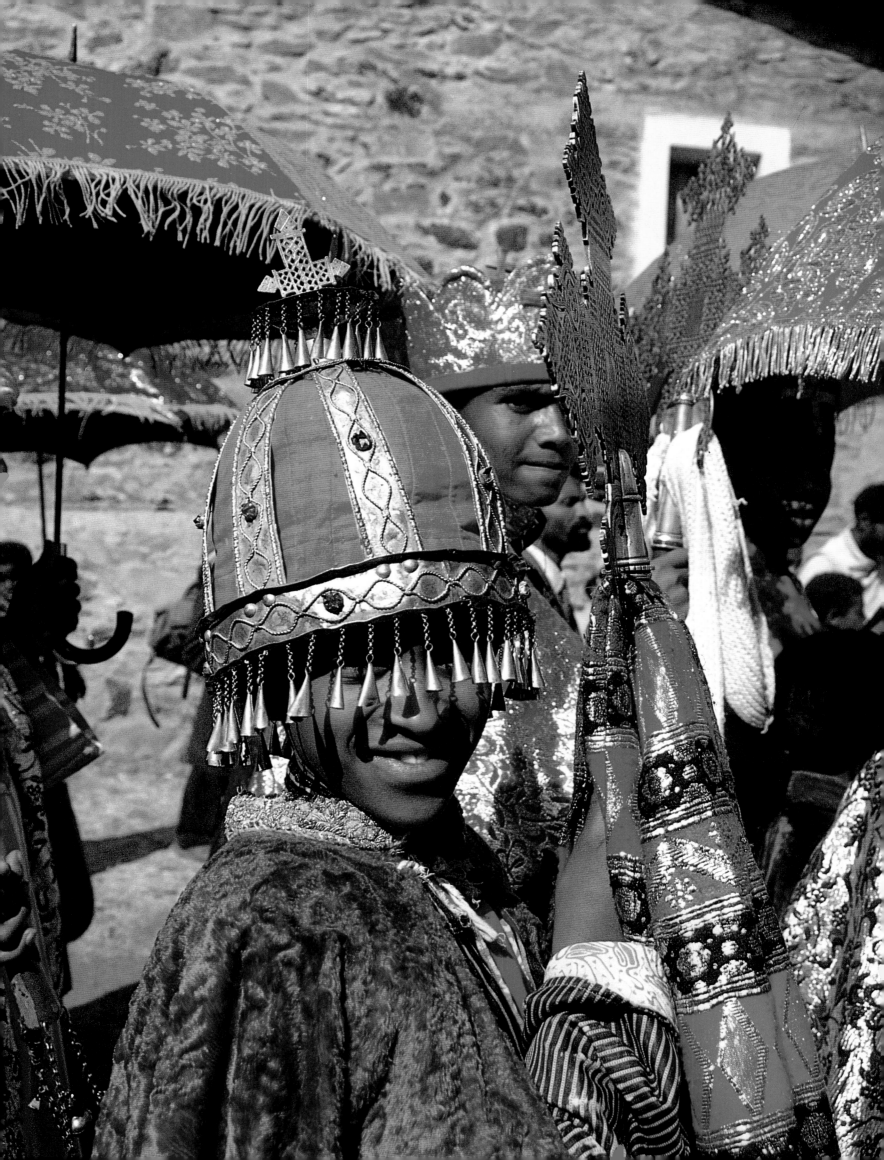

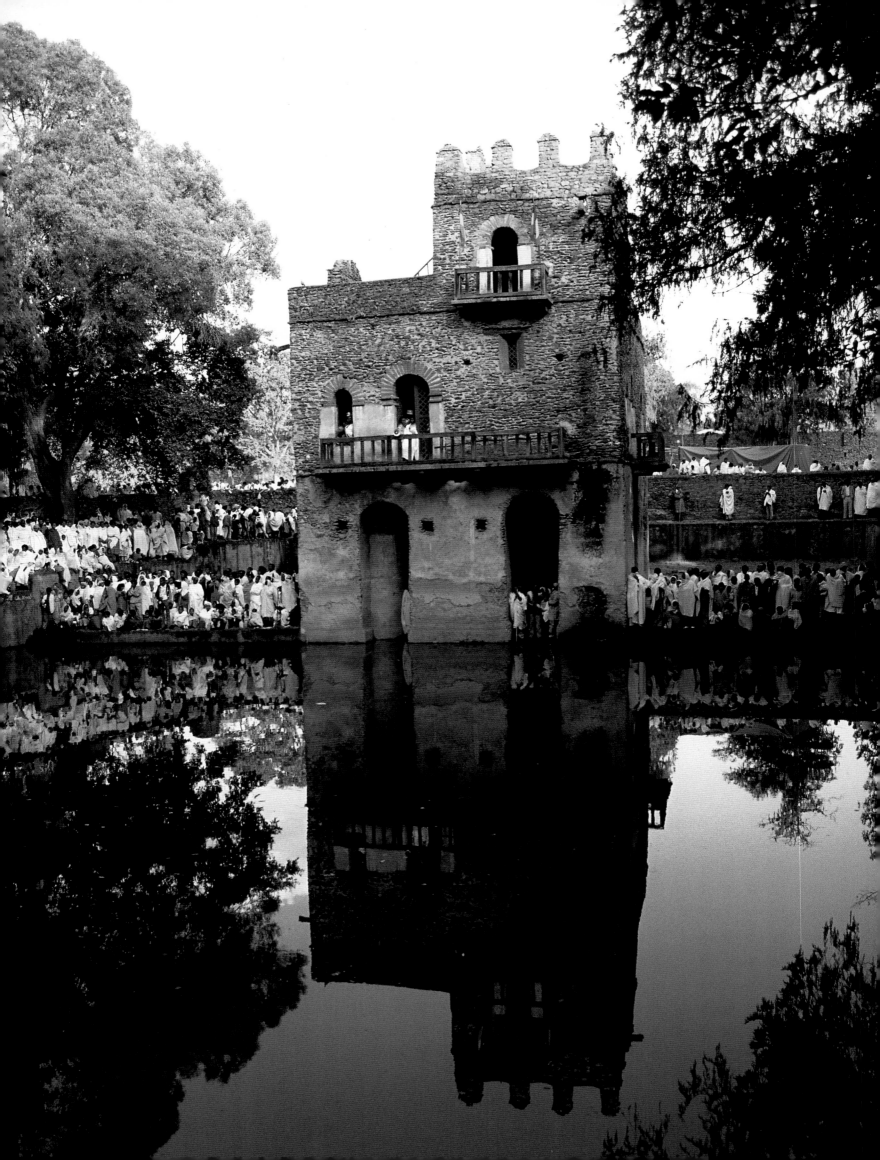

Opposite: Celebrants at the Timkat festival in Gondar line up by Emperor Fasilidas's 'Bath' alongside one of his castles.

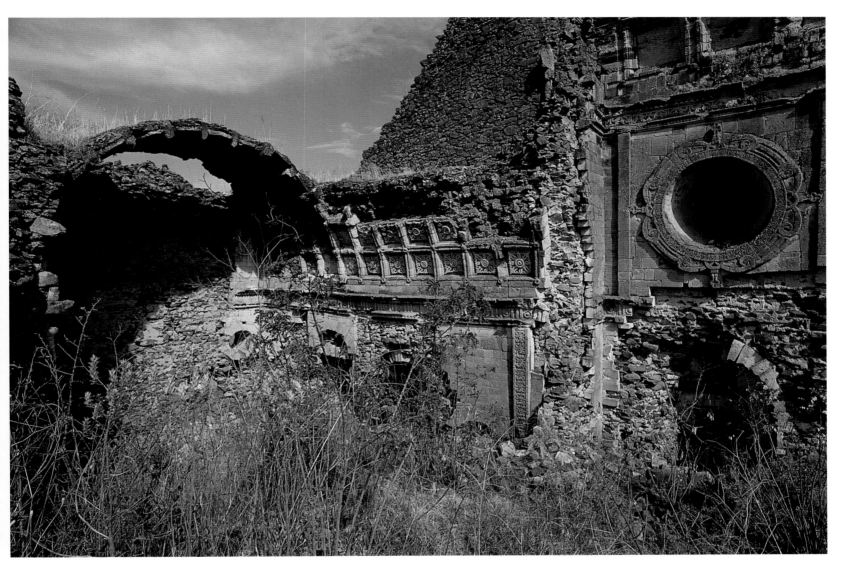

Above: Ruined castle built at Lake Tana by Emperor Susneyos. The arch is all that is left of the bridge over the castle moat.

successors built more castles. Surprisingly, these have not withstood the rigours of time as well as Fasilidas's own first castle. A smaller castle close to the original was bombed as recently as 1941, when the Italians who occupied Gondar used it as a military operations centre. The raid by a British RAF bomber came as Allied troops, together with the Ethiopian Patriot guerrillas, advanced on the town.

One of several Westerners who visited Gondar's picturesque castles in the 18th century was James Bruce who had just solved a mystery, or at least half of a mystery — the source of the River Nile. This conundrum had fascinated the outside world for many centuries. Even in biblical times Roman legions had been sent south from Egypt to find the Nile's origin but never returned. Bruce was convinced that the Blue Nile — or Abbay — was the main source of the Nile and showed no interest in the longer White Nile, although geographers already knew both existed. In

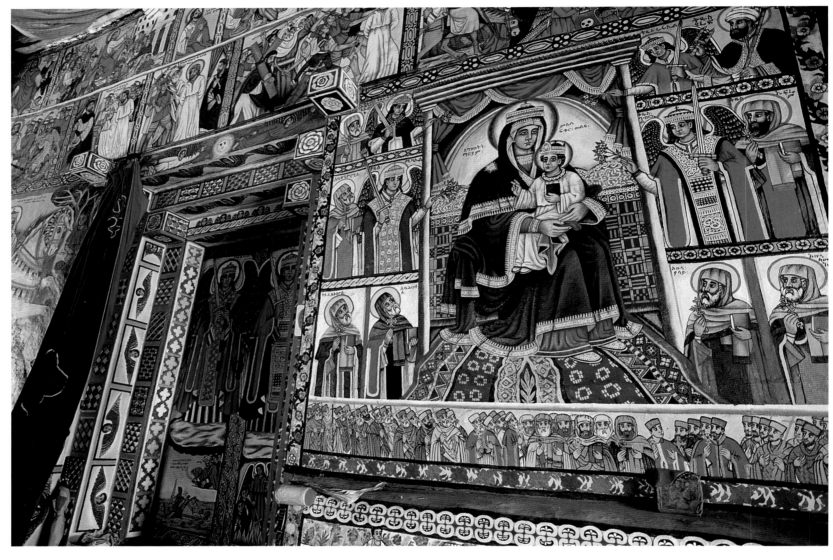

Above: Riot of ecclesiastical art adorns the interior of Amde Tsion monastery on Mandaba Peninsula, Lake Tana.

1770, after a roundabout journey from Cairo, Bruce finally reached Lake Tana to see where the Blue Nile begins its 1,450-kilometre (900-mile) journey to the Mediterranean. But he was not the first Westerner to make the arduous journey to Ethiopia's largest lake. One-and-a-half centuries before him, Father Pedro Paez had been to Lake Tana and visited Tissisat Falls, which are spectacular during the rainy season.

Lake Tana, 2,000 metres (6,000ft) above sea-level and extending over 3,600 square metres (1,860 square miles) is of immense historical interest. Of its thirty-three islands, large and small, some twenty have churches or monasteries which date back for centuries. Most of the well-preserved murals and other pieces of religious art they contain may be viewed during a voyage by motor launch from Bahar Dar, or from Gorgora on the lake's northern shore. Legend has it that the Ark of the Covenant was kept at one of the island monasteries on Lake Tana before it was returned to

Opposite: Ruins of a castle built at Lake Tana by Emperor Susneyos, father of Fasilidas and founder of the House of Gondar.

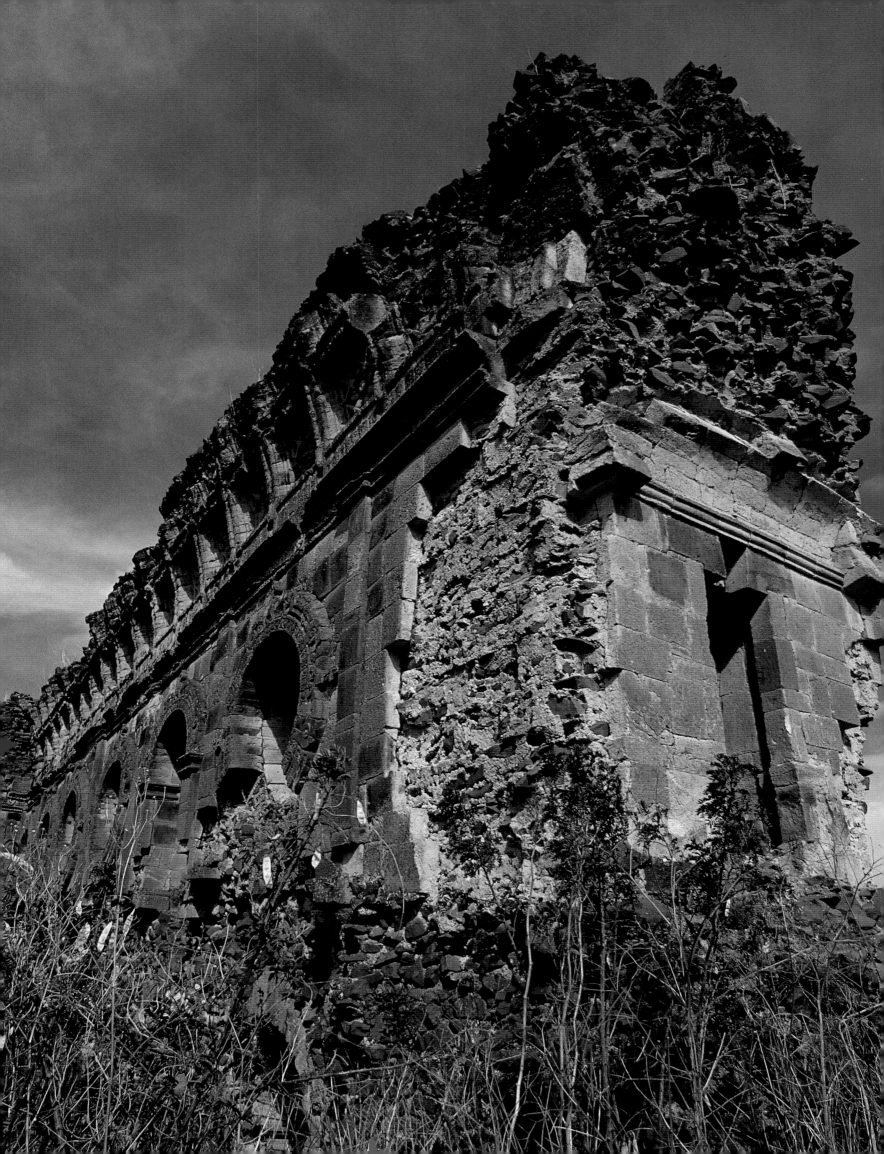

Axum. After plunging over the Tissisat Falls, the infant Blue Nile takes a huge sweep through a one-and-a-half-kilometre-deep (one mile) gorge for almost 700 kilometres (450 miles) until it reaches the flat plains and the Sudanese border. Most of the gorge has walls so steep that no one can descend to the humid, malarial banks of the river, except where tributaries enter. On a clear day, the course of the river is shown by a line of clouds caused by moisture from the roaring torrent.

Although the longer White Nile is fairly consistent in volume throughout the year, the Blue Nile swells rapidly after the rains fall in the Ethiopian highlands, which form a vast catchment area. Where the two join at Khartoum, measurements show that annually the Blue Nile provides six-sevenths of the total volume of water which reaches Egypt to empty into the Mediterranean. As for the colour, the Blue Nile water looks blue only in the dry season; at other times it is a deep chocolate colour due to the

Above: Seventeenth-century stone bridge reputedly built by the Portuguese is still in use on the track to the Blue Nile Falls at Tissisat.

huge amount of silt it skims from Ethiopia's precious topsoil. The White Nile is more of a greyish white as it does not carry so much silt. The contrast is best seen from the air just south of Khartoum where the two rivers meet.

At one point, the road from Gondar to Addis Ababa plunges down into the Nile gorge to cross a modern bridge and then climbs, in a series of dizzying hairpin bends, the southern wall of the gorge. From there the view of this stupendous natural wonder — like so much in Ethiopia — is one that remains forever printed on the mind.

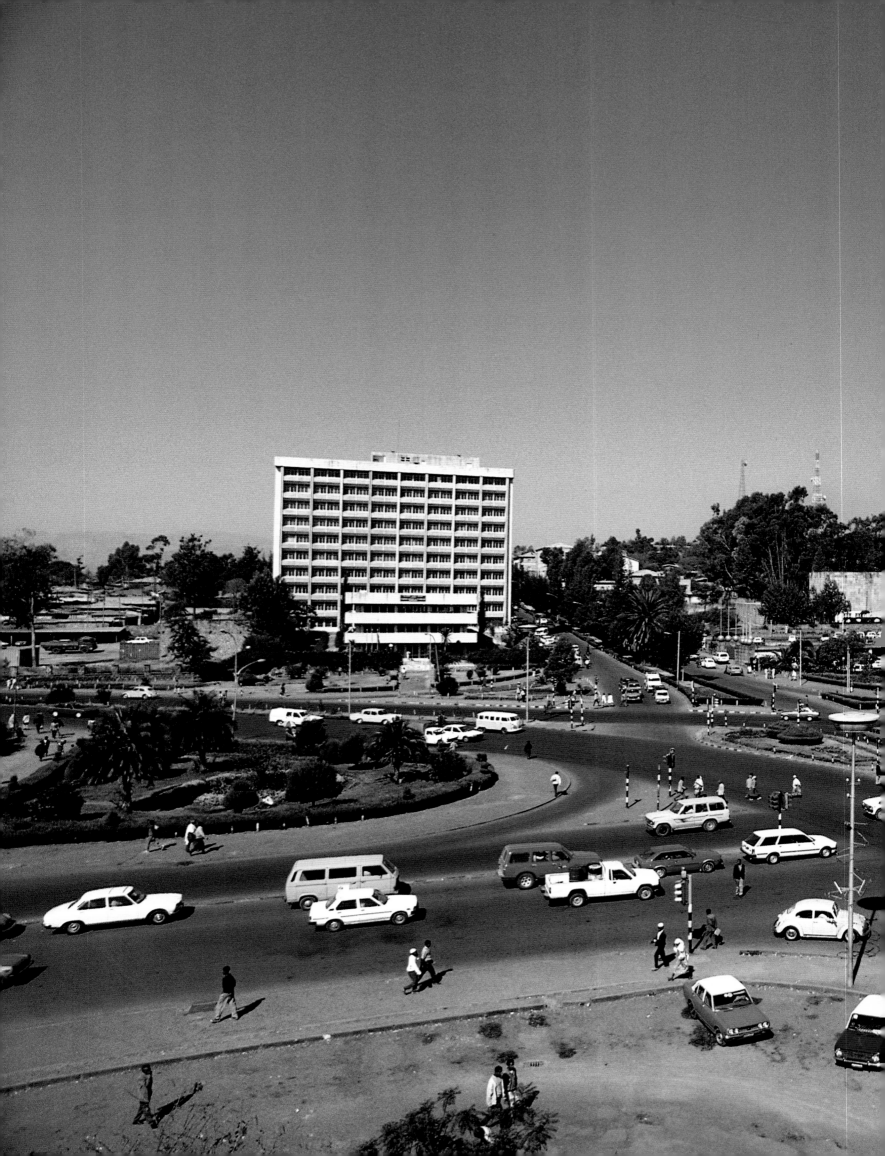

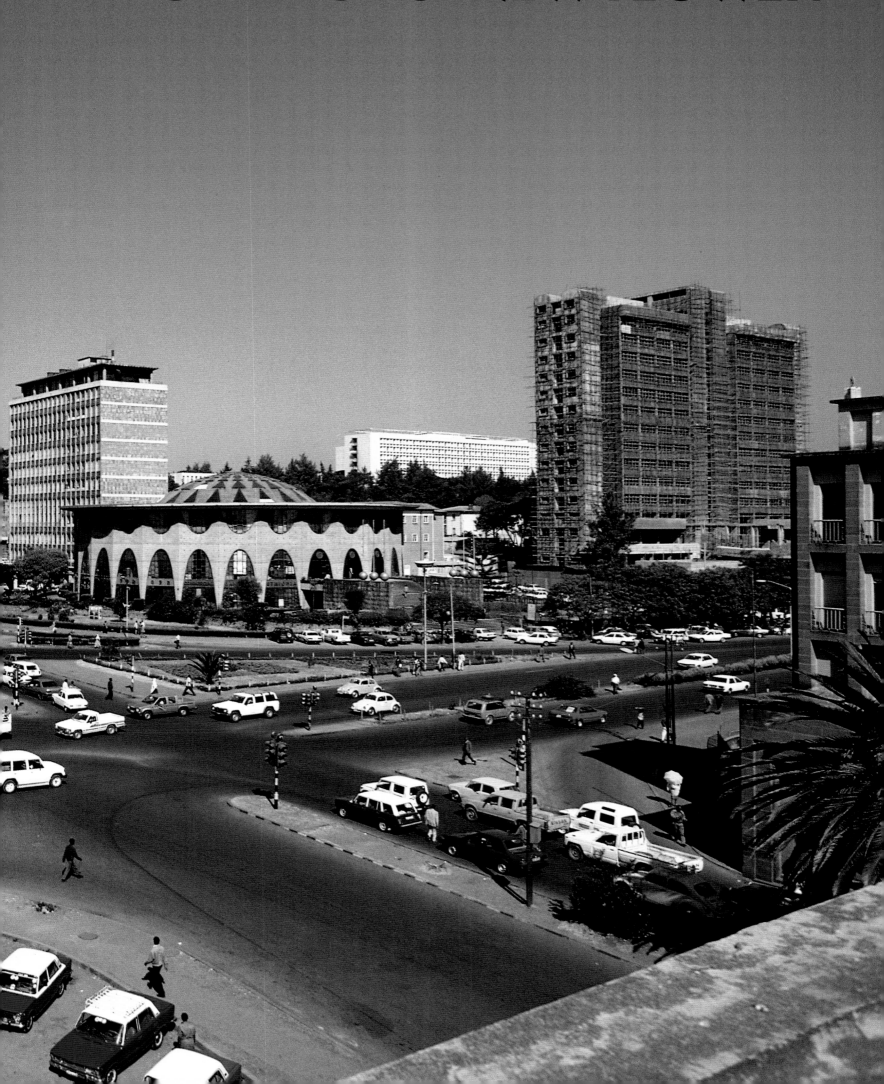

Previous pages: The circular Commercial Bank of Ethiopia building dominates this busy intersection in the centre of Addis Ababa.

No one knows exactly when Addis Ababa was founded because Emperor Menelik II could not make up his mind about the exact location for many years, but it can be dated either to 1886 or 1887.

What is certain is that in 1878 the emperor decided to move the capital south from Ankober, which stood on the edge of the central plateau. First of all he set up a tented camp on Mount Wuchacha, where the slopes were thickly forested with juniper and *podocarpus* trees. Its strategic location, west of where Addis Ababa now stands, proved an ideal defensive site.

However, three years later some 16th-century ruins were found in the nearby Entoto Mountains, which were thought to have been where an earlier capital stood. Menelik told his courtiers that it was only right that he should build his new capital on that site.

But after moving his camp and the accompanying army to Entoto, he found the site had drawbacks. Although it was ideal for defence, on a high ridge, over 3,000 metres (9,800ft) above sea level, all the wood for building and heating had to be hauled up from the forests in the foothills. Worst of all, the exposed ridge was constantly buffeted by high winds and heavy rains, while thunderstorms and hailstorms made life intolerable in the wet season.

When Menelik was satisfied that the surrounding countryside was peaceful, and with no enemy threat, he thought it better to choose a site lower down in the foothills where the climate was more equable and the land ideal for food crops.

What most attracted his consort, Queen Taytu, were the hot springs on the lower south-facing slopes at a place called Filwoha (Amharic for 'boiling water'), where she and many companions paid frequent visits to enjoy the hot, gushing mineral waters. Soon the royal court was staying at Filwoha for weeks on end. Menelik gave his wife some ground on which to build a palace, while he divided his time between the two places.

Eventually, in 1891, Menelik decided to abandon the top site to settle down in the foothills at the location his empress had already named Addis Ababa, the 'New Flower'. Even then her husband had his doubts because the surrounding area was being stripped of trees as more and more buildings went up and construction and fuel timber became scarce.

The emperor, recalling the thick forests he had known to the west of Addis Ababa, toyed with the idea of developing the area and for two years, between 1900 and 1902, stayed at a place which the empress dubbed Addis Alem, 'New World'. He had visions of creating it as 'the Axum of the south' and ordered a palace to be built at Addis Alem. Back in Addis Ababa, meanwhile, the mud-built houses were being replaced by more substantial stone dwellings for private use. By then the Addis Ababa

Above: Monument in Addis Ababa which marks the victory over the Italian occupiers.

Opposite: Churchill Avenue, the capital's most impressive thoroughfare, stretches from the Railway Station up to City Hall.

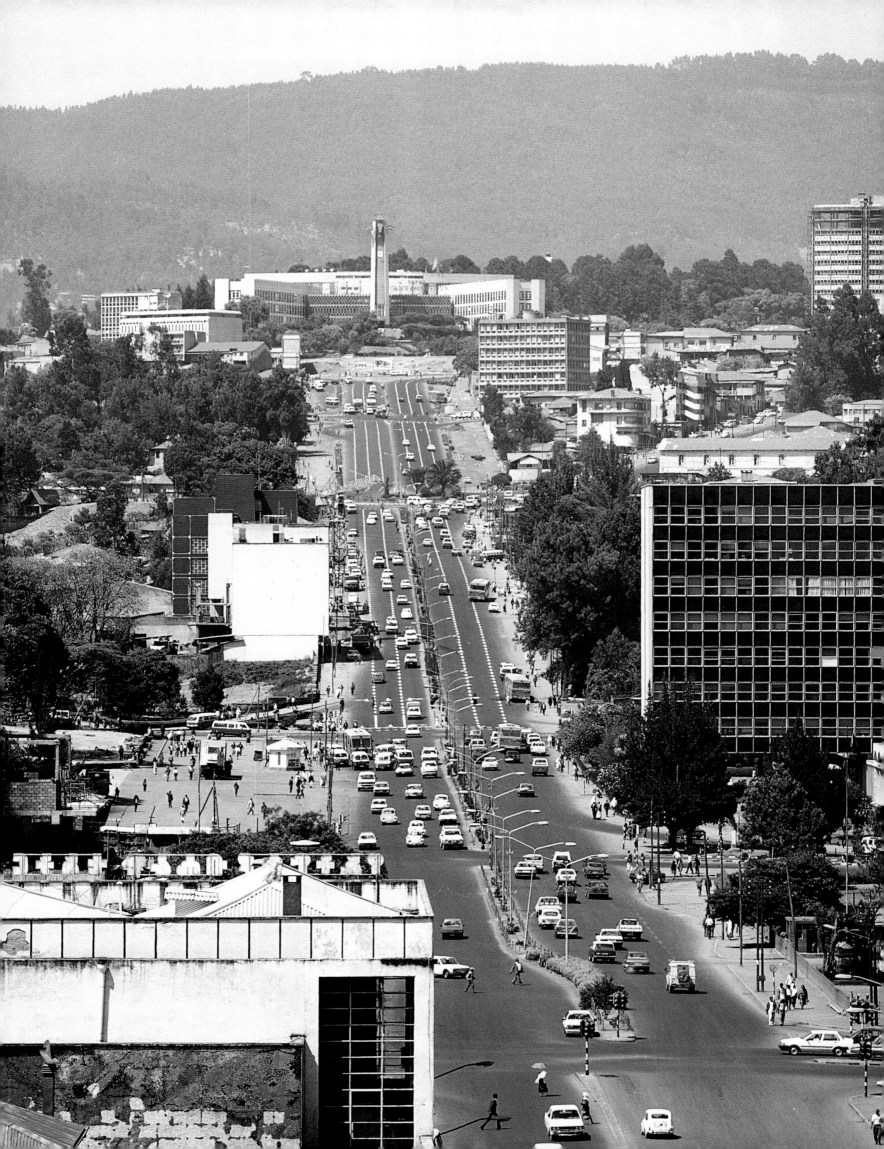

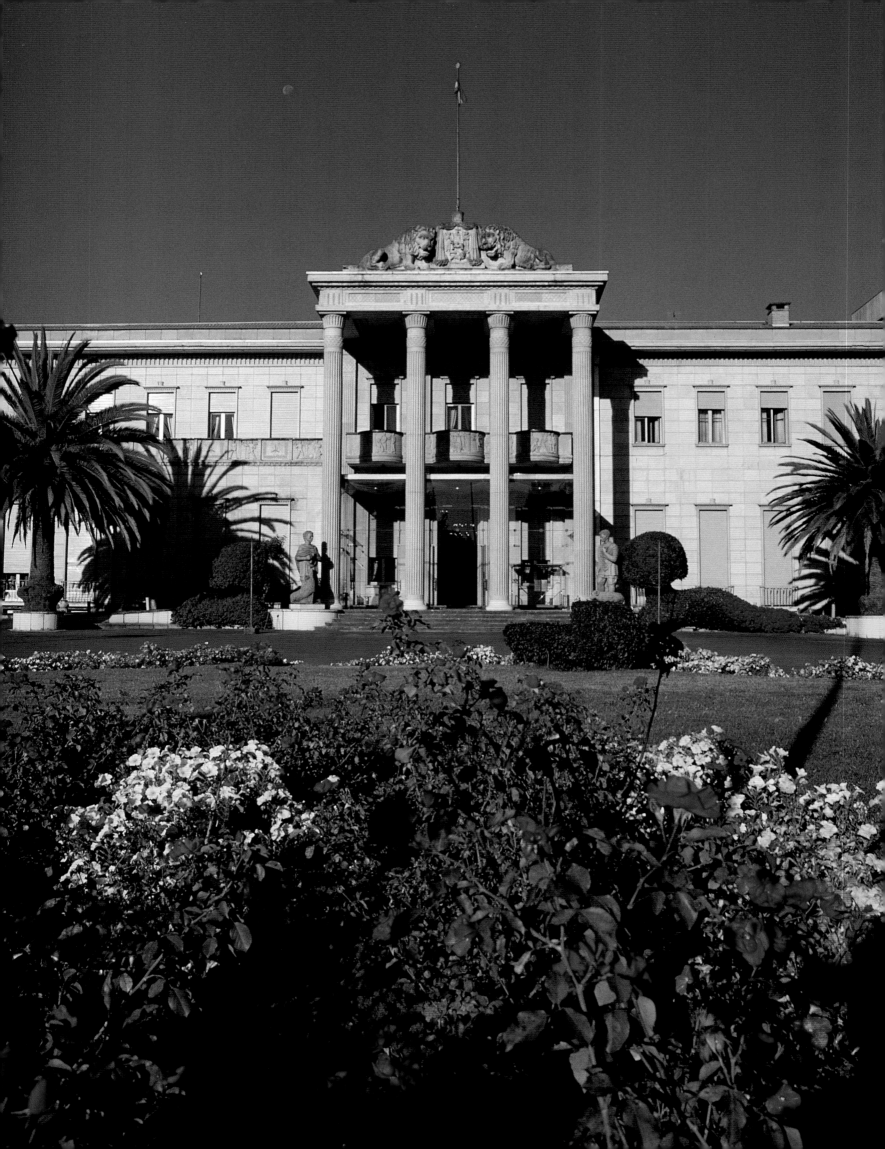

Opposite: Modern palace used by the late Emperor Haile Selassie.

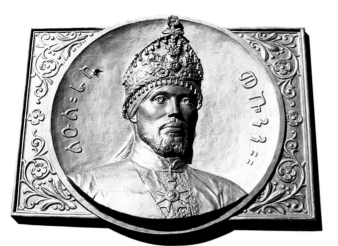

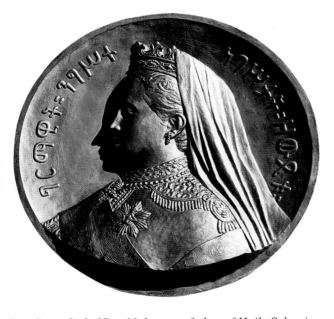

Top: Bas relief of Ras Makonnen, father of Haile Selassie, on the Lion of Judah Monument near Addis Ababa Railway Station.

Above: Plaque of the late Empress Zawditu, daughter of Menelik, on the same Lion Monument.

firewood problem had eased, following the importation of fast-growing eucalyptus trees from Australia given the name *bahr zaf*, Amharic for 'tree from beyond the sea'. Soon they spread throughout the surrounding countryside. They were so much more numerous than indigenous Ethiopian trees in the vicinity that one foreigner dubbed the city 'eucalyptopolis'. So, in 1902, Menelik returned to Addis Ababa, having decided to turn the palace at Addis Alem into a church which he named Saint Mary of Zion, after the eponymous Axum church.

A magnificent royal palace on a prominent site overlooking the fast expanding capital soon took shape. Its three-gabled reception hall was so large it could accommodate 5,000 dinner guests at one sitting. One of the last occasions it was used was when French President Charles de Gaulle paid a state visit to Ethiopia and Emperor Haile Selassie arranged a lavish banquet. Hundreds of guests were served a succession of dishes by scores of waiters as they were entertained in the huge hall by traditional dancers from every province. A spectacular fireworks display ended the reception.

The old palace, now referred to as Menelik's Palace, used to have a whole pride of caged lions in the grounds. In Haile Selassie's days a tame one enjoyed being patted by visitors who found it roaming around quite freely.

With Menelik's drive and energy in the early 1900s, Addis Ababa continued to expand. Although little attention was paid to town planning many innovations took place even within the new palace grounds which extended for two kilometres and were one-and-a-half kilometres wide. Among the new ventures the compound accommodated were a currency mint, a printing press, a modern clinic and a school. Some small workshops produced jewellery and other items.

Even before 1900 the emperor had formed an internal service using horses, mules and camels to carry special mail to other towns and a foreign postal service began in 1902 when Ethiopia became a member of the Universal Postal Union. Ethiopia's first set of postage stamps, printed in Paris, went on sale in Harar in 1895.

Many of the ideas for modernizing services came from a Swiss engineer, Alfred Ilg. It was at his urging that the railway·from Djibouti was built and a telegraph and telephone service started. The first motor cars were imported in 1902, one from Germany and another from Britain, followed by a steam roller for building roads.

Although the metre-gauge railway reached Dire Dawa in 1902, it was only in 1917, four years after Menelik's death, that it finally arrived in Addis Ababa. Menelik had already made use of Addis Ababa's central location to send out roads connecting with major towns, such as Jimma,

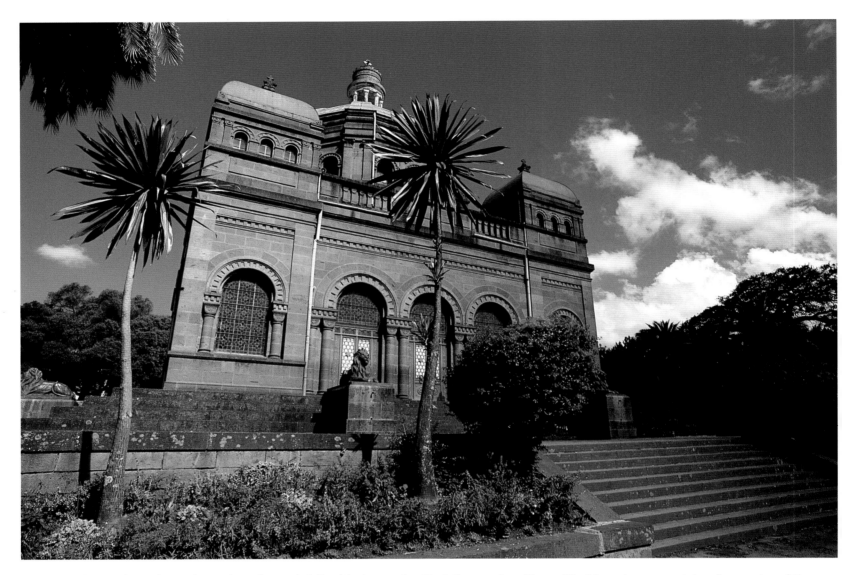

Harar and Gondar. The railway line from Addis Ababa to the Red Sea and the outside world was the final communication link he had longed for.

Above: The Mausoleum containing the remains of Emperor Menelik II.

When Menelik died in 1913 his grandson, Lij Iyasu, took the throne but was never crowned. After a rebellion which broke out three years later, Iyasu fled into the lowlands, pursued by troops loyal to the young Ras Tafari (later Haile Selassie) and was taken prisoner. In 1916 Menelik's daughter, Zauditu, became empress and ruled until 1930 when Haile Selassie ascended the throne.

Although the Empress did not continue Menelik's modernizing process, Addis Ababa grew steadily, especially after the boost given by the new railway link to Djibouti. Emperor Haile Selassie, however, took over from Zauditu only five years before Ethiopia was crushed by Mussolini's invasion. Italian forces captured Addis Ababa in May 1936 and immediately set about removing all reminders of the monarchy and the long Solomonic

Above: Tomb of Emperor Menelik II in Addis Ababa.

dynasty. When the Italians pulled down the imposing statue of Menelik II on horseback which had only recently been erected by Haile Selassie the capital's citizens were dismayed. On Mussolini's orders they also removed and took to Rome the statue of the Lion of Judah, as well as the Axum obelisk.

The Italian Army also instituted a reign of terror against Orthodox Church dignitaries. One missionary during that grim period was later to write in *Fire on the Mountains* : 'Then the local chiefs began to report the continued growth of the Christians' resistance to the authorities. As a result they sent police to investigate and to arrest their leaders. When they found that the Christians prayed for His Majesty (Haile Selassie) they were exceedingly angry and tore down the churches. They also tried to destroy Bibles and Scripture portions.

'Some of the believers who had Amharic Bibles or Scripture portions put them in clay pots and buried them in the ground. Others wrapped them in wild banana leaves and hid them in the grass roofs of their houses. . . . The persecution became so severe that Christians began holding communion and baptismal services at night.'

The departure of the would-be colonizers did not, however, see the end of religious persecution in Ethiopia. It returned in 1974 when the military uprising which raised Mengistu to dictator deposed Emperor Haile Selassie after forty-four years on the Lion of Judah throne. A year later the emperor was killed in mysterious circumstances. A statue in the Trinity Church compound marks the communal grave where sixty ministers of the emperor's cabinet were killed by Mengistu's military junta or Dergue. The compound is also the burial place of many Patriots who actively resisted the Italians during the five-year occupation. Among them was Ras Imru, one of Ethiopia's top commanders in the 1935-6 War. One of the squares in the capital is called *Abuna* Petros, after a bishop of the Orthodox Church of that period. The Italians captured him while he was accompanying a group of Patriots attacking Addis Ababa. After a summary trial *Abuna* Petros was shot on the spot where he had been captured.

Elsewhere in Addis Ababa there is a monument which recalls the brutal 1937 massacre of many civilians by the Italians and an obelisk that marks the 1941 liberation.

The rebellion, which brought Mengistu Haile Mariam and the Provisional Military Council, the Dergue, to power, saw the abolition of the special status which the Orthodox Church enjoyed. The church lost all the land which had been provided by the previous government, although no Orthodox churches were closed. After being closed by Mengistu in 1974, the College of Theology of the Ethiopian Orthodox Church was formally

reopened in October, 1994, at a ceremony attended by *Abuna* Paulos, the Patriarch of the Orthodox Church.

The two largest Protestant churches in Ethiopia are the *Mekane* Jesus, an offshoot of the Lutheran evangelical movement, and *Kale Heywot* ('Word of Life'), linked to the old Sudan Interior Mission (SIM), now rebaptized as the Society of International Missionaries.

The main setback for the Protestant evangelical movement came in May, 1977, when Mengistu's army shut down the powerful Radio Voice of the Gospel, which had been spreading the Lutheran message throughout Africa from its Addis Ababa transmitter. It was then commandeered by the Dergue to augment its own ideological campaign. The station resumed transmission after Mengistu's regime collapsed.

Foreign visitors are often surprised to find so many of Addis Ababa's main streets bearing European and other foreign names. These were chosen by the emperor to show his gratitude to the world leaders, soldiers and countries which helped Ethiopia to expel the Italian fascist rulers and put him back on the imperial throne.

Thus Britain's wartime leader, Winston Churchill, has pride of place in the imposing avenue named after him, perhaps the best example of latter-day town-planning in the capital. The wide thoroughfare stretches about two-and-a-half kilometres (one-and-a-half miles) up a steep incline from the Addis Ababa railway terminal to the modern City Hall. The municipal building, coincidentally, was opened in 1965 by Britain's Queen Elizabeth, who also has a street bearing her name.

Addis Ababa's Railway Station, dating back to 1929, houses the late Haile Selassie's Imperial Train which consists of four coaches. Two, based on the American style, were built by Franco-Belgique in 1930, while the other two, based on the French style, were built in 1954. The interiors of the 1930 stock are still in excellent condition, the mahogany panelling inlaid with ebony strips and brass fittings.

The Imperial sleeping carriage, with two bedrooms with single brass beds, was separated by a small bathroom at one end and a saloon with eight red leather easy chairs at the other, with a small kitchen. The matching coach has a large saloon with fold-away tables which can accommodate sixteen people, plus a large kitchen and a toilet.

The two newer coaches have a similar layout inside, but the exteriors are of aluminium. Small groups may see the Imperial Train with permission from the general manager of the railway company. A rail service operates daily between Addis Ababa and Dire Dawa, leaving the capital at 7.30 am and arriving at Dire Dawa about fourteen hours later. From there a train leaves Dire Dawa every other day at 5.30 am, reaching the

Above: Wall tapestry in the Jubilee Palace depicts Saint George slaying the legendary dragon.

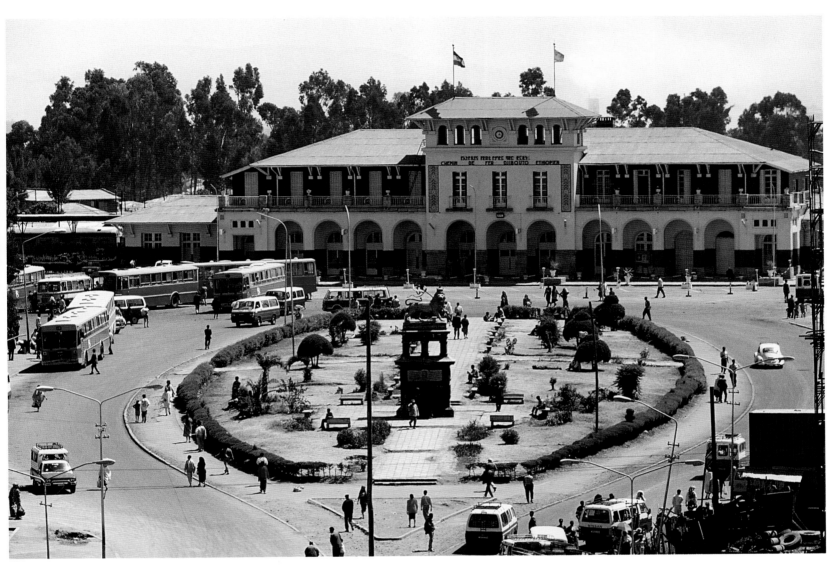

Above: Addis Ababa Railway Station, terminus of the Djibouti–Addis Railway, with the Lion of Judah statue in the centre foreground.

port town of Djibouti seven hours later. Trains running in the opposite direction follow the same timetable. French-made diesel units built into First Class coaches provide the motive power, hauling four matching Third Class carriages on the passenger services.

Other street names in Addis Ababa include British Generals Wavell Cunningham and Wingate, and South Africa's General Smuts. There is a King George Street, a Roosevelt Street and a Marshal Tito Street, as well as a Sudan Street and a Russia Street. The Sudan provided the main base for the Allied troops to attack Italian-occupied Ethiopia during the war. Kenya was another staging point for South African and East African troops to enter Ethiopia from the south. And Jomo Kenyatta Street recalls the warm ties which the emperor forged with the Kenyan nationalist while he led Kenya to independence.

Modern Addis Ababa consists of three main precincts. The eastern side

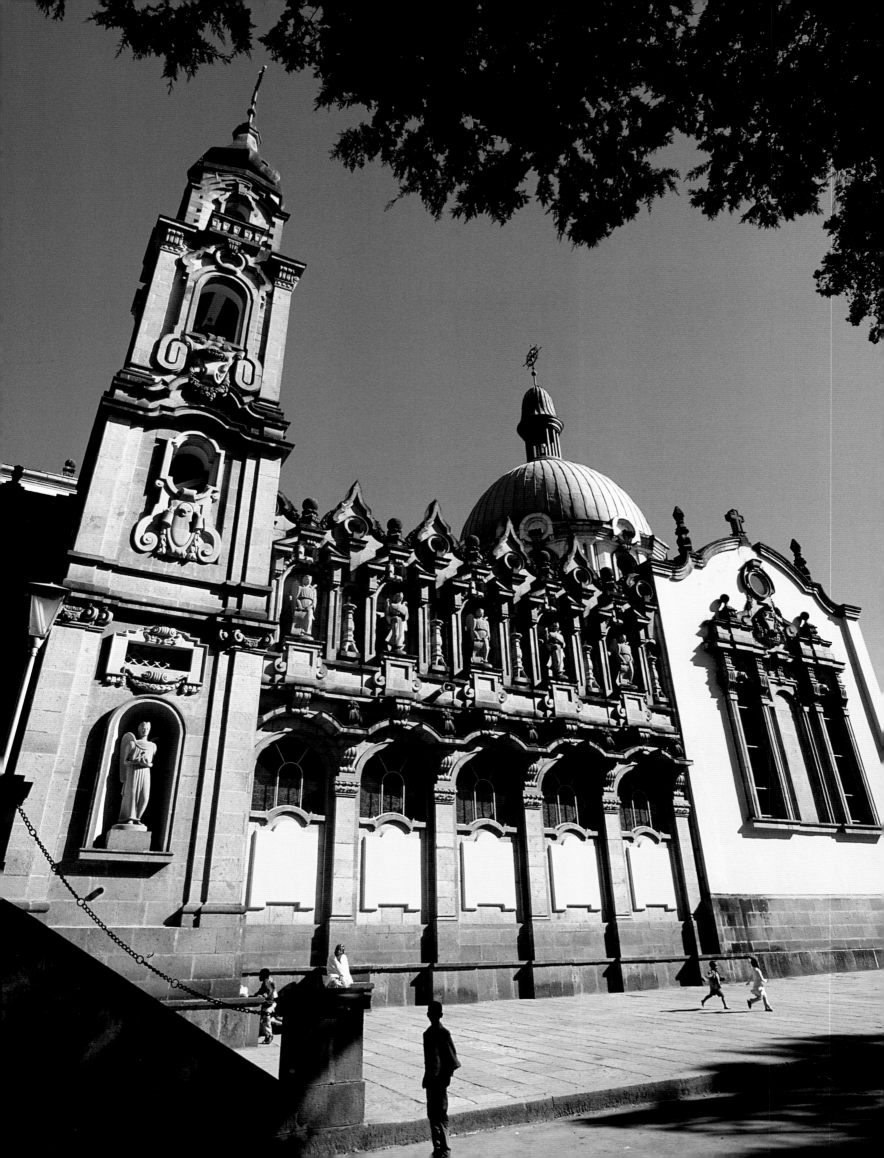

Opposite: Large dome and slender pinnacles of Trinity Cathedral, an outstanding Addis Ababa landmark.

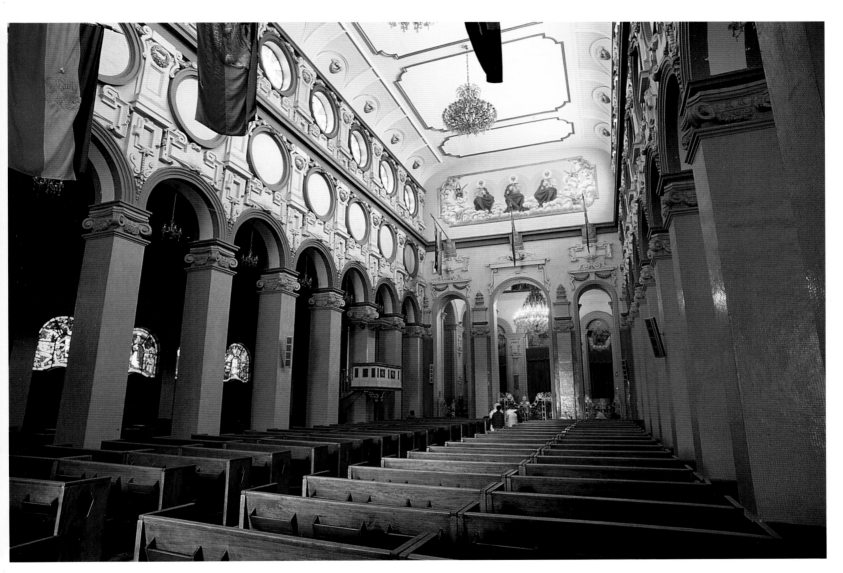

Above: Richly-decorated interior of Trinity Cathedral.

has many government offices and educational centres and some of the most important buildings, such as the old Menelik Palace at the top end of the wide tree-lined Menelik II Avenue, a road which is another splendid example of recent town-planning. The newer National or Jubilee Palace built in Emperor Haile Selassie's early days stands lower down the avenue opposite Africa Hall, the headquarters of the UN Economic Commission for Africa (ECA). Africa Hall also hosts summit meetings of heads of the member states of the Organization of African Unity.

Uphill from Africa Hall is the five-star Hilton Hotel, with its heated, cruciform swimming-pool. The lower end of the well-designed avenue is bounded by the vast Maskal Square. During Mengistu's government this was called Revolution Square, the venue for military parades marking May Day or Revolution Day. In the 1990s on the opposite side of the square, there was still a huge tiered stand which could accommodate

Above: An early 20th-century house with rusting corrugated iron roofing which was once a family health clinic established by the Crown Prince, son of Haile Selassie.

masses of people. The university, with the National Museum and the Institute of Ethiopia Studies museum, are also in this part of the city, as well as the Trinity Church.

The central part of the capital city includes the main commercial area and more government departments. City Hall and Churchill Avenue are also in central Addis Ababa, as is St George's Church, one of the city's Ethiopian Orthodox community churches. Near City Hall, the shopping centre known as the 'Piazza', retains some of its Italian ambience from the occupation period, even to the outdoor cafés with their *cappuccino* machines.

Among the business premises in this central area are the sales offices of the national carrier, Ethiopian Airlines, the main post and telegraph offices, the general hospital and the Commercial Bank of Ethiopia. The hub there is Unity Square, with several hotels nearby, including Ethiopia,

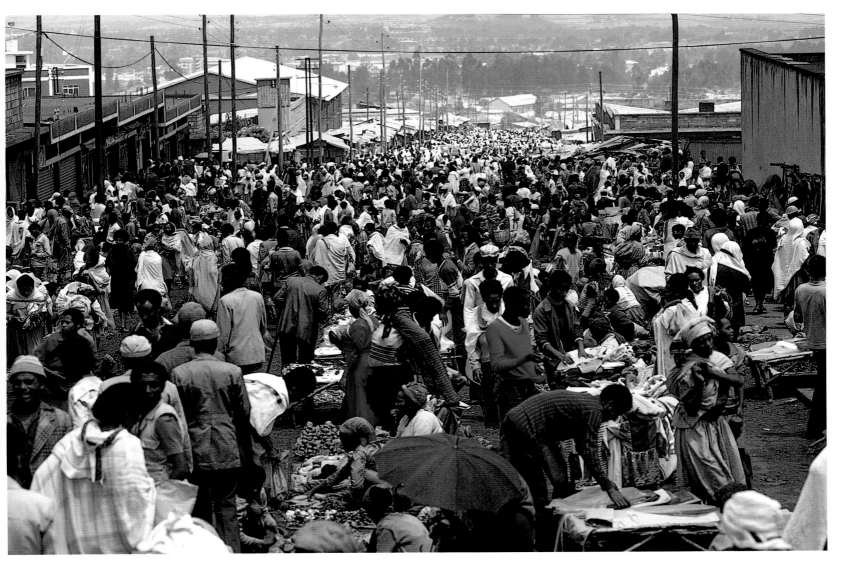

Above: Bustling and colourful Mercato, the largest outdoor market in Africa between Cape Town and Cairo.

Ras and Harambee. The 1,400-seat National Theatre is close to Unity Square and the 27,000-seat sports stadium lies between Unity and Maskal squares.

Located in Addis Ababa's western sector is the fascinating and colourful Mercato. One of the largest open-air markets in the world, it operates throughout the week and pretty much around the clock. Saturday morning, however, is its busiest period — attracting around 50,000 buyers and sellers, hailing from both the city and the surrounding countryside. Rural produce is sold from large warehouses: vegetables, *teff*, wheat and other grains dominate.

The best way for the tourist to get to Mercato, which covers a large — and at times bewildering — area, is to hail one of the blue and white taxis which travel through the market centre, enabling passengers to get off when they see something of interest.

The market complex begins with small shops containing all the practical necessities of everyday life. Music screams at you from the electronics retailers who make a point of turning their radios and cassette players up to full volume to demonstrate the high decibel quality of the equipment. Small boys wander around with goats slung over their shoulders and donkeys patiently carry loads many times their weights. The outdoor market is organized chaos.

The City Council is responsible for the overall administration as the market is sited on council land. But on Saturday morning everybody does his own thing — sellers of tomatoes, cabbages, beetroot, cauliflower, carrots and an endless variety of spices, including *berbere*, or chilli pepper, with its unmistakable odour, sit where they can next to their wares, which they guard as if they were gold. Piles of clothes — new garments, hand-me-downs, bright red dresses and more conservative attire — are placed

Above: Old house in Addis Ababa with improvised additions for greater privacy.

Above: An old house and shop in the Piazza quarter of the modern metropolis of Addis Ababa.

on top of one another making it almost impossible to discover what there is without rummaging through the whole pile. Chickens and goats wander around, seemingly oblivious to their fate, and many goats are marked with red, purple or green paint, to distinguish their ownership.

Numerous corrugated iron 'shanty shops' display bright gumboots next to holy pictures, with an enormous variety of pots, pans, dishes and plastic bowls. Children are everywhere — holding on to their parents, offering to shine shoes, selling sweets, chewing-gum or pot, or standing next to a rusting pair of scales which can tell your weight, with varying degrees of accuracy, for five or ten cents.

The Adarash market halls are divided into two sections: one specializes in imported goods, mainly clothing from Europe, Japan, India and Taiwan; the other in crafts and traditional products. Locally made shoes and leather bags are of a particularly high quality, leather being one of the country's main exports. Most shops in the halls are full — clothes hang on top of more clothes and are certainly not displayed to their best advantage. Tourists, however, may be especially interested in the selection of scarves and brightly-coloured Indian sandals.

The crafts section has more goatskin and animal products than the downtown shops. Of particular interest are the traditional goatskin food-carrying 'baskets', shields, horse-hair brushes and ox-horn products, as well as a fish with a light bulb in its mouth: it may have its limitations as a lamp, but no one can question the skill and creativity which went into its design and production. There is an endless supply of Coptic crosses, especially the elaborate Lalibela ones. Leather paintings, pots, multi-coloured baskets and olivewood wares also abound.

Among the more unusual items are hippopotamus hide shields, traditional knives, spears, prayer sticks, fur rugs, traditional musical instruments and paintings depicting the story of Solomon and the Queen of Sheba. But there are also modern shops — like the Tana Complex department store with five shopping units. Local and imported produce may be found there, with such items as photocopiers, electronic typewriters, cameras, Western-style clothes, stationery and kitchenware.

Mercato, now known as Addis Ketema, New Town, is a place in which, the locals say, you can bargain for anything — even a new soul. It takes some practice to be able to compete with the experts in that art.

After the bustle of Mercato, a refreshing contrast — and better quality goods particularly where gold and silver jewellery are concerned — is offered by the city's second main shopping area, Piazza. As its name suggests, Piazza is a legacy of the Italian occupation and still has a pronounced Italian charater. Sprawling out along Adwa Avenue to the

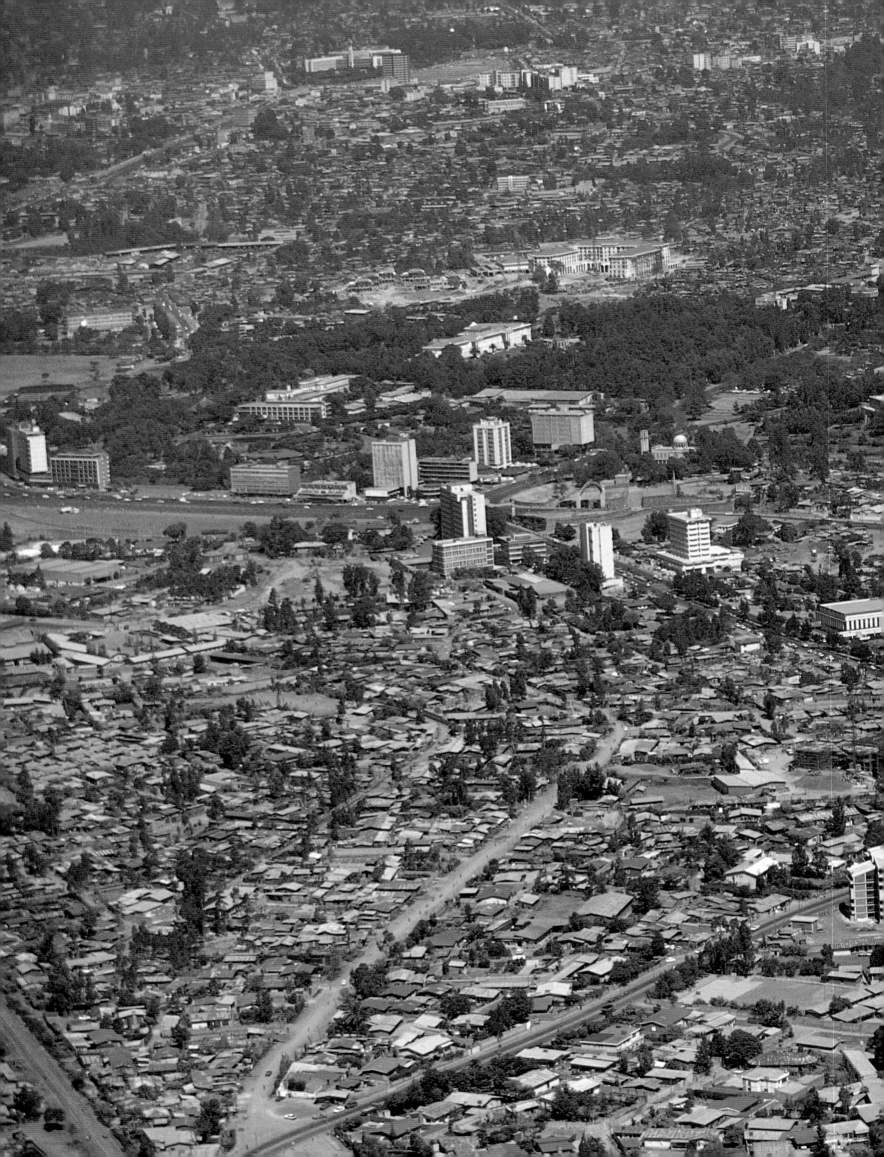

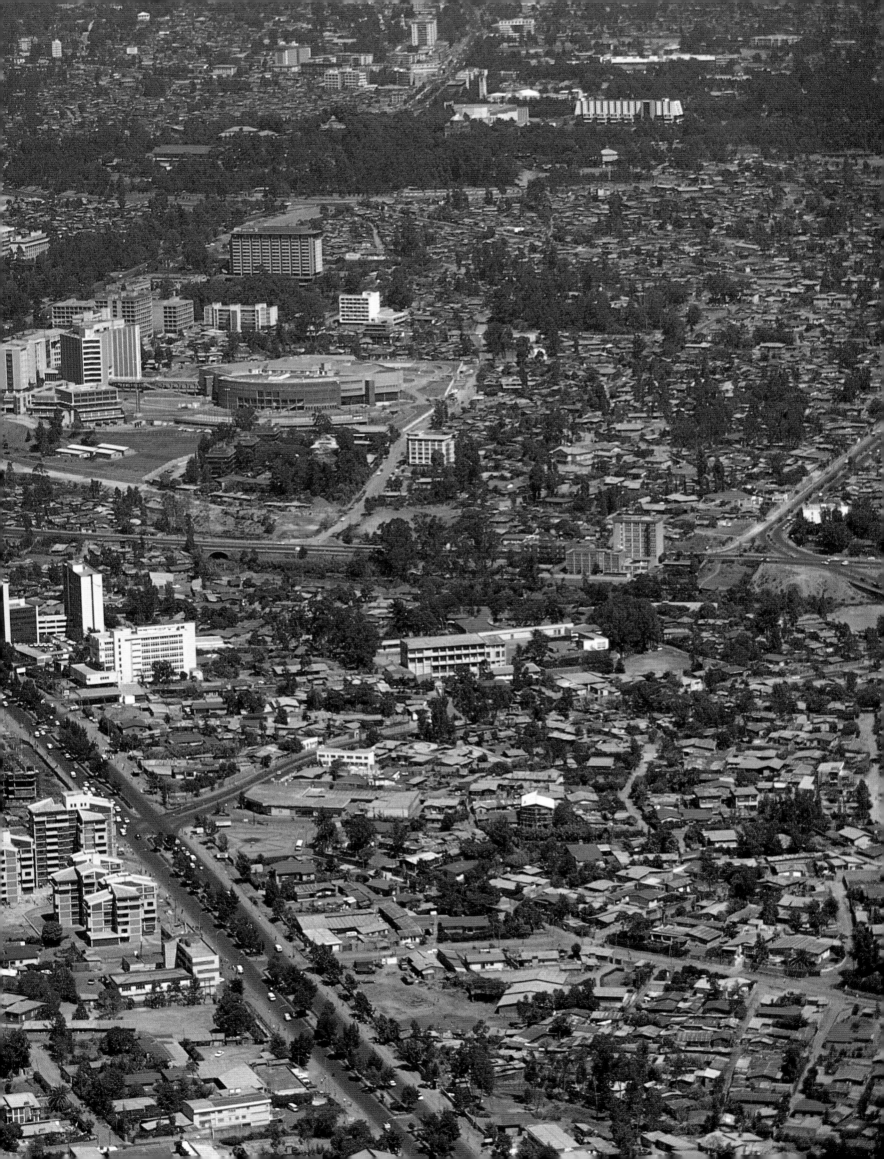

Above: Elegant modern profile of the Addis Ababa Hilton. The swimming pool is fed by natural hot springs beneath the ground.

east of the City Council offices, it is an area of gold and silversmiths, cake shops filled with delicious pastries and doughnuts, coffee-bars specializing in frothy *capuccino*, good quality Ethiopian leather shoes, video libraries, bespoke tailors, and all manner of electronics retailers.

Meanwhile, a short distance to the west and south of Piazza, on the long thoroughfare of Churchill Avenue, there is a wide variety of shops specializing in Ethiopian handicrafts and other curios and souvenirs of interest to the tourist.

Away from the hustle and bustle, walking through the streets of Addis Ababa is pleasant, and quite safe compared with some African capitals. There are many beggars but they are not persistent. However, beware of any importuning teenagers who approach you with the story that an important soccer match is taking place at the stadium and could they have a couple of *birr* for the entrance fee? Invariably they run off in the opposite

direction from the stadium once you give them the 'entrance fee'. The city's two main mosques are in the western section, as is the bus station. In the south-western residential area many embassies are located near the old Lideta Airport, and in the south-east the road leading to the newer Bole Airport has become a veritable 'Embassy Row' — every second plot is either an embassy or a consulate.

Many years ago Addis Ababa became Africa's diplomatic capital. Once the Organization of African Unity (OAU) set up its headquarters in the city in 1963, the diplomatic fraternity doubled in numbers. Now there are more than seventy embassies and consulates. This has created a big demand for hotels and since the recent liberalization of the economy and the tourist industry many new hotels have sprung up. In the past nearly all were state-owned, but within one year fifteen private hotels opened. At most of the larger hotels in Addis Ababa there is a place, such as the foyer, where an intricate coffee ceremony is practised. This is the actual ritual carried out in many Ethiopian households before the beverage is drunk.

At the start a table is scattered with freshly-cut grass to give the fresh and fragrant scent of outdoors. A female attendant, playing the role of the lady of the household, sits on a low stool beside a charcoal brazier. She first lights a stick of incense to provide the right atmosphere. Before the coffee is prepared, the guests are given a titbit, such as popcorn, while the attendant roasts the green coffee beans on a concave pan, slowly turning the beans with an old-style pestle and mortar until they are fully ground.

Only at this stage is the container for boiling the coffee produced, usually a round clay pot with a plump base and a long narrow neck and spout. After the water has been heated, the ground coffee is added through the neck on top, then the water is brought to the boil.

When ready, the coffee is poured into small, traditional cups and sugar is added. Sometimes a sprig of the bitter herb *rue* is supplied. However, though the coffee has a full-blooded flavour, it is not itself bitter.

The time devoted to the ceremony, performed usually after a meal of *injera* and spicy *wot*, is an indication of the importance Ethiopians attach to the drink, which was developed many centuries ago and first exported to the world in the 14th century.

The Hilton Hotel has a thermally-heated pool supplied by a nearby mineral spring, the same source which attracted Empress Taytu 100 years ago. In the same area the swimming pool of a new 1990s hotel, the Sheraton Addis, also draws water from this source. For those visitors who do not have the opportunity to journey through Ethiopia, useful time may be spent in Addis Ababa itself 'catching up' on the geography and history of this fascinating country. Several museums are well worth a visit. The

Above: Smiling Ethiopian girl in traditional dress.

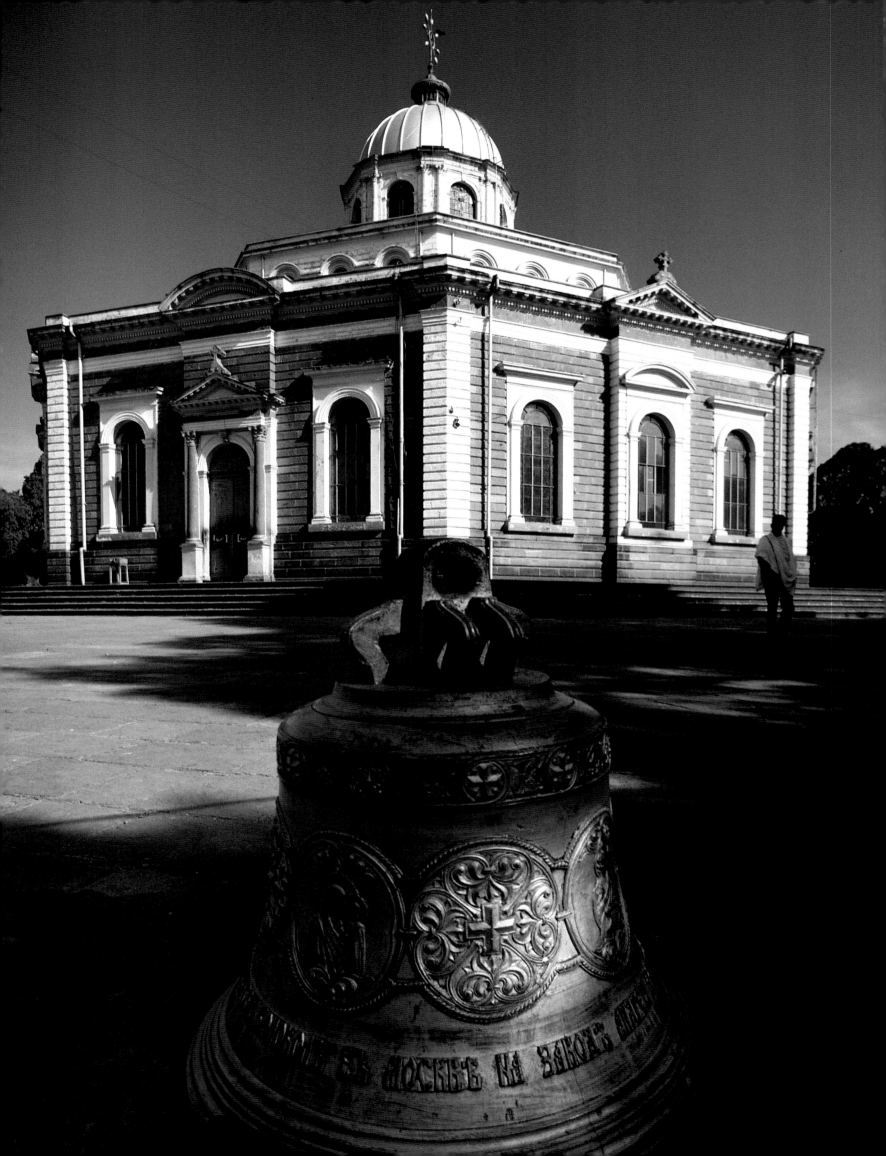

Opposite: Church of St George's in Addis Ababa. The huge bell in foreground was a gift from Tsarist Russia before the Bolshevik revolution.

Above: Interior of St George's Cathedral, with a mural (left) showing St George slaying the dragon.

Addis Ababa Museum, housed in what was the residence of a former Minister for War, Ras (Prince) Biru Haptegebriel, provides a fascinating step back into history. The rooms in its recently-restored wooden structure are filled with old prints of Addis Ababa in the days of Menelik II, ceremonial and other robes worn by him and others, old documents, coins and other antiquities.

The museum is not far from Maskal Square, where the Information Office attached to the Ethiopian Tourism Commission (ETC) has many informative booklets useful for those who want to learn about Ethiopia.

In another part of the city, up Menelik Avenue and past the Menelik Palace and the old Parliament Building, King George Street leads to some of the university buildings. Opposite the Faculty of Technology is the National Museum. Many of its exhibits have been brought to Addis Ababa over the years by French archaeologists from northern Ethiopia.

The prime exhibit is a replica of the world-famous 'Lucy' skeleton. The original priceless fossils are kept in a safe. In 1995, the scanty fossilized remains of what has been jokingly referred to as 'Lucy's elder sister-brother', *Ardipithecus ramidus*, were still being closely examined in the laboratories. Initial testing indicated that *ramidus*, found not far from where 'Lucy' was unearthed, is almost a million years older than the 3.5 million-year-old *Ardipithecus afarensis*, the scientific label for 'Lucy'. Other exhibits in the National Museum include art treasures, historical artefacts and ancient coins — all bearing captions in Amharic and English.

For many the Institute of Ethiopian Studies, an ethnological museum and gallery of traditional Ethiopian art in the grounds of Emperor Haile Selassie's former palace, now the main university campus, is an exciting place. Among its displays are costumes worn by Ethiopia's varied ethnic communities. These include everyday clothing, old warrior dresses, clothes for special festivals and religious robes.

Another section features regional handicrafts — tools and other utensils, such as simple but effective looms and spinning contraptions, ploughs and papyrus reed vessels and other boats, as well as items from remote rural areas.

The institute's art gallery, on the upper floor, features a great variety of church paintings and crosses, as well as traditional-style secular art. Visitors to the Institute's Museum can also see Emperor Haile Selassie's bedroom and bathroom.

A separate section dealing with musical instruments used in Ethiopia down the years is housed in a 19th-century building at the rear of the old Menelik Palace. It is necessary for a guide from the main Ethnological Museum to accompany visitors to this section, as it is opened only by

appointment. And a square mausoleum topped with a large gilt crown, in the Menelik Palace grounds, contains not only the remains of Menelik II, but those of his consort, Empress Taytu, and daughter Zauditu. Archbishop Mateos, who crowned Menelik in 1889, and the daughter of Emperor Haile Selassie, Princess Tsehai, who served as a nurse in Britain during World War II, are also buried there. After the Mengistu regime was overthrown in 1991, when the remains of Emperor Haile Selassie were found in the old Menelik Palace, they were transferred temporarily to this mausoleum.

Although the capital's Orthodox churches are not ancient structures, like so many others in the country, they do contain some excellent religious artwork. St George's Cathedral, facing Sylvia Pankhurst Street, has some elaborate paintings. Probably the most outstanding, appropriately enough, is a huge mural depicting Saint George, mounted on a prancing horse, slaying the dragon. The elegant, octagonal, domed church, built before the Second World War, contains many interesting modern paintings and mosaics, some by Afewerk Tekle, a modern Ethiopian artist.

Although the amazing rock-hewn churches of Lalibela are 642 kilometres (400 miles) from Addis Ababa, it is possible to see a similar, if rather inferior, church on the outskirts of the capital. The old church of Saint Michael is on the Dessie Road, just behind the British embassy compound. From the new St Michael Church, near the main road, a track leads uphill to the old church, which was carved out of solid rock.

On top of Entoto Mountain, near the site where Emperor Menelik II pitched camp, another church provides magnificent views of Addis Ababa spreading southward. It was in the Church of Saint Maryam, which keeps the vestments of several past kings and leaders, that Menelik II was crowned in 1889.

Another notable city landmark is the Selassie, or Trinity Church, with its large dome and many slender pinnacles, inset with statues. Inside is a handsome crystal chandelier and some remarkable stained glass windows. Several such windows are to be found in Addis Ababa, none more striking than those by Afewerk Tekle, whose masterpiece — a bold, modernistic creation depicting 'Africa: Past, Present and Future' — adorns the foyer of the seven-storey Africa Hall.

Another impressive piece of artwork in Africa Hall is a huge mural with the portraits of all the African leaders who attended the OAU inaugural summit in 1963, few of whom were still alive in the 1990s. In front of Trinity Church stands the tomb of Sylvia Pankhurst, a British suffragette and champion of the Ethiopian cause. Her book, *Ethiopia: A Cultural*

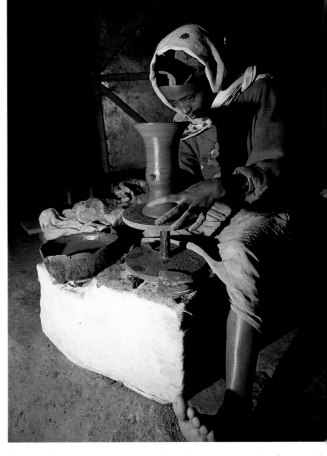

Above: Potter shapes a vessel on her pottery wheel, one of Ethiopia's many cottage industries.

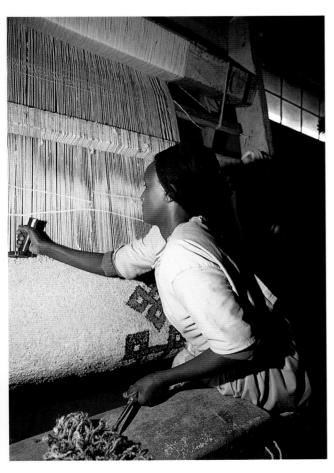

Above: Hand-woven Ethiopian carpets follow a timeless tradition and are in great demand overseas.

History, was the first comprehensive survey of the country's arts and culture — covering music, painting, architecture, literature, philosophy and theology. A street by that name in Addis Ababa is in her memory.

Addis Ababa is a city with countless restaurants. Taxi-drivers are excellent at locating establishments providing particular types of food. Naturally those offering traditional Ethiopian food are much more numerous. The exotic range from Polish to Armenian and Chinese restaurants.

Ethiopians are proud of their national dishes and take every opportunity to familiarize visitors with *injera* and *wot*, which form the basis of any Ethiopian meal, apparently at any time of the day or evening.

As with drinking coffee, so eating *injera* and *wot* is also preceded by a ceremony. This begins with hand-washing, when guests are asked to place their outstretched hands over a small basin and water is poured on the hands from a decorative metal or earthenware jug. A short prayer or grace is said at the end of the brief ceremony.

As 'starters' curds and whey are sometimes served, a bland offering compared with what follows. *Injera*, the Ethiopian bread, is a fermented pancake-like crêpe made from a locally-grown grain called *teff. Teff* looks like grass when growing in the field. Before baking *injera* on a griddle, the flour has to ferment for three or four days. The finished product comes out in thin, grey layers.

Wot is a dish of beef, chicken or vegetable chunks cooked with many spices and always with a hot pepper called *berbere* in Amharic. Spices can include cardamom, cloves, garlic, nutmeg, fennel seeds, coriander and fresh ginger.

Traditionally *injera* and *wot* are served on a special basket-work table which resembles a very colourful mushroom, called *mesob*. On top is a large round basket on which the food is laid out. The entire 'table' is made from brightly-coloured reeds — the best *mesobs* are made in Harar, where basketry has been an art for centuries.

At a formal meal, the head of the table will tear off pieces of *injera* (with the right hand only) and give them to the diners in order of precedence. They are expected to dig into the collation of spicy meat or vegetable on the *mesob*, using the injera like a *chapati* or a *tortilla*, wrapping it round the meat and scooping it up with the hand. It is regarded as a gesture of affection when a diner or host selects a particularly appetizing morsel and places it in a companion's mouth. As a variation, pieces of *doro*, or chicken, will be served. Some Ethiopians find it hard to believe that strangers may be unable to stomach the fiery and peppery *wot*, but, as an alternative, they will gladly produce *alicha*, a much milder dish, often of chicken or

Above: Addis Ababa Museum, once the home of Ras Biru Habtegabriel, a former Minister of War.

lamb, flavoured with onions and ginger. Many Addis Ababa hotels have 'Ethiopian Nights' when all kinds of food are prepared, to the accompaniment of music or dance by troupes who perform various regional styles. At some restaurants minstrels play on their *mosinkos*, one-string fiddles, and sing songs composed on the spot, to the delight of the clients. A provocative dance called *Iskista* is performed by both sexes, who shake their shoulders vigorously backwards and forwards.

There are a number of excellent international restaurants in Addis Ababa where French, Italian, Indian, Chinese, Armenian and Middle Eastern menus are served, and a range of establishments specializing in traditional Ethiopian food. Many pizza parlours have recently sprung up. Although imported beers and spirits are available, at a price, some local brands are good value. Among the better selections of the local wines are Guder and Dukem reds and Cristal Awash, white. All this is very much

Above: Stained-glass windows adorn the Africa Hall in Addis Ababa, where African Heads of State gather for the yearly Organization of African Unity — OAU — summit, are the work of master-artist Afework Tekle.

part of the ambience of a bustling and cosmopolitan 20th-century metropolis. Yet away to the west, over the hills, lies another rarely seen face in this land of many contrasts — a land and a people that have remained virtually unchanged through thousands of years.

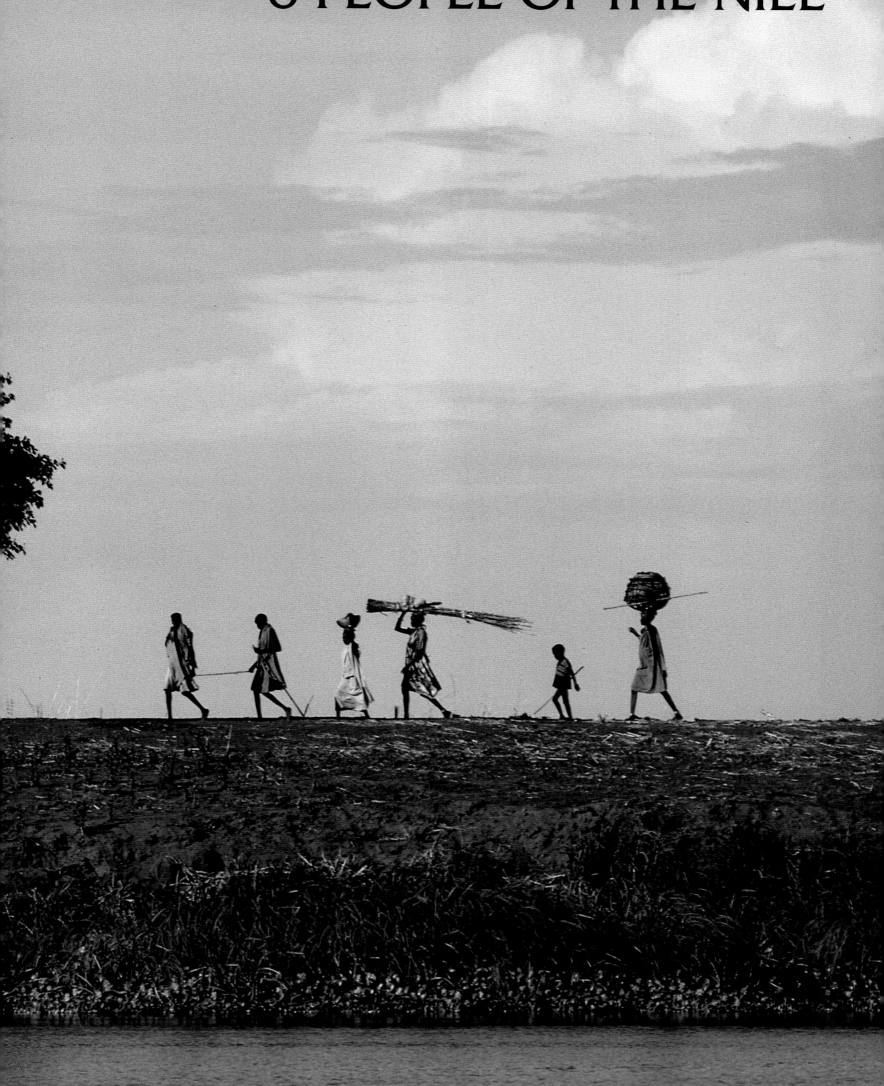

Previous pages: The Baro River, near Gambella, tributary of the White Nile, flows into Sudan where it becomes the Sobat River.

The far west of Ethiopia is a fascinating contrast to the rest of Ethiopia. Remote and seemingly untouched by any modern influences, its lowland plains and swamp country stretch out as far as the eye can see and beyond the horizon. The extensive lowland swamps of the Ilubabor Region resemble the virtually impenetrable 'sudd' of neighbouring Southern Sudan.

The main town, Gambella, is reached by heading west from Addis Ababa, through Welega. The first place to catch the eye on the 753-kilometre (470-mile) trip is Mount Menagasha — aptly described as being like 'an upside-down pudding bowl' — and its forest which contains the last indigenous trees around Addis Ababa, junipers and podocarpus, some of which are over 400 years old.

Now it is a state park with some motorable tracks passing through areas with black-and-white colobus monkeys, Menelik's bushbuck and some duiker, where the small lodge built for former ruler Mengistu Haile Mariam has been renovated for visitors.

Fifty-five kilometres (34 miles) out of Addis Ababa is Addis Alem — 'new world' — the small village that for a short time was Ethiopia's capital. Emperor Menelik II, concerned about the acute shortage of firewood in Addis Ababa at that time, thought it might be more suitable as a capital and ordered a palace to be built here. He had visions of constructing 'the Axum of the south' on this site. But later he changed his mind and returned to Addis Ababa and converted the palace into the Church of St Mary of Zion, an equivalent of Axum's church of the same name.

Fifty kilometres (31 miles) further on is Ambo town, also known as Hagre Hiwot, from which Ethiopia draws its famed mineral water *Ambo* at nearby Senkele Springs. The town's main hotel, with a hot spring-fed swimming pool, is a popular rendezvous for Addis Ababa residents, only one-and-a-half hours' drive away. The nearby Wonchi, Ethiopia's most magnificent crater lake, may be reached by four-wheel-drive vehicles, or on horseback from Ambo.

One point between Addis and Ambo is the dividing line between the watersheds of three major rivers. To the south the Awash rises on its 1,200-kilometre journey (750-mile) to the Danakil Desert; to the south-west tributaries feed the Gibe-Omo River which empties into Kenya's Lake Turkana; and to the north of the main road stands the watershed for several tributaries that flow into the Blue Nile-Abbay gorge.

Vineyards stretch out along dun-coloured slopes on both sides of the main road beyond Ambo. For the next town, Guder, is the centre of the country's wine industry where a popular red wine is named after the

Above: Post Office in Gambella, regional capital of Illubabor.

Opposite: Young Anuak girl near Gambella in western Ethiopia proudly shows off her catch of catfish.

Above: Addis Alem's richly-decorated Church of Saint Mary was intended by Emperor Menelik II to be the southern equivalent of Axum's Saint Mary of Zion.

town. Once the Shewa border gives way to Welega, the vineyards are re-placed by rows of coffee bushes in plantations cared for by Oromo work-ers. Into Welega, the road begins to drop to the foothills of the high central plateau and after the regional capital, Nekemte, a busy market and coffee-handling town, there is a steep descent into the Didessa Valley, another tributary of the Blue Nile.

Then, climbing out of the Didessa Valley, the road reaches Gimbi, beyond which are gold fields where one mine is claimed to be the oldest in the world. As with some other old African gold mines, it is believed to have been the setting for Rider Haggard's *King Solomon's Mines*. Since the Solomonic dynasty is closely connected with Ethiopia, the claim is more plausible than those made about gold mines in Eastern and Southern Africa.

But before reaching this gold mining area a south-west turnoff from the

Above: Ancient stone carvings such as this at Tiya stand testimony to Ethiopia's remarkable antiquities. Some may be gravestones.

main road leads through a series of switchbacks to Dembidolo, gateway to the Ilubabor Region. The focal point for much of the region is the sleepy town of Gambella which nestles on the banks of the Baro River. Downstream, where it enters Sudan's Upper Nile Province it becomes the Sobat.

Gambella, a colonial-style town with a laid-back ambience, where local artisans may be seen working the locally-mined gold, is noted for its high-quality *tej* (mead). At one time it was a busy port, with regular ships arriving at its quays from the White Nile town of Malakal, or from Khartoum further downstream. That was in the days when the Sudan was a condominium of Egypt and Britain when Emperor Menelik II granted Britain a concession to use Gambella and the riverbank to build an import and export trade.

Much of Ethiopia's coffee exports was shipped down the Nile to Egypt and the Mediterranean through Gambella. Incoming boats, with their strings of barges, would unload machinery and manufactured goods from Europe which were stored in solid brick warehouses until they could be transported 'inland' to upcountry markets.

Traffic was seasonal. The boats worked only after the rains had brought down the floodwaters from the Ethiopian mountains. But when the Sudan became independent in 1956 the arrangement was terminated and regular sailings between Ethiopia and the Sudan ceased.

During the 1970s and 1980s an influx of refugees from the Southern Sudan saw hastily-erected camps around the border post of Itang and along the banks of the Baro towards Gambella. To feed these refugees, fleeing the civil war between the rebel Sudan Peoples' Liberation Army (SPLA) and the Khartoum forces, boats bearing relief food and medical supplies from United Nations agencies began to ply once more on the Sobat-Baro between Malakal and Gambella. The long-lasting civil strife had an adverse effect on Ilubabor. Development took second place to the urgently-needed emergency relief of thousands of Sudanese refugees, many of whom were close relatives of the Nilotic people living in western Ilubabor. But although Gambella has become a backwater, its wharves and warehouses, even though empty of cargo, remain in good condition.

What Gambella today shares in common with Dire Dawa are carefully-planned, tree-lined streets, with colonial-style bungalows surrounded by hedges — shades of a brief British influence, as is the Gallic 'touch' given to Dire Dawa by the French contractors who built the Djibouti-Addis Ababa Railway.

Some of the busiest spots in Gambella are found along the banks of the Baro River, where people wash clothes while others bathe or simply laze

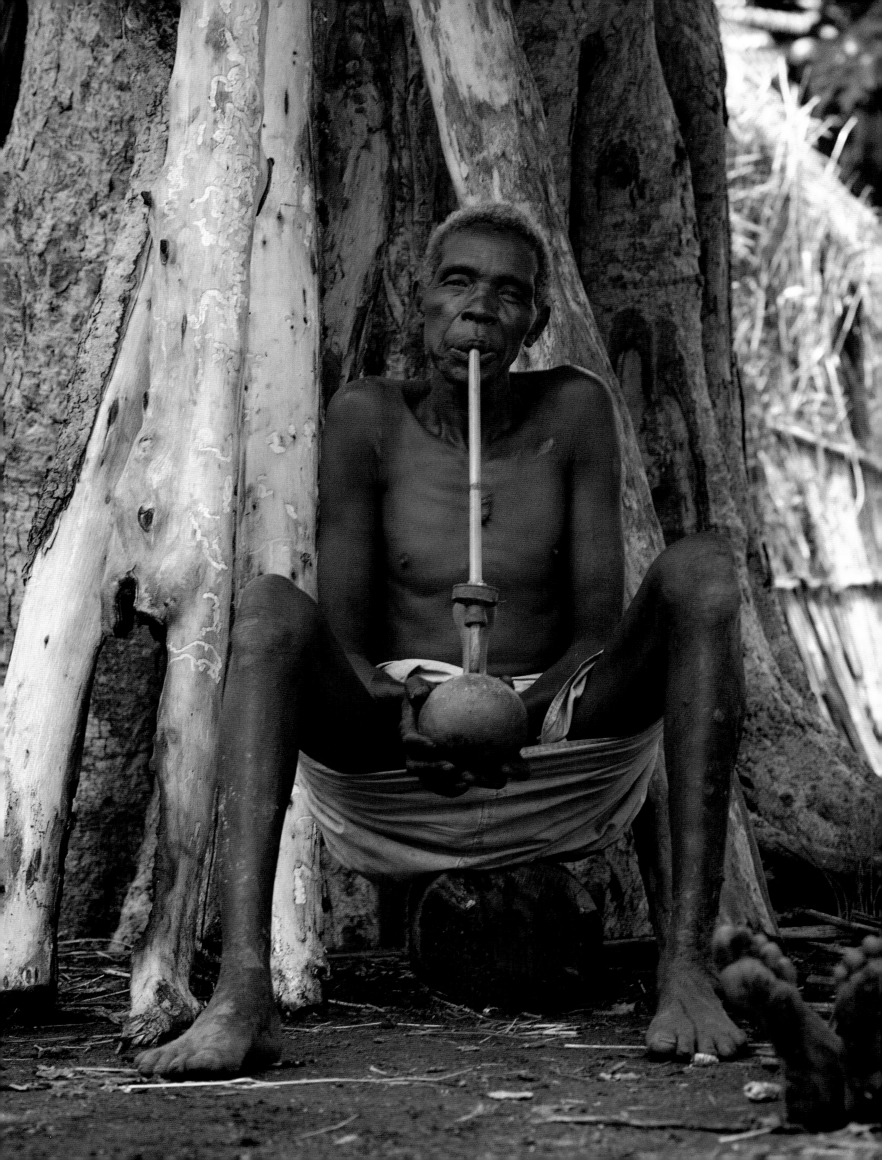

Overleaf: Nubile young maidens head for the deeper waters of the Baro River for their daily bath.

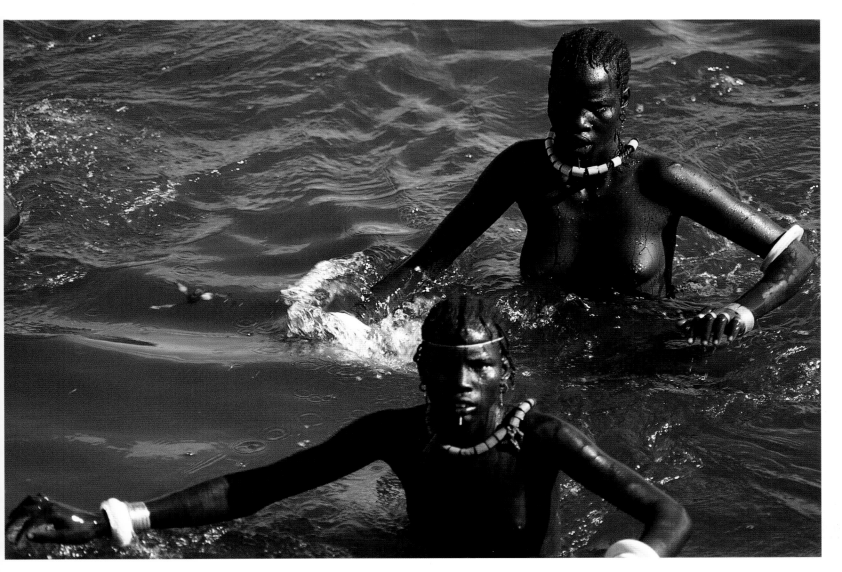

Above: Nilotic bathers brave the crocodiles in the Baro River near Gambella.

Opposite: Anuak elder in Illubabor enjoys a smoke with his home-made 'hubble-bubble' pipe of bamboo and a gourd.

on the sandy beaches. Dugout canoes drift by on the slow current as fishermen go after Nile perch, carp or catfish — always on the alert for the aggressive 'tiger-fish' which lives up to its name, a ferocious little creature when hooked.

The nearby Gambella National Park contains lowland animals seen nowhere else in Ethiopia, species more akin to those in the southern Sudan. However, there is a constant migration to and from the park of roan antelope, white-eared kob and the rare Nile lechwe. The national park, extending for almost 2,000 square kilometres (770 square miles), was originally a protected wetlands area since much of it is crocodile infested swamp. Despite a regular air service by Ethiopian Airlines from Addis Ababa to the remote town of Gambella this protected area receives only a few visitors.

The local languages are Nilo-Saharan, totally unrelated to the Semitic

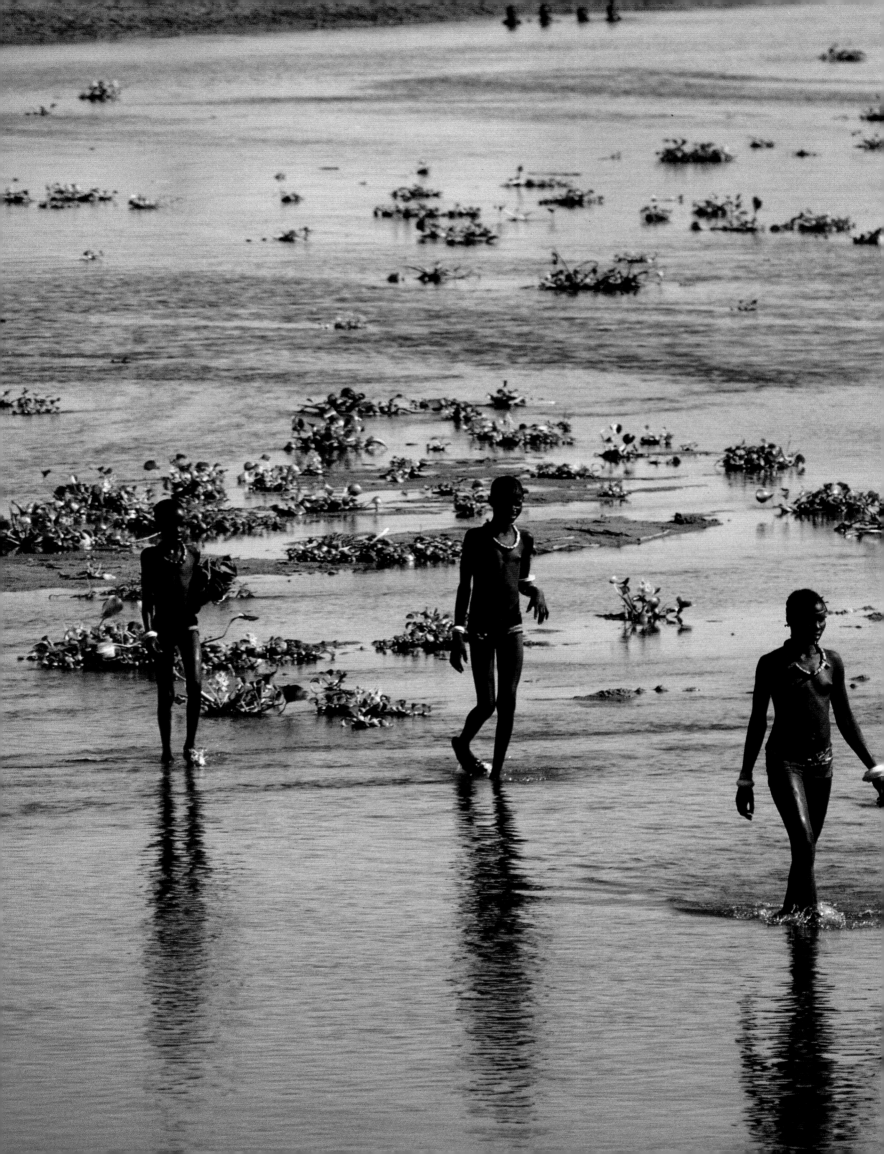

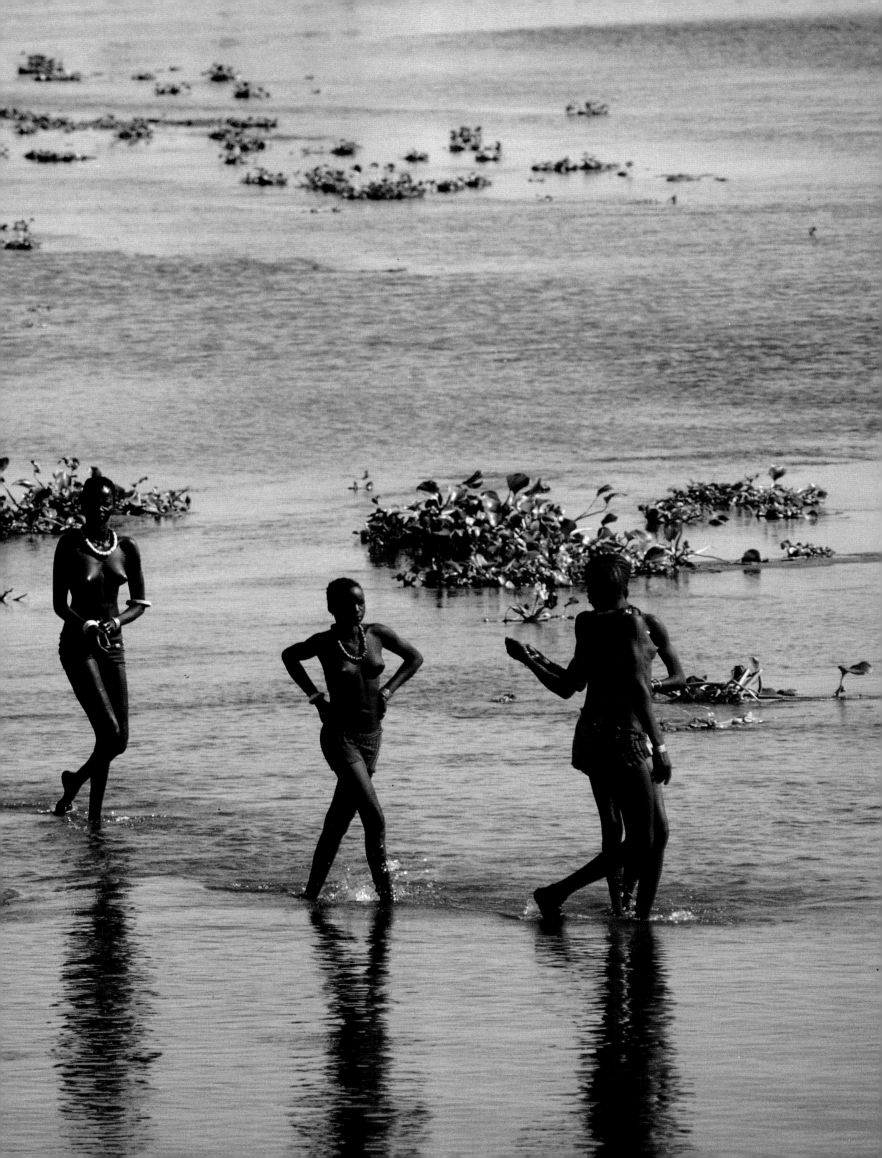

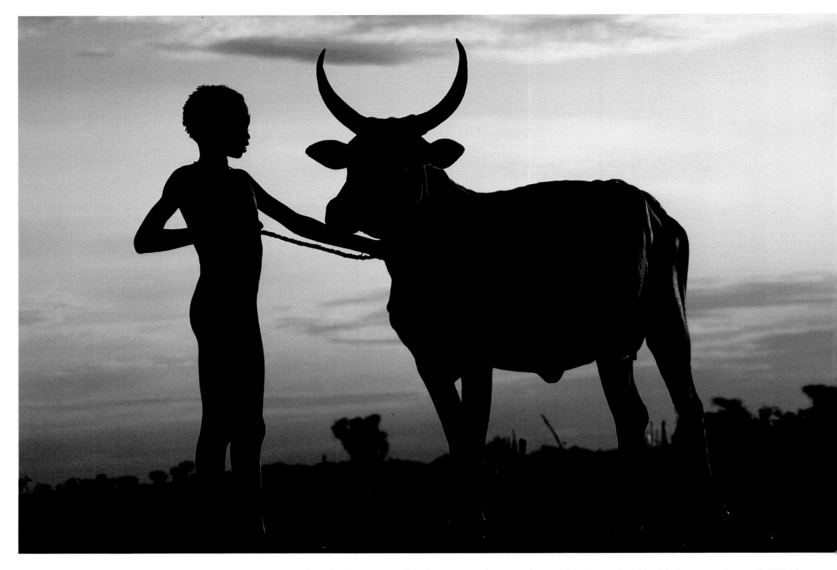

Above: Cattle are held in high esteem by such Nilotic communities as the Nuer people of Illubabor.

and Cushitic tongues which dominate much of the rest of Ethiopia. The lowlands of grasslands, acacia clumps and swamps that roll away as far as the eye can see are home to two main tribes — the Anuak and the Nuer. The Anuak are mainly fisherfolk who practise some desultory cultivation of sorghum. They live in the country between Gambella and Itang to the west, not in large villages but, by preference, in small family groups of half-a-dozen or so huts under shady mango trees.

Their thatched-roof huts, often with several tiers of thatch to keep out the torrential rains, are used mainly for sleeping as the Anuak spend most of the daylight hours outside, even when it rains. Both men and women enjoy smoking long clay pipes with aromatic tobacco.

Although naked to the waist, Anuak women wear heavy bead necklaces and sport fancy hairstyles, usually in furrows interlaced with beads and eye-catching extras, such as white colobus monkey tails. Anuak men also

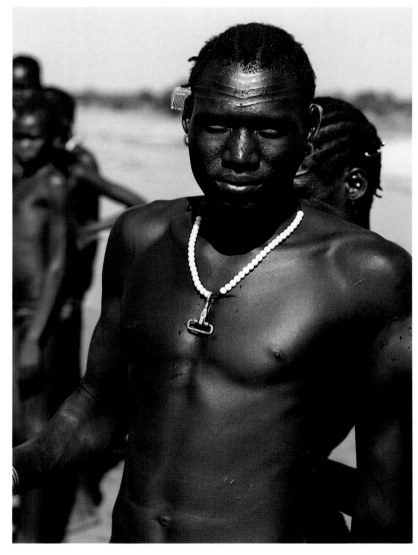

Above: Scarification of the body forms part of the Nuer culture of adornment.

Above right: Nuer tribespeople on the bank of the Baro River.

wear the minimum of clothing, except when they procure some material to wear as a sarong; and to go to the market some women wear long ankle-length *shammas*. Nearer the border with the Sudan's Upper Nile Province, on the grassy plains west and south-west of Itang the Nuer people graze huge herds of cattle. Primarily pastoralists, they do fish along the Baro River or in the numerous swamps. Like their Dinka cousins in the Sudan, the Nuer attachment to cattle is legendary and they compose poems and sing to their favourite animals.

Much more gregarious than the Anuak neighbours, the Nuer live in large villages of hundreds of huts, built at intervals along the Baro banks. They also have cattle camps for those with herds grazing far from home.

Scarification is practised by both men and women as a form of embellishment. Like the Shilluk of the Sudan, Nuer men cut deep scars causing bumps on their stomachs; they even have small bumps patterned on their

brows. Heavy bone bangles are popular as jewellery, also ivory. Women often wear spikes of ivory or brass pierced in their lower lips. Just outside Gambella a modern single-span bridge, Ethiopia's largest, crosses the Baro River. On the bank below, numerous people bathe and it is puzzling how they seem to know where the water is free of crocodiles for many are to be seen all along the Baro. The townspeople still remember the time, back in 1968, when a volunteer from the US Peace Corps met a grisly death after he encountered one of these large reptiles while swimming in the Baro.

From Gambella to Addis Ababa one route connects with the Jimma road, but before reaching Kaffa and the coffee country again, another tortuous route leads to the highland plateau on the western wall of the Great Rift.

There is a long, steep 900-metre (3,000ft) climb before the road reaches the cooler highland air at Gore, a colourful market town on top of the escarpment, where Nilotic plains dwellers sometimes venture to sell their wares, but they often have language problems as the Cushitic-speakers find the lowland Nilo-Saharan tongue strange.

Gore, on the most westerly tip of the plateau, was created as a military garrison by Emperor Menelik II in the 19th century but is now one of Ilubabor's most important towns.

Another twenty-five kilometres (15 miles) on, and much higher, is the regional capital of Metu, a typical frontier town surrounded by thick forests and alive with brightly-plumed birds. Weekends see a huge influx of Oromo farmers from the surrounding farmlands, the furthest point they reached in their 16th-century migration westwards. Not surprisingly, they and other local highland tribes seldom descend to the hot and humid swamp country, but they do trade with the Nilotes from time to time. By now the road has climbed above 1,830 metres (6,000 feet) and, in the evening chill, warm clothing and goatskin hats are commonplace. Bedele, a town well-known for its brewery, lies 110 kilometres (69 miles) further on. But as honey is a major product the local *tej* (mead) is as popular as the Bedele beer.

Just a short distance from the town the Baro River begins its rocky descent to the lowland plain in a series of spectacular waterfalls. A few kilometres to the north-east rises the Didessa River, a tributary of the Blue Nile.

A T-junction now faces the eastward traveller, from which the road south leads to Agaro in the heart of the 'coffee country', the Kefa (Kaffa) Region. It is said that Agaro, a thriving modern town, is Ethiopia's richest. Little wonder because so much coffee passes through it for export, one of the country's most important foreign exchange sources. For centuries

Opposite: Traditional Gurage homestead in Ethiopia's verdant southern highlands with their distinctive thatched-roof circular homes, surrounded by groves of enset, the false banana.

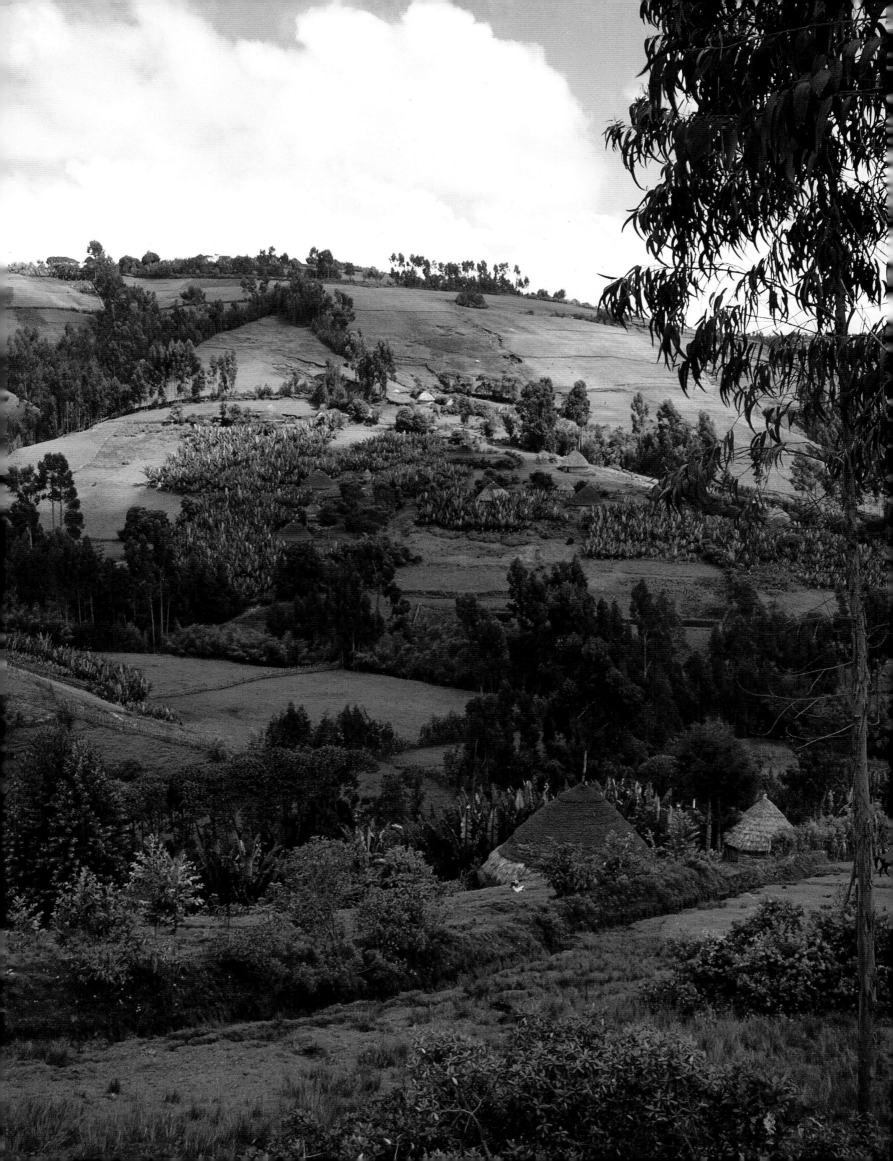

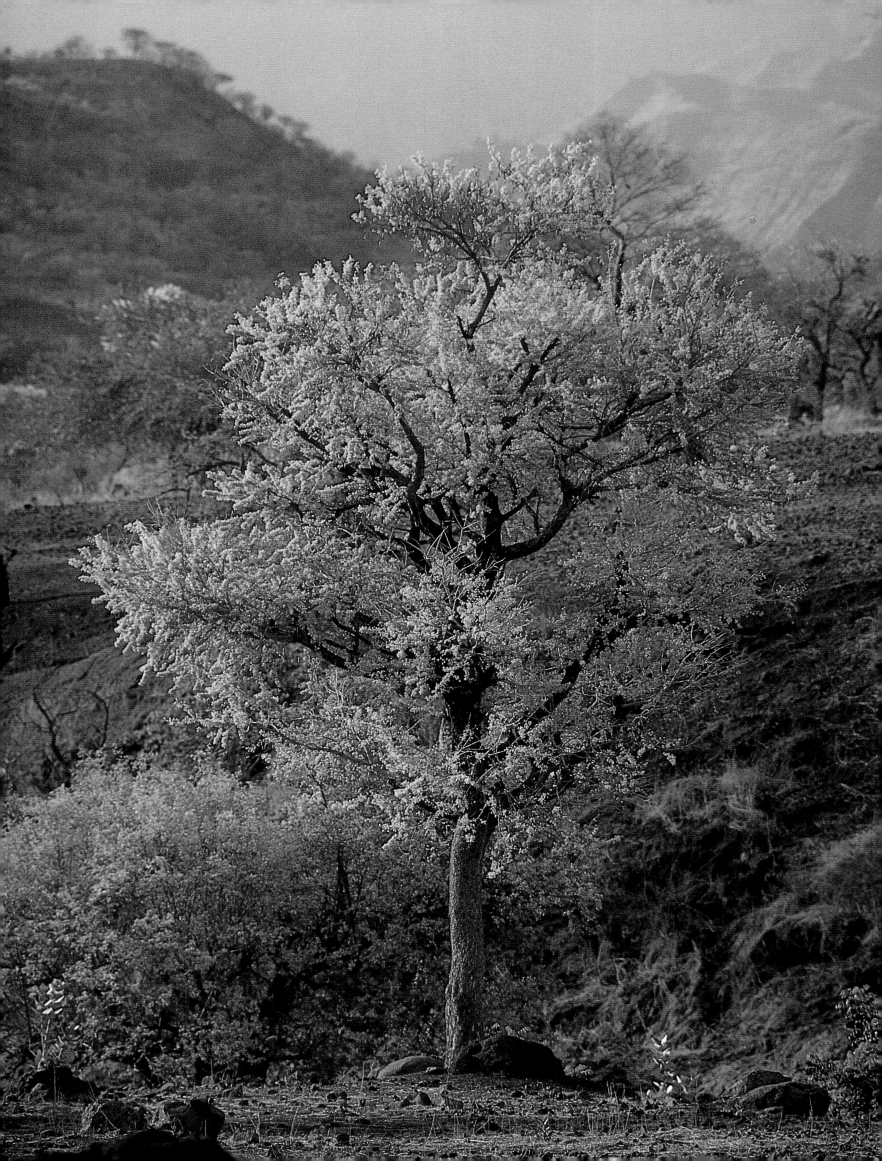

coffee grew wild there. An altitude of between 1,370 metres (4,500 feet) and 1,830 metres (6,000ft) above sea level, just the right amount of rainfall (between 58 and 97 inches), and slightly acidic topsoil is an ideal environment for cultivating high-quality *arabica*. Many highly-productive farms and cooperative societies combine to make Ethiopia one of the world leaders in *arabica*.

Kaffa being free of frost, despite its altitude, also produces many types of grain as well as legumes and root crops. Jimma, one of Ethiopia's main towns, is the regional capital. It originated as the centre of an early Oromo monarchy which at one time extended for 13,000 square kilometres (5,000 square miles). It was conveniently situated on a major trade route, away from any large mountains, deep ravines or major rivers.

The old Jimma kingdom was rich enough to pay tribute to Menelik II when he expanded his territory at the end of the 19th century. According to some historians, the Oromo monarch's palace at Jiren, now a suburb of Jimma, was always crammed with soldiers, servants, eunuchs and concubines, as well as scribes, lawyers and musicians.

In addition to the large group of Jimma Oromo, the Gimirra, or Bench, have lived for centuries in semi-isolation in the thickly-forested part of the Kaffa highlands. At one time they were industrious farmers and fierce warriors, but from the 15th century their culture was almost wiped out by slavers hunting down the Gimirra in the forests like animals.

Large numbers were kept in captivity in the old Oromo kingdom, while others were shipped to Europe and Arabia. It is hard to believe some reports that this persecution went on until the middle of the 20th century. Now the remaining Gimirra cling to their cultural identity, at one time in danger of disappearing. The name 'Gimirra' means 'honey collector' or 'tree climber', which denotes one of their old occupations, apart from hunting wild animals. Bees have great significance for the people who also cultivate millet, barley, *teff* and *enset*. The thick forests, once the Gimirra habitat, have been depleted to make room for food and coffee production. Indeed, many areas of Ethiopia have suffered environmental degradation due to population and development pressures.

But some areas of this awesome land remain as pristine as when man first walked the remote savannah grasslands and isolated valleys — nowhere more so than in the untouched extreme southern regions of Ethiopia's Great Rift Valley.

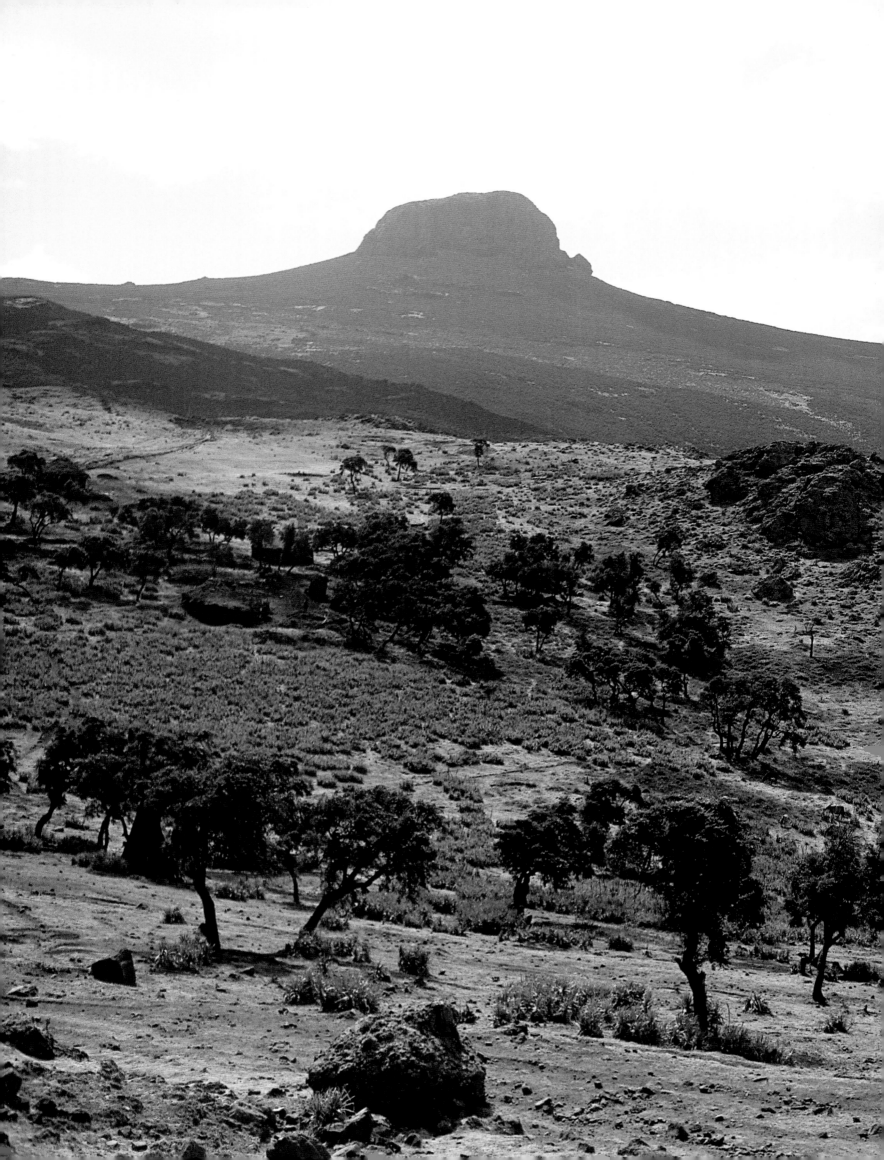

The Great Rift Valley, a deep scar clearly visible from 90,000 kilometres (55,000 miles) out in space, runs more than 8,000 kilometres (5,000 miles) from the Dead Sea, through the Red Sea and down the eastern side of Africa to end as an underwater trench in the Antarctic Ocean. It has been a region of great instability in the earth's crust since its cataclysmic formation twenty-five million years ago. Even today volcanoes, some still active, also steam vents and boiling hot springs, are evidence of the constant movement and activity below the surface.

Within Africa the seam is slowly widening as the eastern segment moves eastwards at the rate of a few centimetres every century. This continental crack divides Ethiopia into two halves.

Along the southern stretch of the Rift Valley, with the high mountain country of the Bale Region to the east and a lower escarpment to the west, the so-called 'southern wilderness' beckons, a place where roads are few but the scenery is unspoiled and enchanting. Its inhabitants, many of whom belong to tribes little known to the rest of Ethiopia, far less to the rest of the world, follow quaint age-old customs which they still value and preserve.

The road south from Addis Ababa through Ghion to the upstream head of the Omo River, perhaps the greatest of all the rivers along the Rift Valley but one which never reaches the sea and empties itself into Kenya's Lake Turkana, is full of fascination, a constant reminder of the varied contrasts of this dramatic country.

This road extends for 335 kilometres (210 miles) to Jimma, and for travellers with time there are many interesting places worth visiting between Addis and the spot where the Little Gibe and Gibe rivers join to form the Omo. Tempting handicrafts are for sale by the roadside and large cattle herds graze the lush grass on either side of the road, and many small villages are surrounded by euphorbia hedges.

Just half-an-hour's drive out of the capital a road branches off to Alem Gena and doubles back again, crossing the Awash River to reach the archaeological site at Melka Konture. There, since 1965, at the entrance to the Awash gorge, geologists and archaeologists have been excavating an area where man's ancestors lived two million years ago. Tools, such as two-edged hand axes, black obsidian 'scrapers' and sets of 'bolas', have been uncovered as well as traces of human shelters and food they ate.

These have been dated to the Middle and Late Stone Ages, but further down, at the lowest levels, simpler 'pebble tools' of an earlier era have also been found. Walking upstream you may see some of these Stone Age tools on the surface, but it is strictly prohibited to collect such artefacts and the local people see to it that this law is observed. Close at hand is the

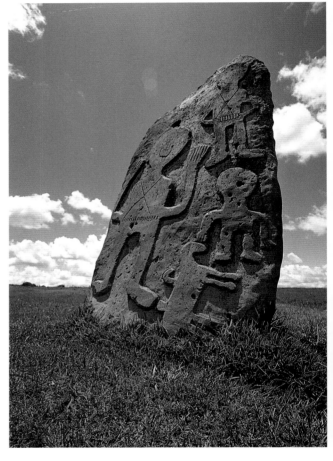

Above: Carved stone in Bale Province, believed to be a tombstone.

Opposite: Palm-fringed hot spring near the Awash National Park.

Adadi Maryam Church, remarkable for the fact that it is carved out of solid rock — one of the most southerly rock-hewn churches in Ethiopia and, as the crow flies, nearly 400 kilometres (250 miles) from the famous churches of Lalibela. However, the Adadi Maryam Church is of inferior workmanship, although legend has it that King Lalibela also had this church built as the last of its kind.

Visitors wishing to view it should seek the services of an Amharic-speaking guide as the church is difficult to find and permission has to be obtained to inspect the interior. Oddly enough, about twenty-five kilometres (15 miles) beyond the church an open meadow in the centre of Tiya village containing a number of stelae (obelisks) is considered as important a prehistoric site as that at Axum and is also listed as a UNESCO World Heritage Site. Many of the small, sharp-pointed stones, similar to the older ones at Axum, are decorated with images of swords

Above: Adadi Maryam, a church hewn out of rock just south of Addis Ababa, although far from Lalibela, is reputed to have been the last church built by the 12th-century ruler, Emperor Lalibela.

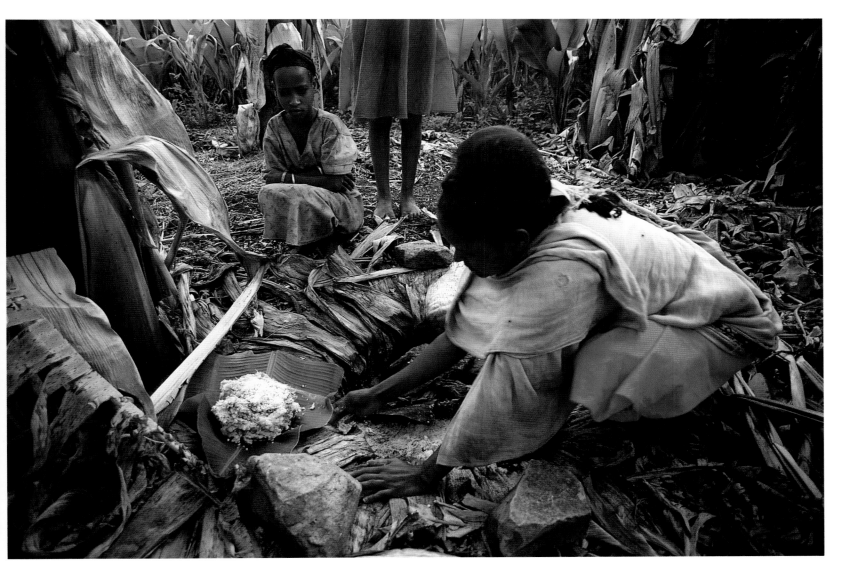

Above: Flour made from the tubers of the enset or false banana, is the staple diet of the Gurage and some other people of southern Ethiopia.

and other items. From there to Ghion the road passes through mountainous country, with the Menagasha National Forest rising on the right. Before Teji village a bridge spans the Awash River, early on its long course to the Danakil Desert.

Ghion, or Weliso, is famed for its natural hot springs, with mineral properties said to cure all aches and pains. The Ras Hotel, built around the springs, has 'bath tubs' the size of small swimming pools and also a number of private cabins built in the traditional *tukul* style. The hotel's main swimming pool, surrounded by grass lawns, ideal for picnics, is also fed from the hot springs.

The town is the home of Abba Wolde Tensa'e, a Christian healer with a long-standing reputation for his cures, usually carried out on Sundays, who also specializes in 'casting out devils'.

The Gurage who live hereabouts are a group of mixed Semitic and

Cushitic stock which speak a Semitic language. They are believed to be descended from military colonialists who long ago came from northern Ethiopia. Now a mixed community of Christians and Muslims they are very hard-working with a self-reliant economy.

Their round huts are distinguished by high roofs. Some holdings occupy up to ten hectares (twenty-five acres), the gardens surrounded by rows of *enset* trees, the youngest on the outside, with the inside rows progressively older and taller.

The trees provide many of the materials on which the Gurage depend. The barks and fibres of felled *enset* trees are used for building and making rope. When dug up, their massive bulbous roots are shredded and then buried again, after being wrapped in leaves. They ferment into a thick, cheesy paste which the Gurage cook for many hours until unleavened flour is produced. This is then baked into a grey, waffle-flavoured bread, their staple diet.

Beyond the *enset* plantations some coffee is usually grown, also the mild stimulant called *khat* (chat) and tobacco. The firewood comes from the eucalyptus trees which dot the green and fertile countryside of the southern highlands. The combination, common in these parts, provides a fairly comfortable lifestyle.

Many huts have walls of woven basketwork and most are extremely spacious, with divisions for sleeping, cooking and living, and some room left for livestock. Beautifully patterned clay pots are a Gurage speciality and many are to be found outside their houses in this meadow-like landscape, one of the most beautiful in the whole country.

Since the region is fairly close to Addis Ababa many Gurage travel to the capital in search of employment and are much in demand for carpentry and other artisans' work. In the old days artisans used to be classed with hunters and treated as a group inferior to other Gurage.

Soon the road drops into the deep valley of the Little Gibe River, which runs into the much bigger Gibe River. There the road crosses the main river before Abelti town. At this point the river's name changes to Omo. It is below the bridge that visitors interested in experiencing the thrills of 'white-water' rafting board the inflatable rubber dinghies to start their adventure.

The south's largest river gushes down the Omo Valley from the central highlands through a series of narrow gorges — until it slows to a meander in the lowland plains to empty itself into Kenya's Lake Turkana.

In the undeveloped south-western corner of Ethiopia the turbulent torrent of a long stretch of the Omo River is one of the most popular places for 'white-water' rafting, a sport that has been developed as a

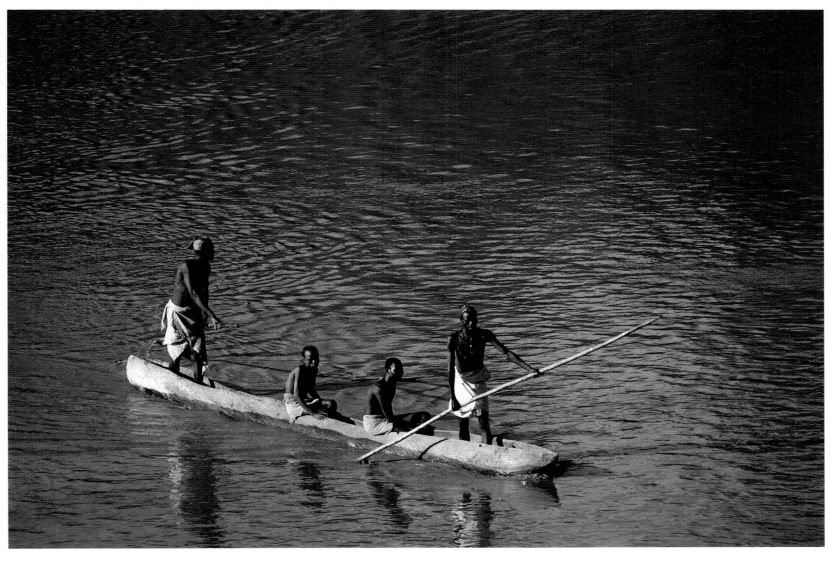

Above: Bume men cross the lower Omo River by dug-out canoe. Most people in this area cross the river on inflated animal bladders.

commercial venture. Inflated rubber rafts tumble and twist as they shudder down the rapids, at other times gliding through silent, still water in gorges so deep they almost blot out the sky.

River-rafting along the Omo and other white water Ethiopian rivers, such as the Awash, features prominently on the itineraries of international travel agencies. These vary from 'white-water' rafting for nine days on a middle stretch of the Omo to a twenty-three-day adventure almost to the river's end at Lake Turkana. Owing to the river's inaccessibility in these deep canyons, the rafts only beach where motorable tracks reach the bank, and crews and passengers may disembark and take on fresh supplies.

It was in 1973 that a group of young Americans, skilled in the art of 'white-water' rafting along America's Colorado River which passes through Grand Canyon, visited the Omo River to find out if all the tales they had heard about the remote African river were true. They had been

told that rafting down it would be an exciting experience. With little preparation or geographical data to guide them they set off in their rubber dinghies and were soon hurtling over turbulent cataracts and sweeping round tight bends. Later they described their experience, far exceeding their wildest expectations, as like being inside a washing machine. Indeed they named one of the roughest sections 'Rinse and agitate'.

But at least they had been forewarned about the crocodiles and the hippos they would encounter. And even before they set sail in their dinghies they named their new African enterprise 'Sobek Expeditions', Sobek being the name of the ancient crocodile god associated with the Nile in Egypt.

In the years since Sobek has maintained its rafting trips down the Omo every September and October (when the river is in spate), with only a few exceptions. After sampling possibilities in other parts of Africa, including

Above: Tourists relax on a quiet stretch of the Omo River after a hectic trip in its turbulent 'white water.' Some journeys can last up to two weeks.

Overleaf: Hippo in one of the pools on a quiet reach of the Omo River.

the Zambezi River, and in such countries as Peru, Pakistan and Papua New Guinea, the pioneers still think the Omo River is the best for this thrilling sport — for the devil-may-care adventurous, but certainly not for the squeamish and faint-hearted.

Once afloat the passengers have no direct contact with the outside world for the next eight or nine days, although they frequently see people collecting water at places where they are able to descend into the gorge. Eventually, dizzy and drenched, the rafters reach a place where a Bailey bridge across the river links the Gemu Gofa Region with Kefa — the only connection.

There the crews change and the dinghies take on new passengers prepared to spend two weeks on the rafts. As the valley widens out to provide some distant views of the many farms and coffee plots in Kefa the swift current eases. Now the Omo heads west for about 180 kilometres (111 miles) until it is joined by a large tributary, the Dincia River, and swings south once more into the Omo National Park.

At this stage the nearest village is a three-day walk away and a motorable road a seven-day walk. Other boats are few and far between as most locals cross the river on inflated goatskins.

In the upper reaches, where the river carves its way through the highland plateau, the gorges are so steep it is difficult to descend to the bank. Where it drops to lower altitudes, the Omo has good beaches on which rafters may rest for a couple of days, explore their surroundings and meet local people, some of whom have seldom set eyes on other Ethiopians, leave alone visitors from other continents. Along the next stretch shorter but still turbulent rapids carry such names as 'Henderson's Hydraulic', 'Potamus Plunge', 'Double Trouble' and the 'Haystack'. They build to a climax once the longer 'Gypsy's Bane' is reached and end in what the raft crews call 'a soaring rooster tail'. But even in deceptively tranquil water, there are dangerous eddies, the worst being a 'keeper hole' which can hold an inflatable raft in its grip for several minutes before escaping. And then . . . the three-part 'roller-coaster'.

The end of the 'obstacle race' comes in the Omo National Park, which extends along the western bank of the Omo for 100 kilometres (60 miles). The park has a 'twin' to the east called Mago National Park. Both cover an extensive area of wild country where there is prolific wildlife. The Omo Park covers 4,000 square kilometres (2,366 square miles); the Mago is smaller, at 2,162 square kilometres (1,279 square miles).

Large herds of eland, elephant and buffalo feed on the vast, rolling grasslands and many zebra and giraffe, with some cheetah, lion and leopard, inhabit this 'lost world', along with gerenuk, lesser kudu, Lelwel

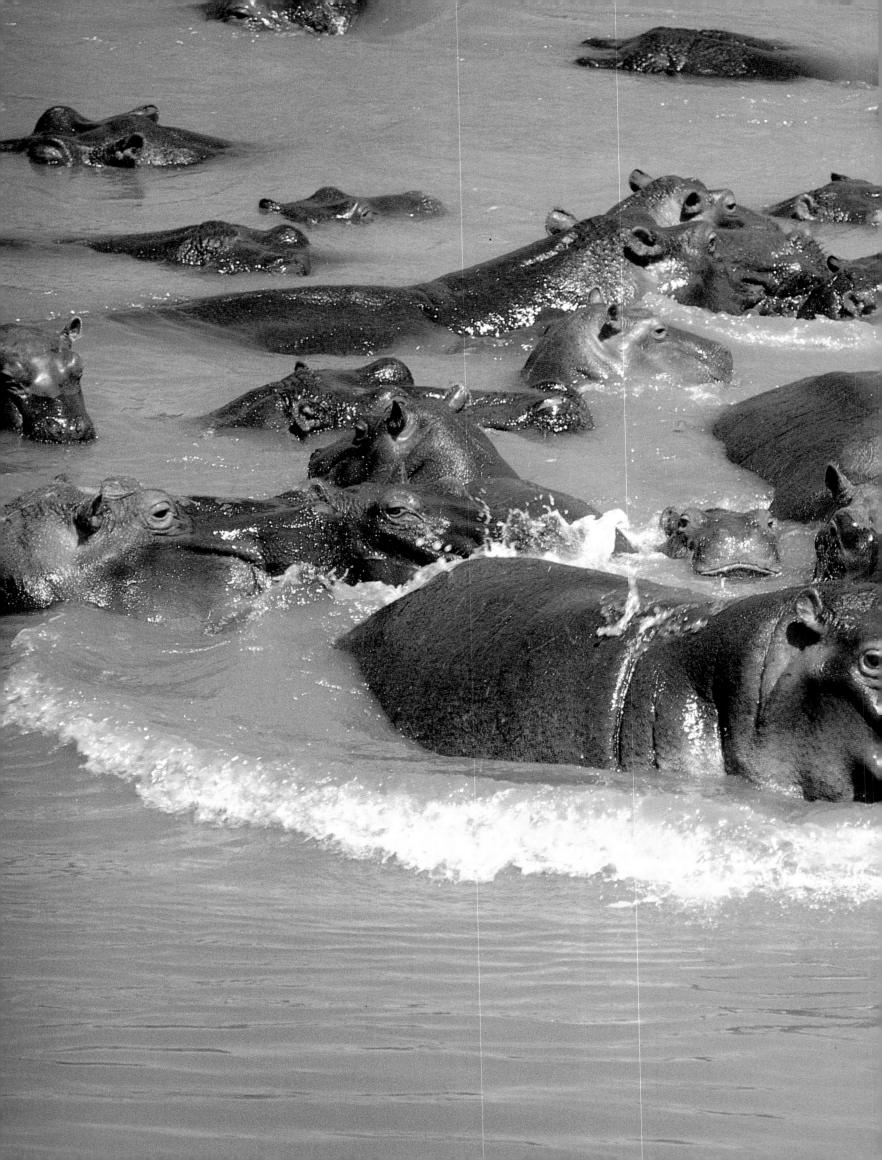

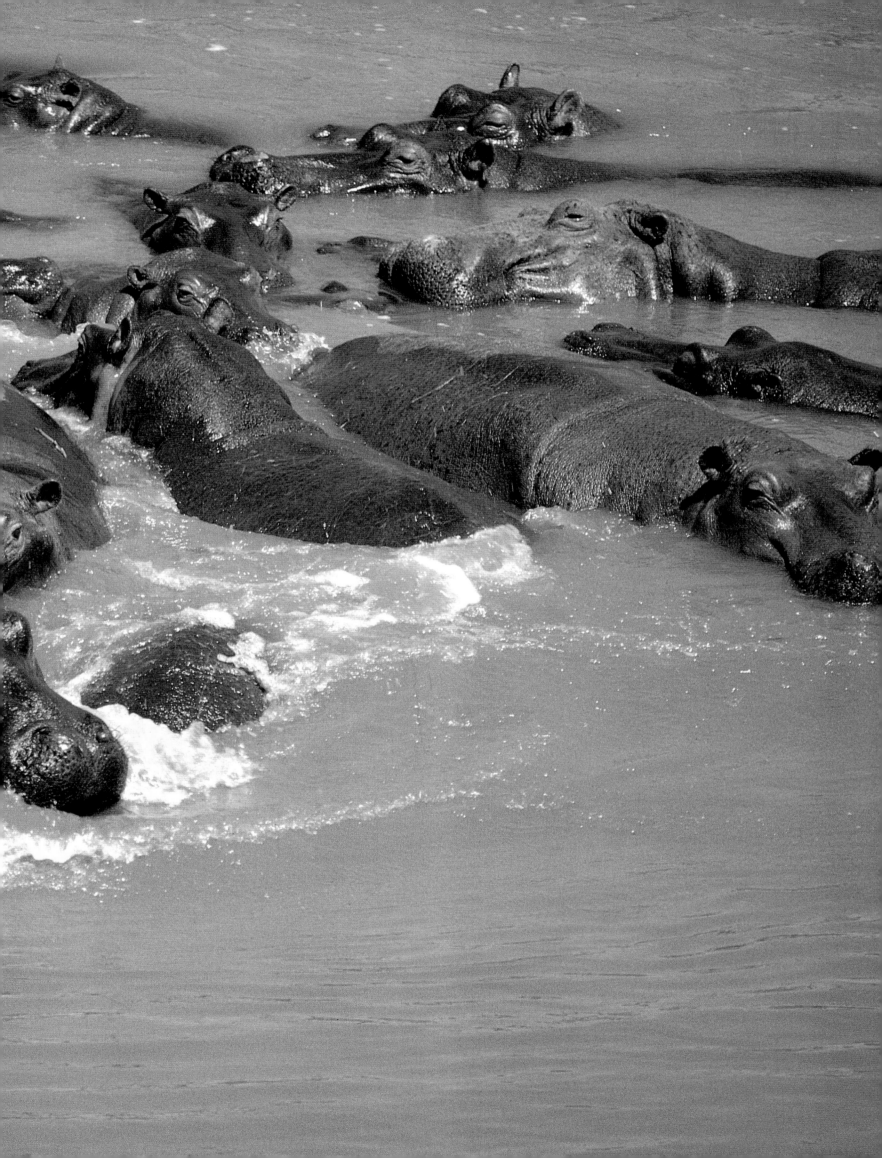

hartebeest, topi and oryx. In the dry season the Lillibai Spring is a favoured drinking spot for mammals and there are more than 300 bird species. Like the Omo park, Mago National Park is difficult to reach due to lack of scheduled air services. The only regular flights are to remote Jinka which is linked to Arba Minch by an all-weather road. But there are few if any vehicles for hire when you get on the ground.

And land vehicles have to traverse rough tracks and cross rivers by ferries which do not always function. Local authorities are trying to improve access roads and a German-aid organization has upgraded roads in the Mago and Omo National Parks.

Conservationists believe that the vast underdeveloped borderland in Ethiopia's far south-western corner will remain an unspoiled paradise for naturalists long after wildlife in neighbouring countries becomes extinct because of wide-scale poaching and growing human pressure for more grazing and arable land,

On the fringes of the national parks, the lower Omo Valley is home to an astonishing mixture of small, contrasting tribal groups. Lifestyles are as varied as the people themselves. The Mursi and the Surma, best reached from Mago Park, mix basic subsistence cultivation with small-scale cattle herding and lead lives of harsh simplicity, uncluttered by the pressures and anxieties of the modern world outside.

Above: Mursi woman with large, traditional clay disc inserted in her lower lip.

Both tribes are renowned for the strange custom followed by their women. On reaching maturity they have their lower lips slit and circular clay discs inserted. This results in a bizarre appearance to the stranger but to the Mursi and the Surma it adds to the women's beauty — the larger the disc the more desirable the wearer. The discs measure up to ten centimetres (four inches) in diameter.

Oddly enough, thousands of kilometres to the south of the continent, the Makonde of Tanzania and Mozambique follow a similar custom. Anthropologists suggest it was an old and deliberate practice, not for beauty, but to make the wearers so repugnant that slave-traders would shy clear of seizing such girls for the harems of Arabia.

Many communities along the Omo Valley, with no other materials like paper or canvas on which to express their artistic impulses, practise body scarification. Mursi warriors still follow the custom of carving deep crescent-shaped incisions in their arms to show the number of enemies they have killed in battle. The Surma and their Karo neighbours utilize various clays and vegetable dyes to trace amazing patterns on one anothers' faces, chests, arms and legs.

As they live so close to the soil, mud is one commodity never in short supply and they splash it liberally on to their heads. Hamer women wear

Above: Mursi men of the lower Omo Valley play a game of 'bao', a traditional form of recreation popular throughout much of Africa.

their hair in dense ringlets smeared with mud and ghee. If they are lucky to find some strips of shiny metal, they add one or two to their hair style. Most trendy are the aluminium plates hanging from their foreheads. The Karo men and their Garebe neighbours sculpt their hair with mud into extravagant shapes, topped off with a red-ochred mud 'cap' to hold an ostrich feather or two. As they seldom wear any clothes, some wily ones work a few banknotes into the mud 'cap' which doubles up as a 'wallet'.

Goatskins are plentiful and most women wear leather skirts, often embroidered with colourful beadwork or cut into long strips. For an 'eye-catcher' a leather skirt fringed with an array of shiny nails that jingle in motion never fails. Women's jewellery consists of shiny metal or wire worn as bangles or necklaces.

Among the traditional ceremonies are ritual stick-fights performed by young Surma and Mursi men with great vigour, much to the amusement

of the eligible girls in the audience. For the Hamer youths, the 'rite of passage' into manhood is the 'jumping on the bull' ceremony, somewhat reminiscent of those in some Spanish villages. But in Hamer country each young man has to jump on a line of up to thirty bulls, going from one back to another without falling to the ground. The successful entrants then walk out of the arena by a special gateway — and into manhood.

The Omo Valley people and those of the hinterland on either side belong to a common language group called Ometo, not to be confused with Oromo. The Wolayta, one of the tribes belonging to the Ometo language group, close to the Omo River, have an interesting background. Although smaller in stature than their present neighbours they are believed to be directly descended from the original local inhabitants. There are some churches fashioned out of the local bedrock, as in Lalibela, and the area is dotted with stone monoliths of unknown origin. But the Wolayta have no known connection either to Axum or to Lalibela and its famous hand-hewn rock temples.

The Wolayta also build dome-shape houses, much more spacious than those of their neighbours, with special partitions to accommodate the various family members, their cattle, sheep and goats. According to some, this custom of sharing accommodation with the domestic animals not only keeps the livestock safe from predators but also provides 'central heating' on chilly nights. The Wolayta are also known throughout Ethiopia for their erotic dancing.

Another Ometo-speaking group are the Dorze, who extend from the Omo River banks to the hills overlooking Lake Abaya. Once much-feared warriors, Dorze menfolk have settled down to farming or weaving. Many of the rugs and wall hangings made by Dorze weavers are snapped up at the Mercato in Addis Ababa and are also exported around the world. Cotton scarves from there are also much in demand.

Dorze huts are beehive-shaped, made from bamboo, but they are usually much taller than others of this style, rising to about twelve metres (38ft). Every house has its own small garden, surrounded by *enset*, and the Dorze grow vegetables, spices and tobacco — the latter to cater for their insatiable desire to smoke.

When their houses begin to rot, or are attacked by termites, the Dorze simply dig them up and, after sewing bamboo struts around the bases to preserve the shape, mobilize all the neighbours, men, women and children, to carry the structures to other sites. Each house is said to last for about forty years, after which it is abandoned, or burnt, and a new one built.

The land where these groups live is wild and desolate, untouched by

Above: Distinctive beehive-shaped Dorze home built from bamboo and the leaves of enset, the false banana. Once renowned warriors, the Dorze now farm and weave for a living. Their cotton cloth is famous for making Dorze shawls (gabbis), much in demand in Addis Ababa.

time or modern civilisation. Ethiopia's Gamo Gofa Province is among one of the last great untouched wildernesses of the world. It is there at its southernmost tip, just east of what is known as the Ilemi triangle where the borders of Ethiopia meet those of Sudan, Uganda and Kenya, that the waters of Ethiopia's second largest river cut a swathe through a 32-kilometre-wide (20 miles) impenetrable thicket of swamp and papyrus to discharge twenty million cubic metres of life-sustaining water each year into Lake Turkana, East Africa's fourth largest lake. It is there in Ethiopia's far south-west corner that another fossil-hunter's treasury lies. In the lower Omo Valley early humanoid fossils dating back between 1.8 and three million years have been found.

East of the Omo delta lies dry land, punctuated in good years by the seasonal lake of Chew Bahir, in Ethiopia's former Sidamo Province, beyond which lies the dusty desert town of Yabello, the last sizeable town on

the road running south to Moyale and the Kenyan border. Long-distance drivers should note that the carpeted Ethiopian section of the Addis-Ababa-Nairobi road is in much better condition than on the Kenyan side, certainly better than the segment between the border and Isiolo.

A sizeable wildlife sanctuary has been established north-east of Yabello — another for the preservation of Swayne's hartebeest. In addition to the antelope, the area's red soil is home to twenty-four other animal species, including the rare greater and lesser kudu. It is also an important bird sanctuary with about 194 species, including the endemic Stresemann's bush crow and white-tailed swallow. Although there is no accommodation for visitors in the 2,496-square-kilometre (1,477-square-mile) sanctuary, there is an hotel in Yabello.

East of there hot and barren plains of dry savannah and acacia bushes stretch all the way into Somalia. This is Borena (Boran) country, the southernmost Cushitic group, close to the Oromo but with many of their own customs.

Camels and cattle are their livelihood and they spend much of each year searching for grass and water for their livestock. The hostile, unyielding environment does have water beneath the surface, but in places the Borena have to dig deep through the stony ground before they strike the vital liquid.

Such wells, dug down by hand for many metres, have steps built every two metres (6-7ft). These are provided for the teams of men and women who work in unison drawing the water, throwing up their laden giraffe-skin buckets, singing an echoing melody that seems to lighten their daily burden. The person at the top of each well pours the water into a long mud trough where the camels and cattle wait expectantly. The deepest Borena well, recorded by travellers, went down eighteen stages — thirty-six metres (115ft).

The Borena's closest neighbours to the west, the people of Konso District, have been described as being almost cut off from the outside world, totally unaffected by other cultures, except for their dealings with their neighbours, the Borena (Boran). Their main trading items are cowrie shells and salt. Like the Oromo, the Konso have adopted the age-grade system of local government, but are entirely traditional in religion, with a strong attachment to serpents, which they see as powerful spirits ruling their lives.

In such dry territory people have to make the most of the scanty rain they get, so the Konso have had long experience in building dry-stone walls and stone terraces before they plant. As stones abound there they make much use of them — for building dams, grinding grain, sharpening

Above: Wooden totems are placed on the graves of the Konso dead.

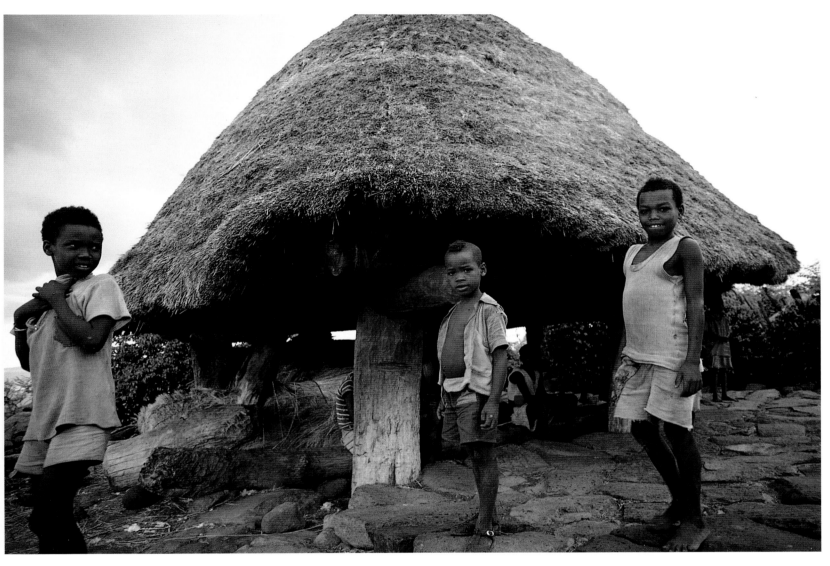

Above: Konso children outside a shelter in their dry, stony country near the Kenya border.

spears and cooking fires. Communal work among the Konso farmers seems to have become habitual down the ages and this greatly improves their harvests of sweet potatoes, cotton and sorghum. Weaving is the local industry, especially thick cotton blankets called *belukos*, which are in great demand throughout Ethiopia.

But the communal spirit doesn't seem to have seeped down into Konso homes, for their small stone or wooden houses have a very special wooden tunnel-like entrance, so low that visitors have to crawl in and out on hands and knees. This, the Konso explain, is so that the residents have sufficient time to judge whether the caller is friend or foe. Friendly visitors, however, are often given huts to stay in. Ninety kilometres (55 miles) north of the Konso's remote lands stands Arba Minch, cool and welcome relief from the burning heat of Ethiopia's semi-arid southern lands. Arba Minch — the name is Amharic for 'forty springs' — is set

amid a country with abundant water, on a high, cool ridge overlooking two of the southern Rift's most beautiful lakes — Chamo and Abaya. A long day's drive from Addis Ababa, the town is served regularly by Ethiopian Airlines.

Perched on the foothills of 4,200-metre-high (13,440ft) Mount Guge, Arba Minch, with just one modest hotel, is directly opposite the Nechisar — 'white grass' — National Park entrance.

The two lakes it overlooks are divided by a hilly ridge with the delightful name of 'the Bridge of Heaven'. Extending for 1,600-square kilometres (946-square miles), Lake Abaya is not only the longest but also the largest of all of Ethiopia's Rift Valley lakes. Its reddish-brown mineral water contrasts with the clear blue waters of its southern neighbour, Lake Chamo. Many small rivers empty into both lakes.

Crocodiles and hippos abound and hippo hunters from the local Ganjule and Guji tribes carry on a lucrative trade in those parts of the lakes not inside the national park. And there is a crocodile market at the mouth of the small Kulfo River which flows into Lake Chamo. North, on

Above left: Saddle-billed stork on the shore of Lake Chamo — one of ten stork species found in Ethiopia.

Above: The white-billed starling, endemic to Ethiopia, favours cliffs and gorges near waterfalls.

Opposite; top left: Thick-billed ravens are the commonest crow species found in Ethiopia.
Top right: African pied kingfisher, one of the nine species found in Ethiopia.
Bottom left: Sacred ibis are found throughout Ethiopia, especially near swamps, river banks and ploughed fields.
Bottom right: The Abyssinian ground hornbill is widespread in grasslands up to 3,000 metres above sea-level.

the shores of Lake Abaya, is a crocodile farm, also outside the park boundary. Both lakes boast a rich birdlife. There is excellent fishing, especially for Nile perch, which can weigh in at more than 100 kilos (220Ibs). These fish are fairly easy to catch, but the spirited 'tiger fish', also plentiful here, live up to their name and give anglers some real sport.

Visitors to the Nechisar Park are cautioned to avoid the rainy seasons as the black cotton soil tracks in the park may bog down even the most powerful 4WD vehicle. Under a German aid project to give employment to former soldiers, Nechisar Park roads have been upgraded.

From Arba Minch the Amharo mountain range, rising to 3,600 metres (11,520ft), bars direct access to the main Addis Ababa road. While some old maps indicate a secondary track leading to the town of Dilla, the recommended route nowadays is an all-weather gravel road that runs eastwards through Sodo.

From Sodo the road descends to the floor of the Rift Valley and the busy 'crossroads' town of Shashamene where long-distance trucks weave their way between gesticulating drivers of local horse-drawn carts and high street traders.

Another interesting wildlife reserve known as the Senkele Sanctuary, located a short distance from Shashamene, was set aside especially to preserve Swayne's hartebeest, one of Ethiopia's endemic species. However, they have all perished. Also found in the open savannah country, alternating with wooded patches of this little-developed area of fifty-four-square kilometres (32-square miles) are Bohor reedbuck, a yellow antelope, oribi, a smaller version of reedbuck, as well as some rare greater kudu. And there are ninety-one bird species.

To the south, the main highway to Kenya passes through Yirga Alem and Wendo, where a fork east leads to the gold-mining country around Kibre Mengist. Unlike South Africa's Witwatersrand, however, mining operations are surrounded by secrecy and strict security precautions. Visitors are discouraged, but if they keep to the main road they can pass through towards Dolo on the border with Somalia without any problems, other than car searches at police roadblocks.

Further northward the main road reaches the beautiful town of Awasa, close to a popular weekend resort for Addis Ababa's citizens. The smallest in the chain of Rift Valley lakes, Lake Awasa is only twenty-one metres (67ft) deep but lies in a setting of great beauty. The surrounding country-side is fertile with farms growing coffee and tropical fruit, much of which is exported to Europe. Awasa town is the capital of the Southern Ethiopian Nations, Nationalities and Peoples' Administrative State — formerly Sidamo — an important centre with several good hotels, some

Above: Male black-winged lovebird, one of Ethiopia's 800 different species of resident and migratory birds.

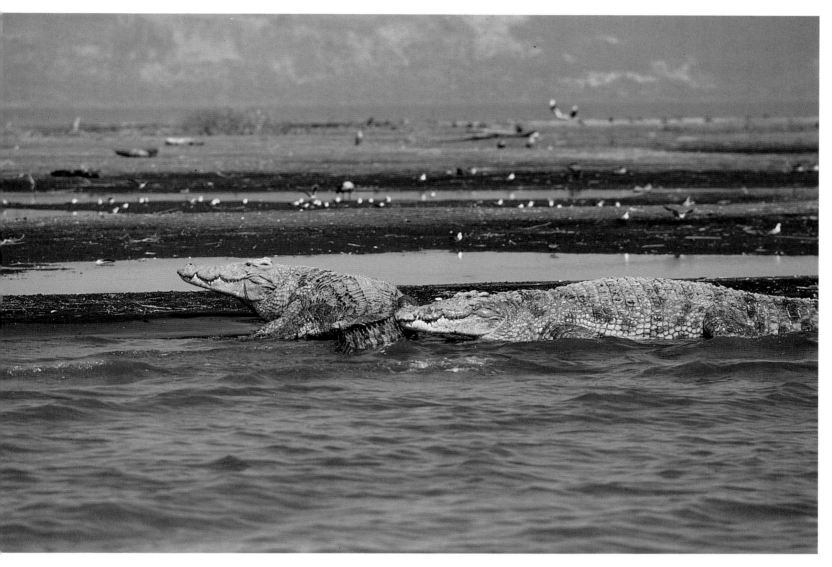

Above: Nile crocodile seek the warmth of the sun on the shores of Lake Chamo. They are so numerous that the reptiles are hunted commercially outside the Nechisar National Park, which also extends to the adjoining Lake Abaya.

by the lakeside, together with good campsites. The lake's waters are host to barbus, tilapia and catfish and a fascinating variety of birdlife, with an abundance of storks and herons mingling with kingfishers, darters, plovers, wild ducks, Egyptian geese, crakes and cormorants. A track suitable for 4WD vehicles which encircles the lake offers good views of the surrounding Sidamo countryside.

The Sidama people, who live in the northern part of this expansive region which stretches all the way south to the Kenyan border at Moyale, are well known for the plentiful coffee they grow there as well as in neighbouring Kefa and Gamo Gofa to the west. While many Sidama follow their traditional beliefs, there are also many Christians and Muslims.

Traditionalists believe implicitly in 'the eye' (evil spirit) and in sacred groves of trees. Some keep pythons in their homes, regarding them as

reincarnations. The reptiles also provide effective guards against robbers. The bamboo that grows profusely on the mountain slopes on either side of the Rift Valley is used by the Sidama for building houses. The bamboo is woven into a framework which is filled with fresh grass and the broad green leaves of the *enset*, or 'false banana' when the rainy season approaches. The result is an attractive beehive-shaped hut with a small porch at the front entrance.

It is customary for family members to occupy the right side of such huts with livestock kept on the left side. While the men build the huts, they grow vegetables with their wives' help. Only women market the crops as well as cleaning the house and cooking.

Along this section of the Ethiopian Rift landlocked Ethiopia's scenic 'Lake District' attracts large numbers of city people as well as foreign tourists. The first of these, a fascinating trio of lakes — Shalla, Abijatta and Langano — straddle the main road just north of Awasa.

Lake Shalla which, at a depth of 200 metres (640ft), is the deepest of all Ethiopia's Rift Valley lakes has a symbiotic relationship with Lake Abijatta, just to the north, but secluded by a ridge of land that rises to 1,500 metres (4,800ft) at the summit of which is Mount Pike. In contrast to Abijatta, Lake Shalla's water is extremely saline, with hot, sulphurous springs bubbling up on the shores. Its tawny water, described by some visitors as 'like cold tea', is soapy to the touch. Because of this the lake contains hardly any fish.

This is where the symbiotic relationship between Shalla and Abijatta comes in. It concerns the large colony of great white pelicans which because of their quiet, undisturbed atmosphere has chosen islands in Lake Shalla as breeding grounds. But the lake's soda waters do not contain enough fish to feed the pelicans. Thus, every morning at about 10 a swarm of pelicans make use of a convenient thermal current of air to waft them up and over the ridge between the two lakes and skim down again to land on Lake Abijatta. When they catch enough fish to take back to the breeding pelicans on Lake Shalla another thermal conveniently wafts them 'home' again.

In the 1960s two films made there by Dieter Plage for the British television series *Survival* so impressed Emperor Selassie that he insisted on going to Lake Shalla and sailing out to Pelican Island to see the morning exodus for himself. As a result, he ordered the authorities to formally gazette the twin lakes as a national park.

An ingenious cameraman, the German film-maker borrowed a stuffed pelican from the Addis Ababa museum and converted it into a floating 'hide' which enabled him to float with his Arriflex cine-camera close up to

Above: Fertile lands of what was formerly northern Sidamo, produce many fruits including pineapples, in colourful contrast to the semi-arid country in the south.

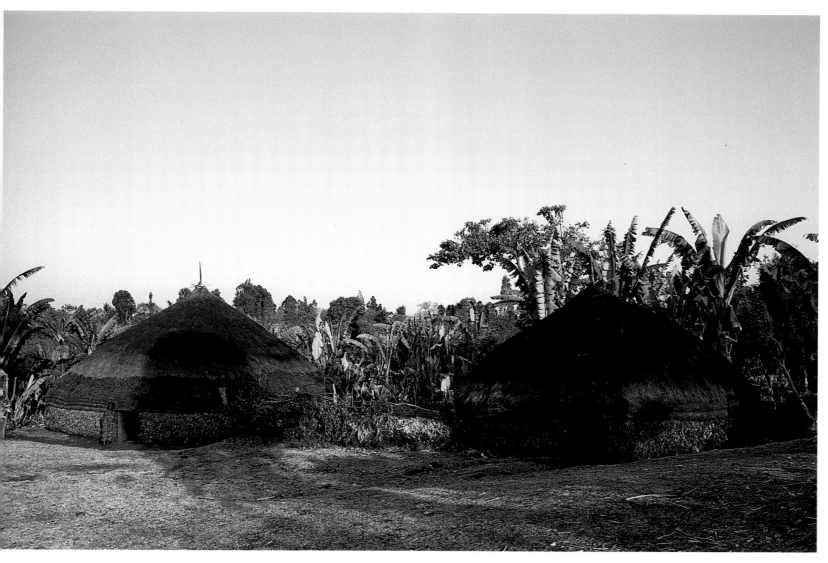

Above: Sidamo huts amid a grove of enset, the 'false banana', which provides tubers that when pounded into flour provide the population of this southern province with their staple diet. Rich in starch but deficient in protein, doctors consider it has little nutritional value.

the pelicans and secure some amazing pictures for his films *Air Lift* and *Pelican Fly-away*. But one day during the 'shoot', when he returned to shore and removed the pelican head, he found that he had been followed by a baby pelican which thought Plage was its mother. It stayed with the beached dummy 'head' all night and returned to its rightful parent only the next morning.

Lake Abijatta's clear-blue waters are a glittering contrast to brownish Lake Langano. With abundant birdlife and filled with various kinds of fish, not only is this a great lake for fishermen but for bird fanciers, too.

Just east of Abijatta, on the other side of the main road, Lake Langano, popular with enthusiasts for water-skiing, sailing, boating and wind-surfing, has several sandy bays and good campsites as well as an hotel.

The nearest to Addis Ababa — 160 kilometres (100 miles) to the north, along a good asphalt highway, more or less a two-hour drive — of this

necklace of seven scintillating lakes is Lake Zuway which lies east of the main highway. From the road the first glimpse of the lake is through a sparse screen of tall trees. As the lake is fringed by reedy swamps, the best views are from boats which can be hired easily.

Five islands dot Zuway, three of which have old Orthodox churches on them. One, formerly known as Debre Sion, or Mount Zion, has an old monastery which contains a vast collection of ancient illustrated manuscripts. Legend has it that at one time the Ark of the Covenant was kept in the monastery after being brought secretly by Axumite priests to prevent capture or destruction when Axum was overrun. Many reed boats, *tankwa*, ply Lake Zuway, a paradise for local fishermen. The fish are also a great attraction for myriad aquatic birds, including knob-billed geese, pelicans and saddle-billed storks. All these lakes lie in the lee of two great mountain ranges where the eastern Rift escarpment rises dramatically to

Above: African jacana, known as a 'lily trotter', on Lake Awasa in the Rift Valley.

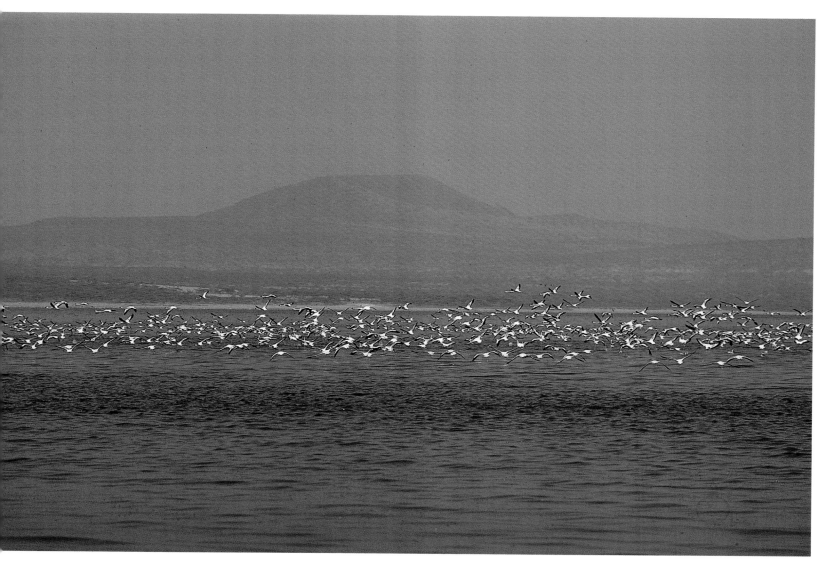

Above: Flamingos on Lake Abijatta in the Rift Valley.

form the Arsi Mountains, which stand between 3,500 and 4,000 metres (11,200-12,800ft) high, and the even more magnificent Bale Mountain range. Many of those who live in this area of the Rift are Oromo, a huge group from the slopes of the Arsi Mountains which spreads in a wide southern arc from south-western Ethiopia to the south, south-east and into the north-east, all in an area now called Oromiya.

The Oromo are divided into six main groups and some 600 sub-groups. Although their customs vary in some respects the one common thread linking all Oromo is the Geda (age-grade system) by which they were traditionally governed. Under the system a man's life is divided into age-sets of eight years each, sons following normally two age-groups behind their fathers. When they reach the fourth set, between the ages of twenty-four and thirty-two, they govern the other people in the Oromo group. After eight years in power the men pass this on to the following age-set.

Once a nomadic race, the Cushitic-speaking Oromo now lead a more sedentary life farming the more fertile areas. In the more arid lands, however, they still keep herds of cattle. In central Ethiopia they have mainly embraced Christianity but Islam has a strong hold on the rest. Others retain their traditional religious beliefs.

Nowadays Oromo men wear the typical Ethiopian white toga, the *waya*, while women wear either leather skirts embroidered with colourful beadwork or simple white cotton garments. Oromo, such as the large Arsi group, keep many cattle and the beasts play a major role in society. Cattle dung is used with mud to 'cement' hut floors and walls and to provide cooking fuel and, where necessary, heating. A man owning more than 1,000 cattle is by tradition entitled to wear a 'crown' of straw or some other local material.

Their circular dung-and-mud walled houses are roofed with grass in

Above left: Young Bale man in the lowland plain.

Above: Market-women in Goba town.

Above: Oromo mountain boy.

the shape of a high dome often topped with an ostrich egg or a pot, serving as a fertility symbol.

Ethiopia's second-largest mountain complex — including the Bale Mountain National Park which covers a far larger area than the Simiens — is also Africa's most extensive Afro-alpine habitat. Much of the park is a vast moorland which rises from 1,500 metres (5,000ft) to over 4,000 metres (13,000ft). Its mountains are the source of two of Ethiopia's major rivers, the Webi Shebelle and the Genale-Weyb, which flow south-east into Somalia and the Indian Ocean. Over centuries they have carved out deep gorges with spectacular waterfalls.

The steep Harenna Escarpment, running east-west, divides the park into two — one section at a low altitude and the other a highland area culminating in the highest point in southern Ethiopia, Tullu Deemtu at 4,377 metres (14,300ft) above sea level. A major part of the peak area, a capping of some fairly recent lava flows, is bare of vegetation but has some dramatic rock pillars and ripples.

For zoologists, Bale has two major attractions — the shy, elusive mountain nyala, only found in Ethiopia, and the Simien wolf, in much greater numbers than in the Simien Mountains Park. The mountain nyala (*Tragelaphus buxtoni*) belongs to the same family as the kudu and the small bushbuck.

Experts say that for all practical purposes it should be regarded as a high-altitude race of the greater kudu, but not quite so large. The adult male horns have a similar shape to those of the greater kudu, but have only one-and-a-half turns instead of the kudu's two-and-a-half turns of the spiral. Its thick chocolate-coloured coat has white stripes on the back. Above each hoof there is a white 'garter'. The mountain nyala live in Bale, the adjoining Arsi mountains and the Chercher Mountains near Harar.

In addition to the Bale National Park a more recent mountain nyala sanctuary has been established at Kuni-Muktar, near Asbe Teferi, just off the road from Addis Ababa to Harar and Dire Dawa.

Apart from the Simien Mountains Bale National Park is the only place in the world where the Simien wolf is found. As its main diet are certain rodents, especially giant mole rats, they live mostly at high altitudes. The park's Sanetti Plateau is an especially good area to find them, usually hunting alone. After the breeding season, however, as many as eight adults and cubs may be seen together. Among the larger and more commonly-seen mammals in the Bale Mountains Park are bushbuck, reedbuck, klipspringer, duiker, warthog, golden jackal, spotted hyena, serval cat, Egyptian mongoose, Abyssinian hare, rock hyrax and giant mole-rat. There is no tourist accommodation in the national park, only

Above left: Aloes are common to the Bale Mountains.

Above: In such an Afro-Alpine environment as the Bale Mountains groundsel grows to astonishing heights.

camping under certain circumstances. However, there is the Ras Hotel at the regional capital, Goba, which may be reached by turning east out of the Rift Valley into the Bale Mountain country to Dinsho and the park headquarters, then Robe and finally Goba. An alternative road from Addis Ababa passes through Nazret then turns east through Arsi along the Rift's eastern wall to Adaba to link up with the road from Shashamene. The Bale Mountains National Park is essentially for trekking (on horseback or on foot). Horse treks of several days into the main peak area, with both pack and riding horses and a guide, may be arranged with the park authorities at Dinsho. Short walking tours can be made from Dinsho to the park's northern section. A brief introduction to the park's flora and fauna can be had by taking the one-kilometre-long nature trail up Dinsho Hill. There are camping facilities at Dinsho and at Katcha in the south. Walking through the park increases the chances of spotting the

Above: Trees in the high plateau country of Bale range from hagenia, juniper and African olive to podocarpus, milletia and celtis.

shy mountain nyala at close quarters. At the Dinsho end of the sanctuary as many as 400 nyala have been seen in one afternoon.

Two hills in the park's northern section are worth climbing if you are physically fit. In terms of scenery and the opportunity to see wild animals at close range Gaysay Mountain is a rewarding ascent. On a clear day the view from its Boditi Peak, 3,520 metres (11,600ft) on the park's northern boundary, gives climbers a spectacular panorama of the lower section of the park.

A longer walk and climb up the Weyb River Valley leads to Gasuray Peak, 3,325 metres (10,970ft). The route passes through mature *hagenia* and juniper forests with tall heather at the summit. A traverse of the northern uplands leads through beautiful heather and grass glades with grey tussocks of 'everlasting' flowers here and there. The paper-like yellow blooms which become profuse once the rains begin may last years after

Above: Rock outcrop on the high plateau of the Bale
Mountains. Local legend is that an Ethiopian version of
Robin Hood used a cave there as his hideout.

being picked. Further south, the Alpine Sanetti Plateau is surrounded by several high peaks. Ethiopia's second highest summit, Tullu Deemtu, can also be tackled from the main road which skirts its base on the east and south. From the road it takes one-and-a-half to two hours to reach the summit. Groves of giant lobelia thrive on the slopes.

Slightly lower, but more craggy and rugged, is Mount Batu, rearing up from the plateau's western side. A leopard has been sighted near its summit, as well as some nyala and klipspringers. They are most at home on such rocky slopes. Birds such as the lammergeier and the smaller chough soar above the cliffs. Horses are the customary beasts of burden in Bale — unlike Simien Park where mules are used exclusively. Riders who plan long journeys on horseback should make arrangements well in advance with the warden at the Dinsho Park headquarters. Guides can show riders some of the more popular routes, which may take three or

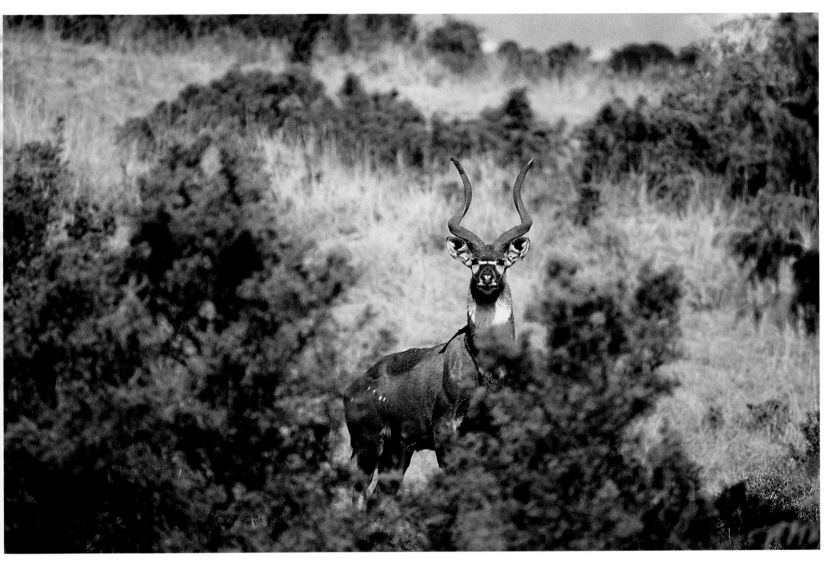

Above: The beautiful, stately Mountain Nyala, one of Ethiopia's rare endemic species, is best seen in the north of Bale Mountains National Park.

four days. For motorists there is equally exciting and impressive scenery to view. The main road from Goba to Addis Ababa runs through the northern tip of Bale National Park and passes the park headquarters at Dinsho. However, from Goba, the main town in the Bale Region, Africa's highest all-weather road climbs up to the Sanetti Plateau, with its chain of tiny tarns. While the plateau itself stands 4,000 metres (13,200 feet) above sea level several surrounding peaks are higher.

From the high plateau with its strange and fascinating Afro-alpine vegetation the road drops suddenly at the Harenna Escarpment through a series of ten dizzying hairpin bends as it zigzags down to the Harenna Forest.

For botanists there is a wealth of wild flowers on the scenic drive through these mountains. Not far from Goba the road is lined with orange-blossomed *leonitis* and in the wet season 'red-hot pokers'

(*kniphofia*) bloom beneath the trees in the forest of juniper and *hagenia* (*kosso*). The forest gives way to a giant St John's wort forest and is soon followed by heather-covered moorlands. Entering the Sanetti Plateau proper the road runs through portals of giant lobelia. The Crane Lakes on the moorland are probably the best place in Bale to find the Simien wolf. On rare occasions even the mountain nyala can be seen there.

Clumps of sagebrush abound in the moorlands whilst on the meadows, banks of streams and the forest floor there are wildflowers too numerous to mention. Some are tiny, others large and showy, some seen all the year round, others only rarely. Back on the all-weather road, as it drops more gradually, the scrub gives way to a lush forest of podocarpus, enormous trees covered with lichens, or 'old man's beard'. Bamboo clumps also grow near the park's southern boundary. About five kilometres (three miles) further on the park road links up with the national road network at

Above left: Lobelia and groundsel on the high plateau of Bale Mountains which has a wide variety of Afro-Alpine vegetation.

Above: Everlasting flowers are found everywhere in the higher altitudes of the Bale Mountains.

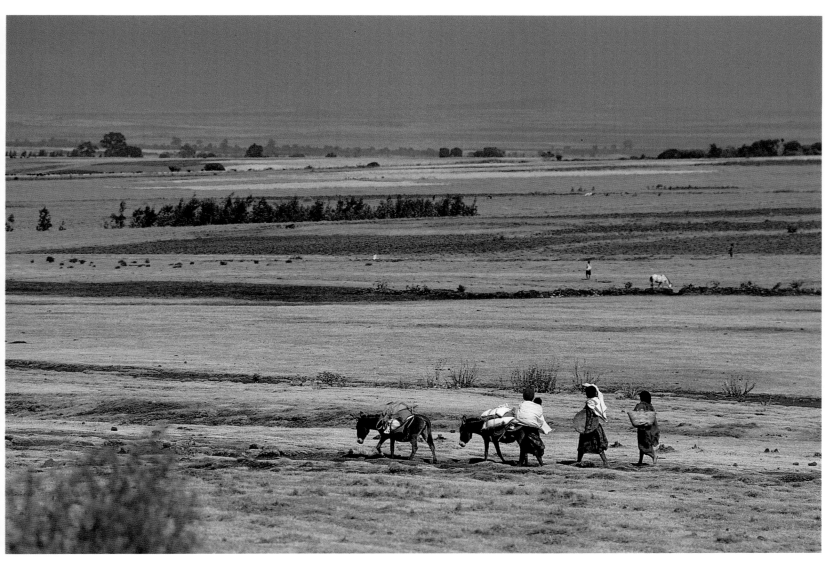

Above: Grain crops cover a wide area of the plains which stretch from the Bale Mountains to the Somalia border.

Mena. While in Bale one natural wonder worth visiting is the network of the Sof Omar Caves on the plains below the mountain complex. These caves, formed by the Weyb River where it enters a vast underworld of limestone and chalk, are 124 kilometres (74 miles) from Robe. The cave's name is derived from a holy man, Sheikh Sof Omar, who took refuge in this hide-away, which has become an important Islamic shrine.

Sof Omar is one of the world's most spectacular and extensive underground systems, with echo chambers, soaring stone pillars and high-arched vaults following the river's course. To walk through this amazing natural phenomenon along the direct route takes about an hour at a good walking pace.

Visitors with time to spare may witness some magnificent rock formations which the Weyb has carved out on its underground odyssey. Of particular interest is the 'Chamber of Columns', where the limestone pillars reach up

to twenty metres (66 feet) to the vaulted grotto's roof. Torches are indispensable there, just as guides are essential to find the route through the labyrinthine passages. Maps of the caves are available from the Ethiopian Tourism Commission, but most guides carry maps with them. Bats abound, as in most caves. But although the Weyb River is infested with crocodiles the reptiles, fortunately, stay away from this dark maze, preferring the sunshine outside.

Surprisingly, another Islamic shrine, which attracts pilgrims from all over eastern Ethiopia, is in an even more isolated location, near the Wabi Shebele River. At this point the river forms the boundary between the Bale and the Arsi regions and is just a short distance from the Harerghe border. This is Shek (Sheikh) Husen, named after another Muslim holy man who lived at this remote spot years ago.

The white chalk taken from the wall surrounding Shek Husen's large complex of mosques, tombs and shrines is greatly revered by the faithful. They take pieces of it back home to treasure. Pilgrims make the long journey on foot by the thousands from distant places to this arid part of Ethiopia, many doing so twice a year.

Those who journey north along the Great Rift Valley and the Awash River come first to the Awash National Park, more than 213 kilometres (133 miles) downstream and then Yangudi-Yassa National Park

Standing beside Awash National Park, the Awash station is an important stop on the railway line from Djibouti to Addis Ababa. The town lies at the junction of the road northward to Assab and another to Dire Dawa and Harar. As the national park is only a four-and-a-half-hour drive from Addis Ababa, it is a popular place where you can see a wide variety of animals and birds in its 827-square kilometres (489-square miles) area, dominated by the extinct Fantale volcano.

Both greater and lesser kudu are found there as well as Beisa oryx, Soemmering's gazelle, Swayne's hartebeest, Salt's dik dik and Defassa waterbuck. Among the felines are leopards, serval cats, the lynx-like caracals and wildcats. Lions are sometimes seen and there are two species of baboon, also grivet monkeys and the black-and-white colobus monkeys which leap from tree to tree as if in flight. In the crags which surround the Fantale crater more sure-footed creatures, such as klipspringers, reedbucks and oryx abound. The volcano last erupted in 1820 and the signs of that lava flow can be seen on its southern slopes. A spring at the extreme northern end of the park spouts water as hot as 36°C (96.8°F).

There the Awash River plunges 600 feet (187 metres) down a dramatic waterfall to enter a gigantic gorge where a seventeen-kilometre (10 miles) stretch of river ideal for white-water-rafting ends at a beach beside the

Opposite: The eerie Sof Omar cave to the east of the Bale Mountains is one of the most spectacular and extensive cave systems in the world.

Overleaf: Lake Awasa, a popular resort for Addis Ababa residents, offers opportunities for fishing, boating, swimming, and bird-watching.

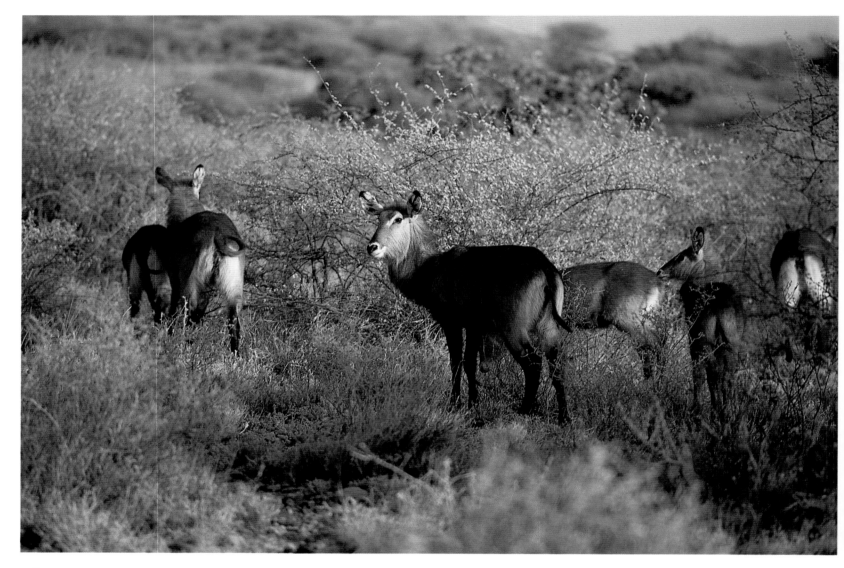

railway station. A scenic site overlooks the magnificent waterfall. The larger Yangudi-Yassa National Park, a little-developed animal reserve of 4,730 square kilometres (2,799 square miles) which lies further north alongside the Addis Ababa-Assab highway, is the home of the almost extinct wild ass.

Among other rare animals now protected there are Soemmering's gazelle, Grevy's zebra, as well as gerenuk (a goat-like animal with a long neck), Beisa oryx and Hydramus baboon. It is also an excellent place for bird life accustomed to such arid areas.

South-east of the park, vast and arid, stretch more semi-desert lands of Ethiopia and a high plateau where lies the last stage of the 'Historic Route'.

Above: The Defassa waterbuck is one of the many ruminant animals in the Awash National Park.

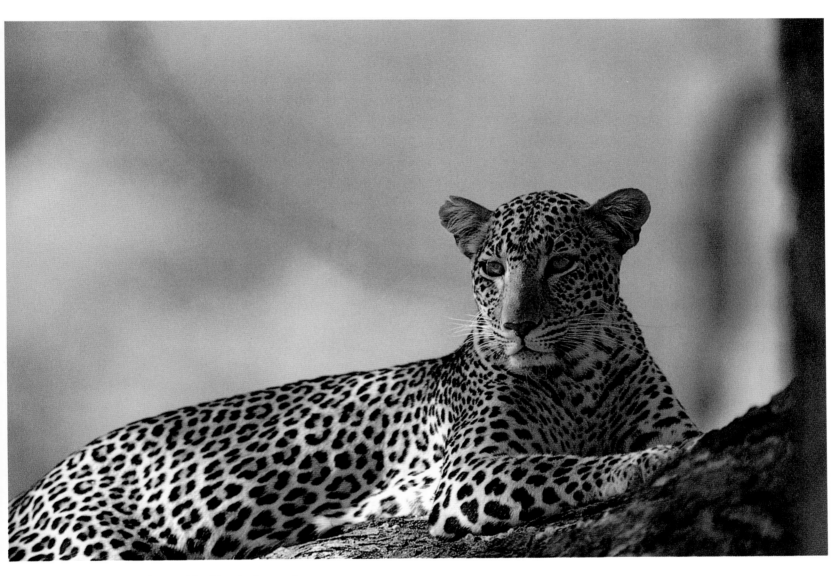

*Above: Rare sighting of a leopard basking in the sun in
Awash National Park.*

Previous pages: Harar, once a city state and still the fourth most sacred Islamic site in the world.

Ethiopia's largest and least-developed region is Harerge in the strategically-important south-eastern corner of the country. Its remotest area, the Ogaden, is a huge wedge projecting deeply into neighbouring Somalia.

Yet despite its size, Harerge has only two all-weather roads — one running south from the highland city of Harar, towards Somalia, the other heading north-east towards the Eritrean port of Assab, near the southern end of the Red Sea.

For visitors from overseas the old city of Harar is the main attraction in the entire region although it has neither a railway station nor an airport. The nearest are at Dire Dawa, linked by a good asphalt and scenic road which winds its way down the mountain slopes. The 1984 census gave Harar a population of 63,000 and Dire Dawa about 100,000, making the latter the second largest Ethiopian town after Addis Ababa.

Despite its remoteness from the central plateau and Addis Ababa which lies 523 kilometres away (326 miles), Harar has long had its own culture and a language called Adare, not known anywhere else. For centuries it was an exclusively Islamic centre with strong trade and cultural links with Yemen. It had little contact with the Ethiopian mainstream until Emperor Menelik II incorporated this age-old Muslim city state into his empire by military force.

Harar's five stout gates — the only means to enter or leave Harar's centre — have been strongly guarded over the years. Behind these walls, erected in the mid-sixteenth century, the citizens built up the city, concentrating on trade with Arabia, India, and even China. This important commercial link with the outside world made Harar famous as an international trading centre.

The intrepid British traveller, Sir Richard Burton, one of the later visitors to Harar, stayed there incognito as a Muslim in 1854. Referring to Gragn's holy war against Ethiopia's Christian Church and Gragn's own killing by the Portuguese, he wrote: 'Thus perished the African hero who dashed to pieces the structures of 2,500 years.'

Local agriculture thrived in the fertile soils of the Chercher and Ahmar Mountains and Harar's coffee was in great demand from Cairo to Baghdad. Destined for Aden and Arabia the stimulant weed *khat* (*Cattula aedulis*), permitted for Muslims in place of alcohol, exchanged hands in massive quantities at the Harar market.

Through three centuries Harar retained its international reputation as the fourth most sacred centre of the Islamic world after Mecca, Medina and the Dome of the Rock in Jerusalem. The most impressive building inside the city walls is the Al-Jami Mosque, whose white-washed minaret

Above: One of the many mosques in Harar. There are ninety mosques and holy shrines – and an Orthodox Christian cathedral – in the city.

Opposite: Old mosque in Harar has been renovated and enlarged.

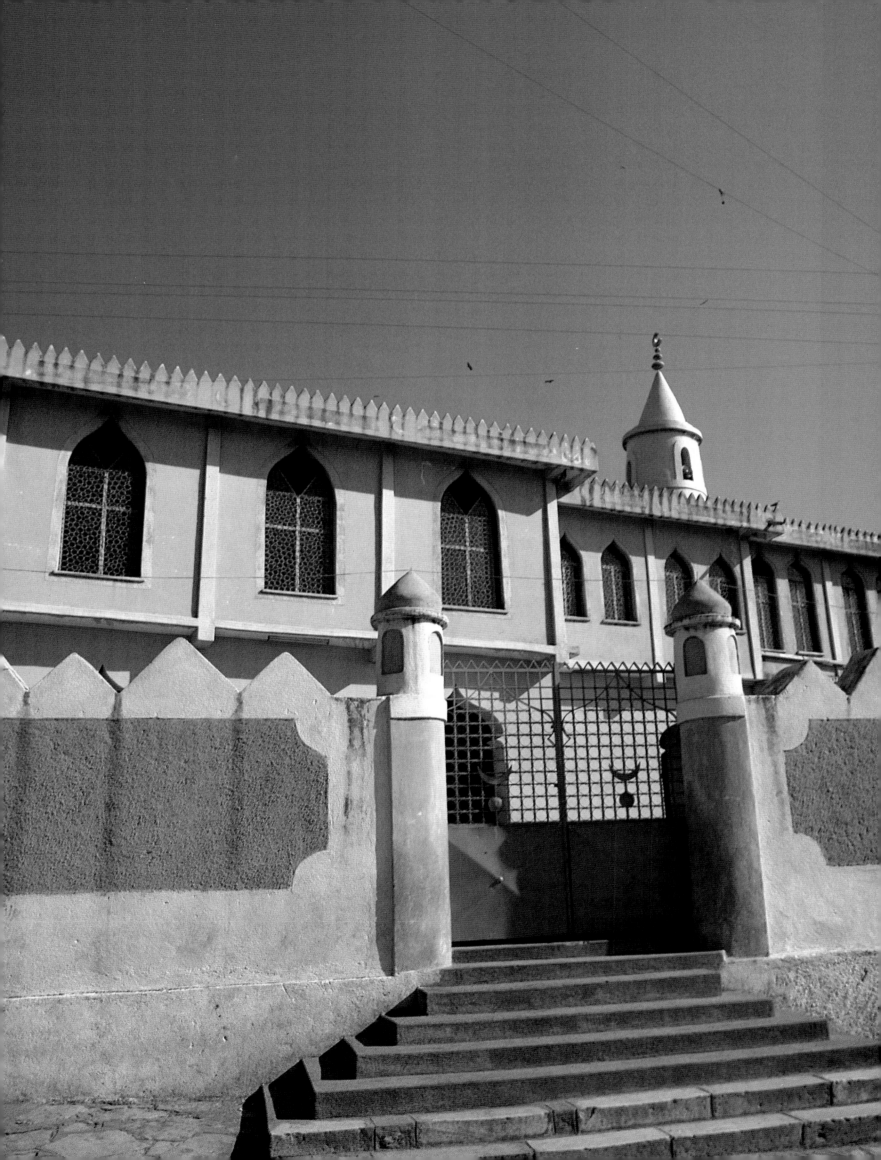

Opposite: Old house with a restored doorway in Harar.

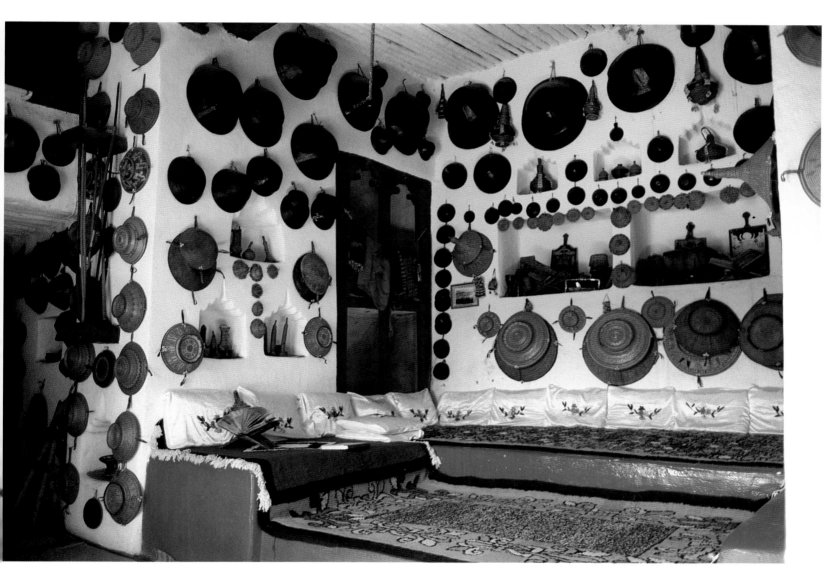

Above: Harari homes are reminiscent of eastern Africa's coastal architecture. Bowls, dishes and basketwork all hang on the wall, but still usable in this Cultural Centre.

still dominates the landscape. There are ninety mosques and holy shrines and an Orthodox cathedral built after Emperor Menelik overran the city-state.

International trade went by a well-worn route through Jijiga to Hargeisa and Berbera port, and Arab and Indian merchants have always been frequent visitors, haggling over their wares in the marketplace of Harar. Most of the silversmiths who plied their craft in the city were Yemeni Jews.

At one time Harar was a market for slaves from all over Eastern Africa and a supplier of eunuchs for Arabia's harems. Although it was long an offence punishable by death to deal in slaves in Ethiopia, domestic serfdom was allowed until about sixty years ago. At other times Harar was ruled by Turks from Yemen and Egyptians. The latter occupied Harar in 1875 after killing its ruler, Emir Amit Abdul Shakur, and the city ceased

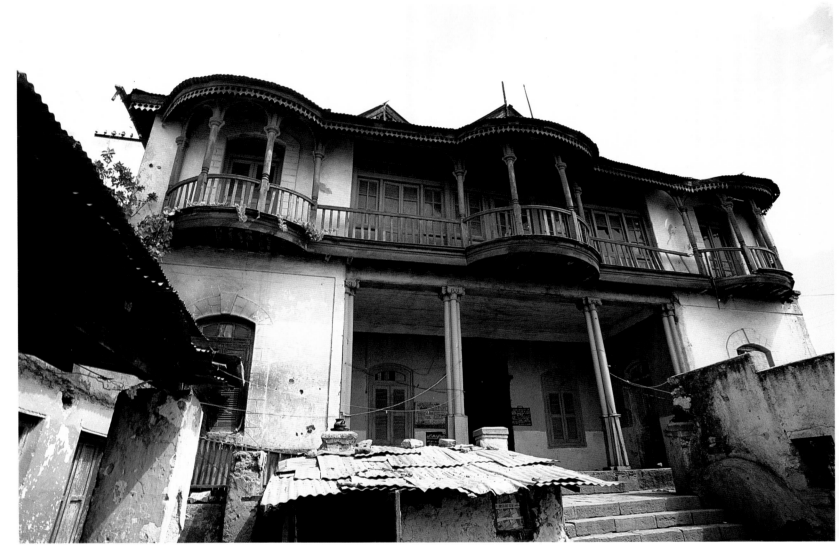

Above: Haile Selassie's house in Harar.

to be an independent city-state. But after only a decade Egyptian plans to set up an 'East African Empire' suddenly collapsed. Following Menelik's take-over in 1887, the emperor immediately set about preaching religious tolerance, which must have been quite a new concept for many citizens.

'We have no intentions of looting or destroying. After taking Harar we will protect and govern everyone according to his religion. We will subdue and pacify the route from Shewa to the sea. That is what we intend to do.'

Menelik appointed his cousin, Ras Makonnen, Haile Selassie's father, Governor of Harar. In his attempt to placate the Muslims and other inhabitants, the emperor gave the task of local administration to a nephew of the emir he had defeated in the battle for the city. Despite the constant warfare which Harar has witnessed over the years, it retains its medieval atmosphere. Harar has both a Muslim and a Christian marketplace,

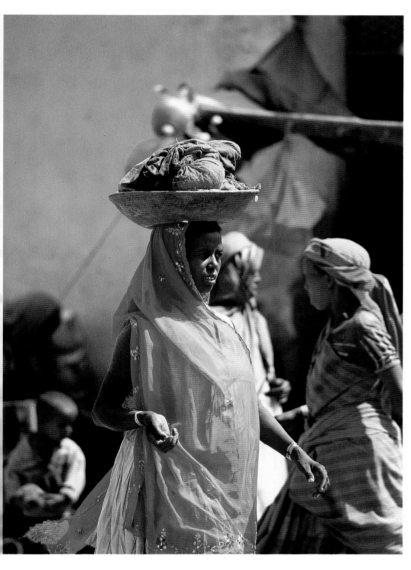
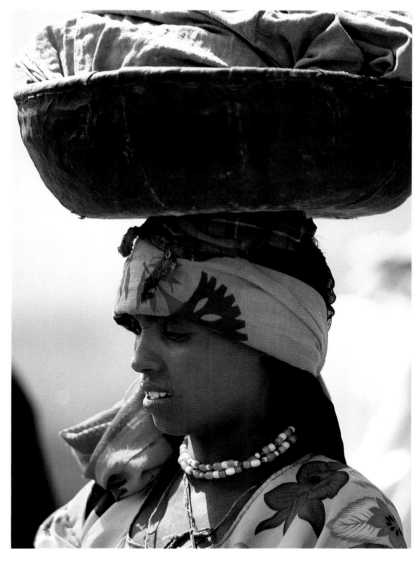

Above and above right: Colourful attire and displays mark market days in Harar.

mainly due to the different kinds of food required by both religions and the need for livestock to be slaughtered Muslim-style. But both have an air of the 'Arabian Nights' about them — of incense and intrigue as the cosmopolitan customers stroll by. The smell of coffee from the nearby Chercher Mountain slopes, said to be some of the finest in the world, fills the air as cups are endlessly poured.

Colourfully-dressed Harari women rub shoulders with rural Oromo, and here and there merchants from Yemen, Djibouti or India discuss business at local stalls. At times a nomadic Somali from the Ogaden or a Danakili man stand out in the crowd. Harar has long enjoyed the reputation of having the most beautiful women in Africa. After his visit — apparently the first white person to be allowed into its defensive walls — Sir Richard Burton wrote at length about the women he saw. An English adventurer who always had an eye for the opposite sex, Sir Richard found

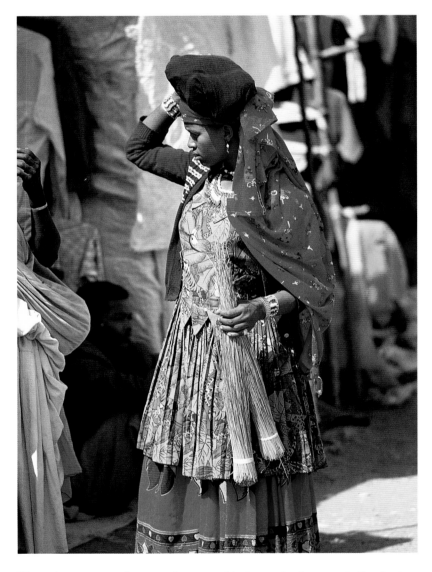

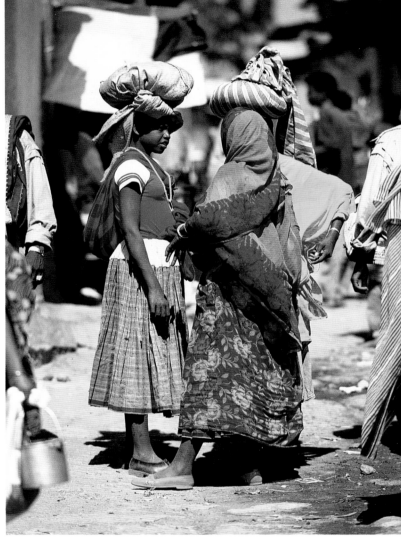

Harari women 'better favoured' than their menfolk. Later many other Westerners traced Burton's footsteps to Harar from the coast. One of them was Arthur Rimbaud, the flamboyant French symbolist poet. A colourful and larger-than-life character, he abandoned a life of debauchery among Parisian literary circles for a more adventurous life-style as an overland trader in the Horn.

Eventually Rimbaud settled down in Harar as a prosperous merchant. Biographers later revealed that Rimbaud had served as an intermediary for Emperor Menelik's diplomatic overtures towards European powers and had even brokered arms shipments for the emperor's army during Menelik's expansionary drive. The rebellious poet-turned-gun-runner is said to have died in France with a heavy leather money-belt strapped around his waist, stuffed with gold-bars, as payment from Menelik. A far cry from the iconoclastic teenager whose inspired verbal imagery helped

Above left: Brightly-dressed woman shops in a Harar market.

Above: Three pause in a market place in Harar to discuss the day's bargains.

Below, top to bottom: Silver jewellery made by a Gurage smith in Kaffa Province; amber beads displayed at Harar Museum; necklace from Agobe, Harerge Province.

Top: Cloak worn by an Ethiopian Ras (Duke) now kept at the museum in Harar.

Above: Ceremonial costume, complete with lion skin, mane and shield, reputed to have belonged to Emperor Menelik II, on display in Harar Museum.

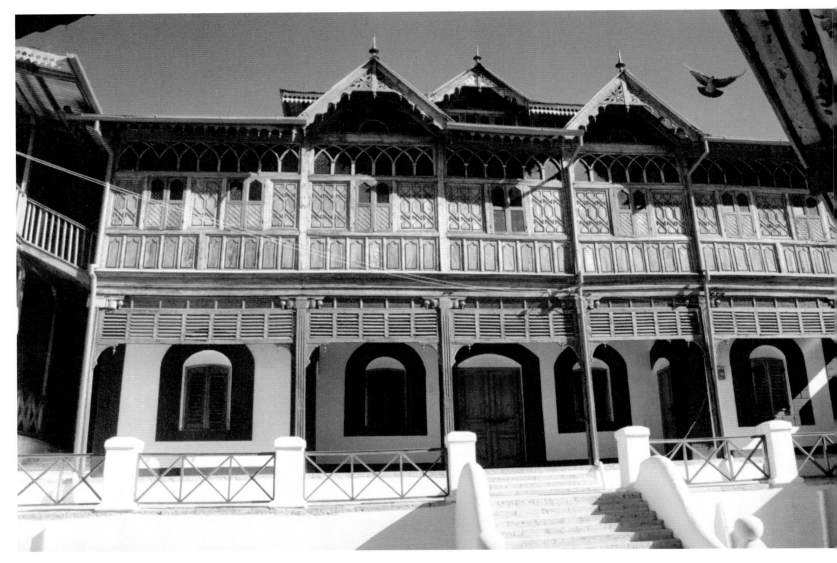

Above: Rimbaud House in Harar wrongly said to have been the home of the eccentric 19th-century French poet and traveller Arthur Rimbaud who lived and traded in the city.

pave the way for an artistic revolution in the European capitals. While Rimbaud continued writing erotic verse for his friends in Europe and frequent letters of complaint to his mother in France, he also found time to run a thriving business in silks, cottons and perfumes from the East in exchange for ivory, gold and coffee from Ethiopia's interior.

The strange, double-storeyed Gothic structure which visitors are now shown as Rimbaud's home, is not the real one. Unusual for a house in Harar, it has a stained glass window which overlooks the old Megalo Gudo market. Among the Westerners who visited Harar years later was the courageous 'game-for-anything' Rosita Forbes, who travelled on horseback and walked more than 1,000 miles (1,600 kilometres) through Ethiopia. In her book *From the Red Sea to the Blue Nile* she was naturally more concerned about the women's situation in and around Harar than about their appearance. She found, for instance: 'No woman may sow

Above: Interior of the Harar house in which Rimbaud was supposed to have lived. The stained-glass is a unique feature.

grain or drive a plough lest the land became sterile . . . The population of Harar is still largely foreign; Somali, Arab, Negroid, a few Yemeni Jews who are silversmiths, and a mixed race descending from Indian and other traders, also Gallas (Oromo) from the neighbouring provinces — a people who overran Abyssinia in the 16th-century — settled there.' On her way to Harar she had sampled *khat* in Yemen and found this stimulant led to three distinct mental conditions — stimulation, restlessness and lassitude.

The narrow alleyways of the inner city, wide enough for only two people to walk abreast, still remain and the aroma of incense and intrigue permeate the raucous atmosphere.

An animal which most people shun, the hyena, plays a special role on the outskirts of Harar. The 'scavengers' have become a tourist attraction and so have the fearless men who feed the hyenas at night, allowing these hungry carnivores to grab chunks of meat from their

mouths – a bizarre kind of nocturnal amusement. While the smell of Harar's world-famous coffee still merges with the noise of clattering cups in the city's marketplaces at Megalo Gudo and the Shewa Gate — as it was called when Rosita Forbes passed through — it is doubtful whether people are still seen walking in pairs handcuffed together, as Forbes described. In some cases she found a debtor firmly handcuffed to his creditor — so that the former would be certain to turn up at the court hearing. Others were murderers linked to the closest relative of the dead person for the same reason.

Rosita Forbes made her epic journey, logged in her diary as 'approx miles 1,089 3/4', in 1925, when Haile Selassie was still Ras Tafari, ruling under a regent. He succeeded to the throne only in 1930, on the death of Empress Zauditu, Menelik's daughter. In a 1935 edition of her book Forbes wrote that the first thing Haile Selassie did on taking over was to free all the slaves in the country. Under the regency he had already decreed that there should be a gradual emancipation of slaves and when he became emperor he took stronger measures to check this trade.

Although approving Haile Selassie's firm rule in the south-east when Governor of Chercher, Rosita Forbes's writing had a touch of acerbity when she warned, in 1935, about an impending Italian invasion of Ethiopia. Even as she wrote Mussolini's forces were girding their loins to launch an armoured attack from Eritrea.

Forbes expressed concern that the Italians might defeat the Ethiopians because the latter 'were too sure of themselves.' After their victory at Adwa they thought they were still invincible four decades later. Wrote Forbes: 'The people of Northern Abyssinia are a courageous people who have lived all their lives in the 16th century and will, one day, after war is declared, find themselves tragically in the twentieth. . . . It remains to be seen whether Italian money will break the resistance of headmen and provincial rulers, already shaken by armaments and engineering, of which at present they have no conception.' Although the people of Harar have lived through centuries of warfare waged by Muslims against Muslims and Christians against Muslims, as well as occupation by various invaders, the city experienced its narrowest escape from annihilation between 1977 and 1978 when Somali President Mohamed Siad Barre suddenly invaded Ethiopia in a modern war.

It was an outcome of the contemporaneous Cold War when Somalia and the Horn of Africa were seen as a strategic asset coveted both by the Western powers and the Soviet bloc. After Somalia gained its independence from Britain and Italy in 1960, many Somali began agitating for 'Greater Somalia', demanding the return of 'Somalia Irredenta', the land

Above: Statue of Ras Makonnen, Haile Selassie's father, in Harar.

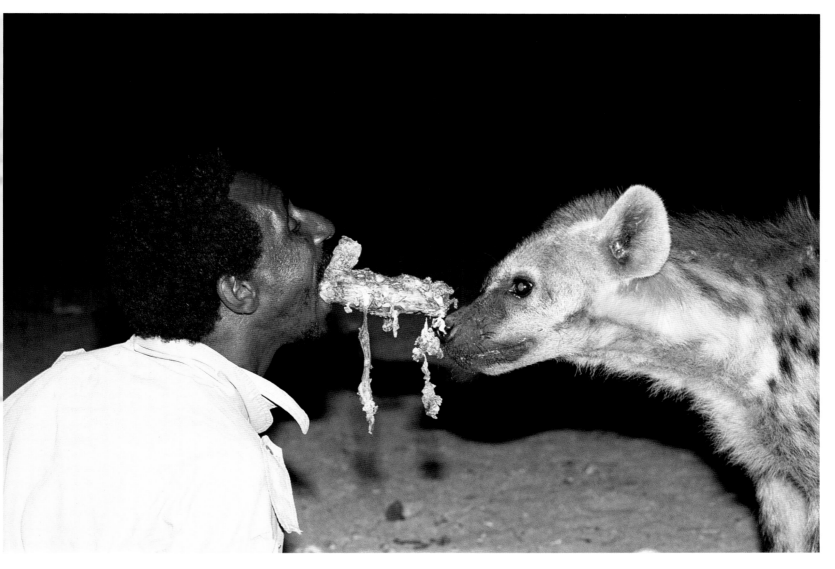

Above: An usual form of nocturnal entertainment is provided by the 'hyena men' of Harar. Each night, outside the city gates, they feed the carnivores with meat from their own mouths.

which they claimed was being unjustly held by neighbouring countries. It included Djibouti, Kenya's Northern Frontier District (now North-Eastern Province) and the Ogaden in south-eastern Ethiopia, together with the former British and Italian Somalilands, by that time united in the newly-independent Somalia.

The failure of the Somali to regain their 'lost' territories by peaceful negotiation led to an intense bitterness that festered from independence in 1960 to 1977 when President Siad Barre launched his major military invasion of what was then Ogaden Province. However, the audacious attack ended in humiliating defeat the following year in a tank battle outside Jijiga, not far from Harar. Once the shattered Somali forces had fled back across the border Harar retreated to the memories of its past glory behind the city-state's defensive walls. Apart from the rich, fertile slopes of the Ahmar and Chercher Mountains where, according to Ethiopians, the

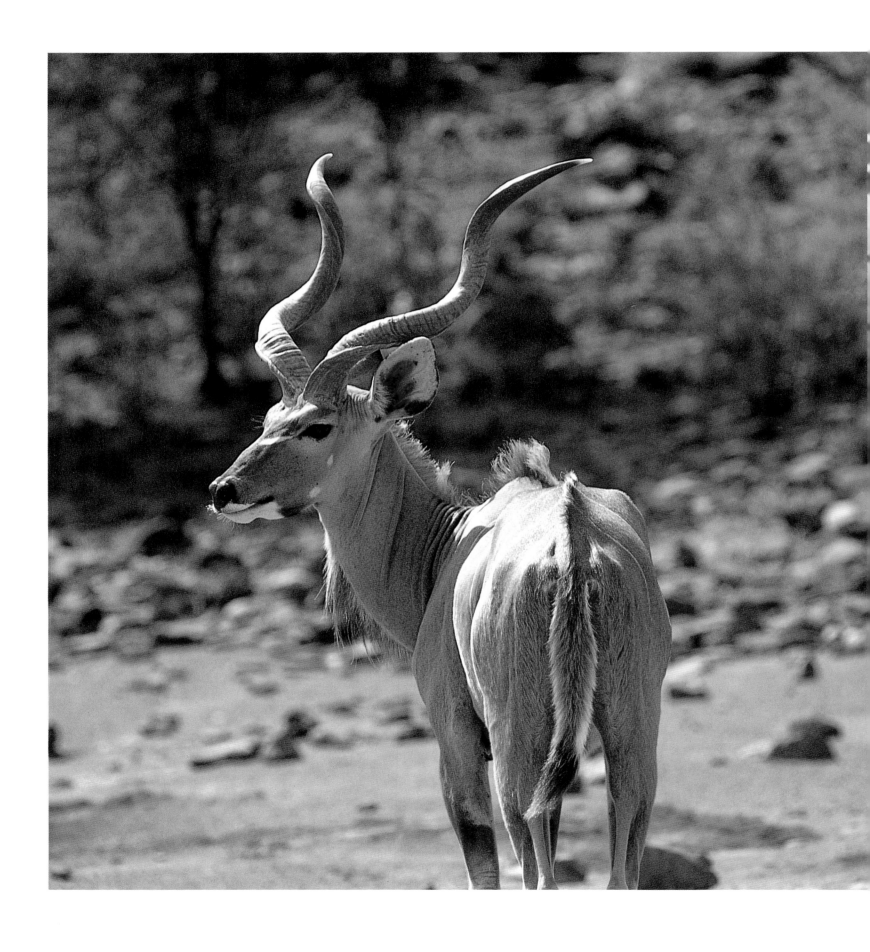

Above: Delicately-balanced rock in the 'Valley of the Marvels' in Harerge, so-named by the Italians during their occupation.

Left: A magnificent greater kudu. They are found in rocky, hilly country in six of Ethiopia's national parks.

world's best coffee is grown, the rest of Harerge Region is savannah scrubland. In the extreme north, this merges into the notoriously arid and scorching Afar Desert inhabited by tough Afar nomads.

A large percentage of the people of the Harerge Region live a harsh and dangerous nomadic existence, herding cattle, sheep, goats or camels. Many of those cultivating the fertile mountain slopes are Oromo who migrated eastwards from Arsi. Those in the Ogaden and along the border with Somalia are entirely of Somali origin.

The only large permanent river, the Wabi Shebele, forms the region's western border with Bale Region. After flowing 1,000 kilometres (617 miles) through Ethiopia, the river eventually reaches the Indian Ocean after travelling another 130 kilometres (80 miles) inside Somalia.

Wildlife abounds in Harerge, ranging from black-maned lions to elephants and a wide variety of antelope and other cloven-hoofed ungulates. On the slopes, stretching down to the southern plain below Harar, Ethiopia's largest wild animal reserve, Babille Elephant Sanctuary extends nearly 7,000 square kilometres (2,700 square miles).

The name is rather misleading for so vast is the sanctuary that the elephants are rarely seen and, being shy, tend to avoid human visitors. But there are some lions as well as wild asses and the magnificent lesser and greater kudu, with their ornate twisted horns. Because of its size no census has ever been taken of its wildlife.

From its northernmost boundary the arid badlands stretch away into infinity and down into the inferno of the Danakil Depression, a region so scorched and withered little survives there in the way of life.

And yet there, where a Journey through Ethiopia began and now ends, lies tangible and well-defined evidence that it was home to one of the earliest of all human species. A discovery that, like so much wherever you go in Ethiopia, makes you pause in wonder.

And ponder the profound history of one of the most beautiful and dramatic regions on earth.

Overleaf: Sundown over a remote region of Ethiopia.

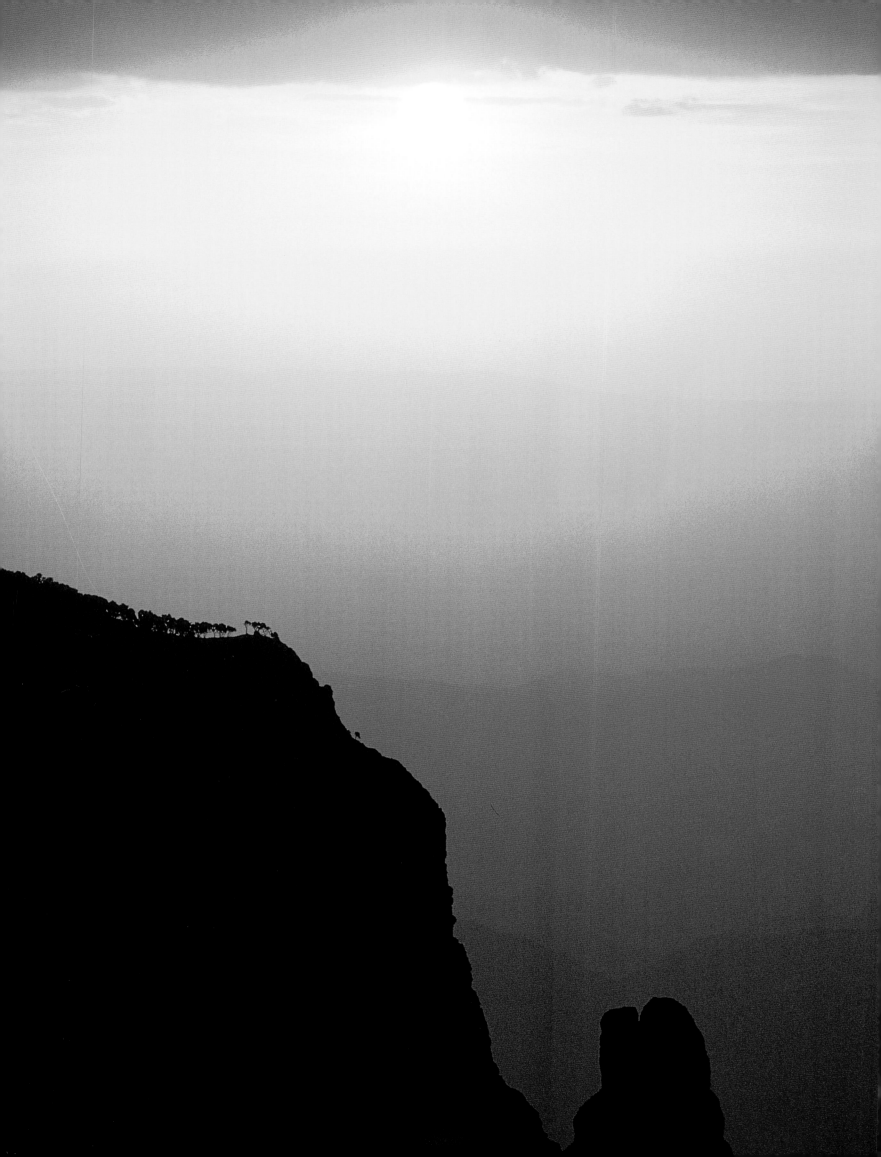

ዘከመ ቀተሉ ለእርዌ ምድር ቂ የየዶር ክ ገብረ

ቅዱስ ፈሲለደስ

ዘከ ምኅ ወደ ዘ ት